HOW TO
cheat
IN
Maya
2010

Tools and Techniques
for the Maya Animator

Eric Luhta

ELSEVIER

Amsterdam • Boston • Heidelberg • London • New York
Oxford • Paris • San Diego • San Francisco • Singapore
Sydney • Tokyo
Focal Press is an imprint of Elsevier

Focal
Press

Focal Press is an imprint of Elsevier
30 Corporate Drive, Suite 400, Burlington, MA 01803, USA
The Boulevard, Langford Lane, Kidlington, Oxford, OX5 1GB, UK

Notices
Knowledge and best practice in this field are constantly changing. As new research and experience
broaden our understanding, changes in research methods, professional practices, or medical treatment
may become necessary.
Practitioners and researchers must always rely on their own experience and knowledge in evaluating and
using any information, methods, compounds, or experiments described herein. In using such information
or methods they should be mindful of their own safety and the safety of others, including parties for
whom they have a professional responsibility.
To the fullest extent of the law, neither the Publisher nor the authors, contributors, or editors, assume
any liability for any injury and/or damage to persons or property as a matter of products liability,
negligence or otherwise, or from any use or operation of any methods, products, instructions, or ideas
contained in the material herein.

Library of Congress Cataloging-in-Publication Data
Luhta, Eric.
 How to cheat in Maya 2010 : tools and techniques for the Maya Animator / Eric Luhta.
 p. cm.
 ISBN 978-0-240-81188-8
 1. Computer animation--Computer programs. 2. Maya (Computer file) I. Title.
 TR897.7.L843 2010
 006.6'96--dc22

 2009040049

British Library Cataloguing-in-Publication Data
A catalogue record for this book is available from the British Library.

ISBN: 978-0-240-81188-8

For information on all Focal Press publications
visit our website at www.elsevierdirect.com

09 10 11 12 5 4 3 2 1

Printed in the United States of America

How to Cheat in Maya 2010

Contents

How to Cheat and Why

The Truth about Cheating

When we hear the word "cheating", we usually think of something negative: deception, trickery, or chicanery. However in this book, cheating is a good thing. If you've watched people who are masters of something at work, it can seem unreal, almost like they're... cheating! But really they just have experience and in-depth knowledge of how to do what they're doing. They know the most efficient way to do a task and make their tools work for them.

That's the goal of this book: to give you in-depth knowledge of animating with Maya so you can skip over the trial-and-error, constant web searches, and pouring through internet forums. Computer animation has its technical side, and just about all animators have struggled with it from time to time. There's nothing more frustrating than knowing what you want to do, but not being able to figure out how to do it. My hope is that this book alleviates the often rocky start of learning to animate with a computer, and becomes your go-to guide as you grow as an artist of motion.

My Philosophy

Before I became an animator, I spent quite a few years teaching music. As I gained teaching experience, one of the methods I found to be extremely effective in quickly transfering knowledge to someone else was isolation of a concept. While learning one thing at a time seems pretty obvious, I haven't met many animators who didn't learn by juggling a bunch of technical concepts in their student projects. While it's definitely possible to learn in trial-by-fire, it can make for some discouraging times. With this book I hope to avoid that approach and give you a firm grasp in the technical concepts of animation. You can quickly absorb the techniques and then easily apply them to your own work, without trying to figure it out in the middle of a project. You will understand how to employ Maya's tools faster and get down to concentrating on making your animation look amazing, rather than why that prop keeps popping out of the character's hand.

As luck would have it, the How to Cheat series is perfect for this style of learning. Every page spread is geared toward a specific concept, which allows you to go through the book cover-to-cover or skip around to the things you want to know about. The choice is yours.

Scene Files and Examples

Just about all of the topics have an accompanying scene file. Most of the topics enable you to follow along, employing the given technique in a prepared animation. Once you understand the technique and have practiced using it in an animation, it will be very easy to transfer it over to whatever you're working on. For chapters that are one long project, scenes are included in a progressive order, so you can jump in anywhere and learn what you want to learn without having to start at the beginning.

Having the scene files for an animation book should prove extremely useful, as you can take a look under the hood and examine the curves and see the movement for yourself. As great as books can be, you really have to see an animation in motion in the end.

Throughout the book, I use a character rig named The Goon, constructed by Cryptic Studios Lead Technical Artist, Sean Burgoon. It's a very fast, stable rig with just the right number of advanced features without getting too complicated.

The scene files are included for Maya 2010. If you're using an older version of Maya, be sure to go to File > Open > options and check Ignore Version. See the Chapter 1 Interlude for more information.

What You Need to Know

While this book starts at the beginning as far as animating is concerned, it does assume a basic knowledge of getting around Maya. You should be able to navigate the viewports (orbit, pan, dolly in 3D space), understand the interface, and be comfortable using the Move, Rotate, and Scale tools. This information is covered in countless places on the web and in other training materials, so I'd rather keep this book tightly focused than rehash what's easily found elsewhere. Also, you should have a basic understanding of the 12 Animation Principles and their uses.

Going Further

Visit the book's website at www.howtocheatinmaya.com. There you can find updates to the rigs, scripts, and tools included with the book. Happy animating!

Eric Luhta
Los Angeles, 2009

Acknowledgments

This book is dedicated to my beautiful wife, Lesley, for her support, unending patience, and boundless love as I worked on it over the past year.

I'm eternally grateful to the following people:

Mom and Dad for always supporting and encouraging me

Lee Wolland for his technical editing and invaluable feedback and assistance

Sean Burgoon for creating the Goon rig, for so generously letting it be the cornerstone of this book, and for sharing his knowledge in his interview

My good friend Kyle Mohr for all his help in creating artwork and doing the flip book animation for the corner, as well as his constant feedback and advice

Katy Spencer, Melinda Rankin, and Laura Lewin at Focal Press for all their support and patience with me throughout the writing process

Steve Caplin for all of his insight and guidance

Chris Williams and P.J. Leffelman for being fantastic leads who taught me so much about animation, and for generously sharing their knowledge in their interviews

Justin Barrett for creating the fantastic Tween Machine tool, www.justinanimator.com

Jason Baskin for his Blake character rig, www.3dcentral.com

Bobby Beck and Taylor Mahony at AnimationMentor.com

All the animators who have taught me so much, mentored me, and been a tremendous inspiration: Pete Nash, Bret Parker, Doug Dooley, Carlos Baena, Shawn Kelly, Amber Martorelli, Juan Carlos Navarro, Jayson Price, James Crossley, Alan Hawkins, Brian Scott, Morgan Kelly, Derek Friesenborg, Jeff Weir

How to Use This Book

I've designed this book so that you can use it in the way that best serves your needs in learning to animate with Maya. You can choose to start at the beginning and read it straight through, as the chapters are ordered progressively. The first few talk about fundamental concepts in workflow and how animators think about the tools available in Maya. Then we start practicing some techniques in the context of animations already started for you, finally moving on to guiding you through doing projects in blocking, walk cycles, polishing, lip sync, and rendering the results.

If you've been animating for awhile, but need some new tips or approaches to problems you've been having, you can simply go to any topic that interests you, and pick it up right there. Even the guided projects include a series of progressive files so you don't need to start from the beginning. If you want some help on animating the spine, just jump to the spread in the walk cycle or blocking chapters, open the file, and you're in business.

Throughout the book I use the abbreviation of "f01" to mean frame 1, or whatever frame number we're talking about. Frame numbers are also included on every screen grab where they're relevant to make things as clear as possible.

There are a couple things that are customary in the How to Cheat series that aren't as crucial with this particular book. The shortcut keys are not defined to Mac or PC, since all the shortcuts we talk about are identical on both platforms. I also skipped using the movie icon for movies, because all the projects are animations and are movies by their very nature. You will see it moving when you open it up in Maya, so I figured it was unnecessary.

The projects are separated by chapter, and some of the projects also have Quicktime movies of the chapter's final result. Also included is the Goon rig in several versions (regular and ninja), as well as scripts, tools, and video tutorials.

For additional info and updates, be sure to check out the book's website:

www.howtocheatinmaya.com

■ This chapter will have your animation ninja skills primed in no time.

1

Workflow Foundations

A LITTLE BIT of workflow goes a long way, especially when animating. Maya offers multitudes of options for customizing, but lucky for us we only need a handful to make our work smooth sailing. This chapter will show you everything you need to organize tools, maximize performance, and unclutter the interface. As in so many things, the basics carry the most weight, so let's get to it!

DOI: 10.1016/B978-0-240-81188-8.50001-1

Setting Up Projects

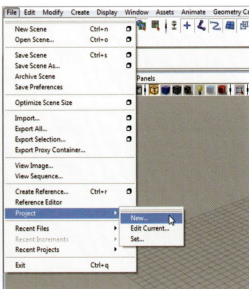

SETTING UP YOUR ANIMATION PROJECT is a crucial step to staying organized. Defining a project tells Maya to create a centralized folder structure and keep everything in it, in addition to keeping you from going crazy. Any data created in Maya, such as scenes, materials, renders, etc. will automatically be placed in the project's folders. For simple animation tests, this is moderately useful at best. But when you get into more polished work that may have multiple shots, sets, textures, lighting, and renders, projects are absolutely vital. Getting into the habit now will pay dividends in your future work. This is basic and introductory information, but it's important enough to still be the first thing in this book!

1 Create a new scene in Maya and go to File > Project > New.

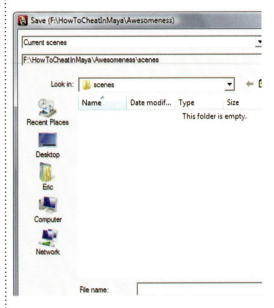

4 You won't see any indication you've created a project until you save your scene. Save it, and in the dialog that appears, you'll notice that Maya has already navigated to the Scenes folder in your project. From this point on, Maya will keep everything organized.

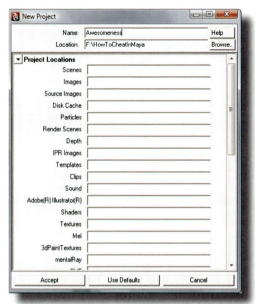

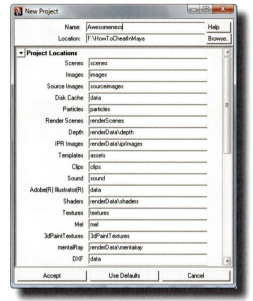

2 Name your project (be sure it's something awesome), and then click the Browse button. Navigate to where you want to save and choose it as the location.

3 The list below are the folders that Maya will sort its various files into. Click the Use Defaults button and the standard folder names will be filled in for you. You can rename them or put in alternate paths if you want to change locations, or create nested folders by using a backslash. When you're finished, click the Accept button.

HOT TIP

Use File > Project > Edit Current to organize your scene files as you work. This is particularly useful if you decide to do different versions of your animation in the middle of working. Using the backslash to add folders into the scenes folder can keep things from getting messy, especially when you have lots of incremental saves and variations.

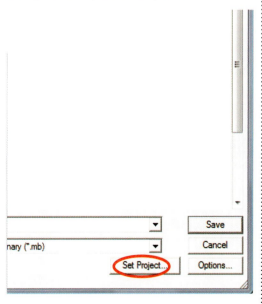

5 You may have noticed when we created the project there was an Edit Current option. This lets you edit the folders. Note that if you change a folder name, it will not rename or delete the original folder, but instead create a new one with the name you entered.

6 The Set option is how you change the current project. It's possible for Maya to tangle up where to save when moving between different projects, so use the Set Project button whenever you open a scene from another project.

Workspace Layout

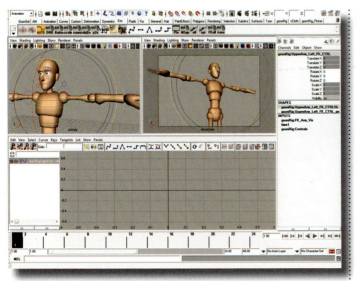

1 Open panelLayout.ma. In any viewport menu, go to Panels > Layouts > Three Panes Split Top. The viewports will be divided into three parts, which we can then define as whatever Maya panels we like.

A N EFFICIENT WORKSPACE shows you everything you need to see, and nothing you don't. Maya's default four panel or single panel layouts leave a lot to be desired for animating, so let's create one that shows us only what we need. While different tasks call for different layouts, there are several tried and true versions that many animators employ. If I think about what information is vital when animating, the three most important to me are: the camera the animation is staged in (shot cam), a view I can navigate through to see what I'm working on, and my graph editor curves. Here's a battle tested panel layout that sets us up for a productive workflow.

4 In the other top window, if it isn't already, Panels > Perspective > persp will give us a perspective window. This way we can move around our animation and focus on what we need without messing up the shot camera.

7 It's helpful to turn on a film gate (View > Camera Settings > Film Gate) so you can make sure the important elements stay in frame. You can also press the Gate button above the panel. Turn off the gate when you playblast to see exactly how your animation will look.

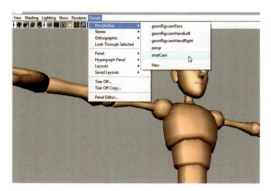

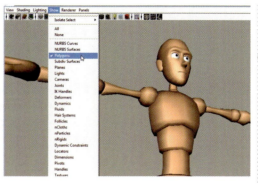

2 I'll set one of the top panels to the shot camera so I can always see how the final animation will be framed. In the Panels > Perspective menu, you can see a list of all the perspective cameras in the scene. Select shotCam.

3 Let's keep things clean and uncluttered so we can focus on composition and performance. Go to Show > None which will make everything disappear. Then go back into Show and select Polygons and Nurbs Surfaces. This shows only our character.

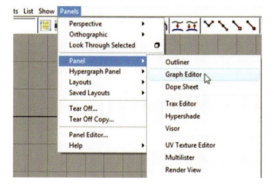

5 Since the Graph Editor is arguably the most important animation editor, we'll put it in the lower panel so we can always keep an eye on our spline curves.

6 We'll discuss the Dope Sheet editor in a later tutorial, but keep in mind the button at the upper right of the Graph Editor. It lets us easily switch between it and Dope Sheet without having to open another editor or change our panels, another advantage to this layout.

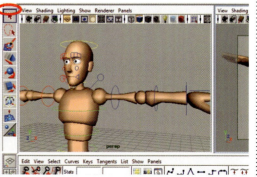

8 I also like to make the timeline bigger in Maya's preferences so it's easier to scrub and do keyframe edits. Making the key tick size bigger can make things easier on the eyes as well.

9 Last, I'll hide the toolbox by clicking on the dotted gray area at the top. Everything here is accessed best with our QWERTY keys, and is just taking up more space for animating.

Playblasting

Stewie character courtesy of AnimationMentor.com

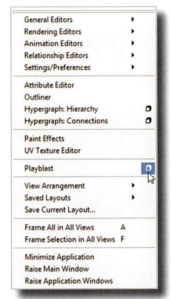

UNLESS YOU'RE USING the simplest characters possible, playing your animation within Maya is often not an option. Character rigs can be too processor intensive for realtime playback, and even with a fast machine that seems to pull it off, there will still be too many slight inaccuracies to rely on for high quality work. Alas, playblasting becomes a way of life for a computer animator.

When Maya playblasts, it takes a screenshot of every frame, creates a movie file out of them, and sends it to the resident movie player on your computer. This way you see exactly what your animation looks like at actual speed. It's simple stuff, but there are some tricks that can be overlooked that we'll look at here.

1 To access the playblast options, go to Window > Playblast > Options box. Whenever you see this box next to a command, it opens a dialog to set how that command will work.

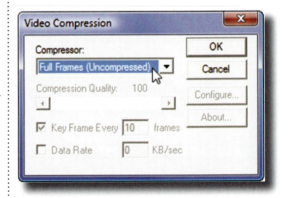

4 A good trick for creating high quality playblasts is to click the Compression button and set to Full Frames. The file will be large, but can then be compressed with Quicktime, DivX, etc. This is generally best for final versions, rather than while working.

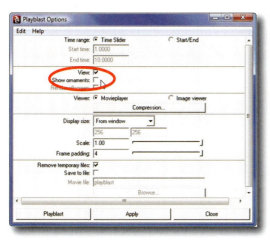

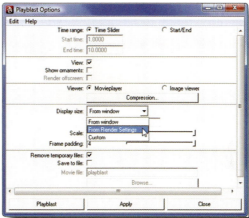

2 Turning off the Show Ornaments checkbox will hide the camera name and viewport's axis reference in the playblast. This can make things look cleaner and less cluttered.

3 Under Display Size, if you have render settings defined, you can set it to From Render Settings and automatically inherit the correct size. This is good for incorporating playblasts into sequences that have shots already rendered. Everything will be the correct size automatically.

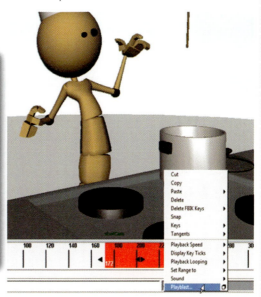

5 Checking Save to File will automatically save the playblast in the directory and with the name you define. This is great for automatically maintaining versions throughout for comparison.

6 To quickly playblast a specific range, hold *Shift* and drag in the timeline to highlight the frames you want. Then right click on the selection and select playblast (hotkeys or using the menu will playblast the entire range).

HOT TIP

Be sure to always maximize the viewport you're playblasting. Since it is using screenshots, playblasting from a smaller window than the playblast size can look very grainy, as it's scaled up by the movie player automatically.

File Referencing

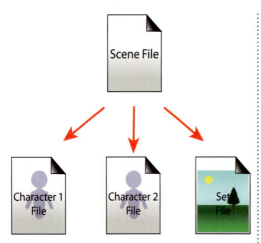

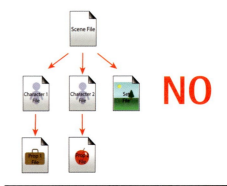

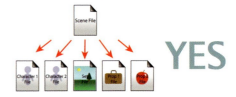

K EEPING YOUR ANIMATION files organized and adaptable is another practice that has a direct impact on your workflow. Making use of Maya's referencing functionality is a key part of maintaining control of your animation assets. When you reference a file, the scene you are working in simply looks at that file and loads it into memory, but not into the scene itself. Referencing allows you to keep your files separated while still working as if everything were in a single scene. This allows you to incorporate revisions to the rigs, models, and props after you've started animating, keep file sizes down, and reuse assets to save time. If you're using a character in 10 different files and they need a revision, updating just the character file will automatically update it in every scene it's referenced in.

Referencing is the fundamental method of incorporating assets in every professional studio. It's also essential if you're working with anyone else on a scene or sequence, as it's the only way to share assets, keep file sizes down, and easily make universal changes. Here are some tricks for making referencing even more flexible.

1 In general, the actual scene file will only have the animation data. The characters are referenced from their separate files. Always keep only one layer of referencing by not having referenced files reference other scenes. This can cause strange behavior since infinite loops of referenced files can be created.

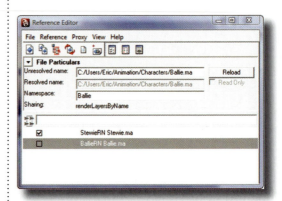

4 Under File > Reference Editor there is a list of all references in your scene. You can load and unload references to increase performance using the checkboxes. Unloading a reference still saves all the animation data on it, so you can do it as necessary while working.

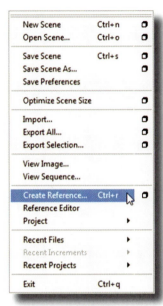

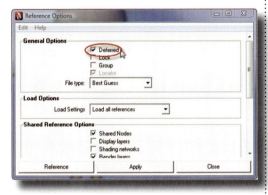

HOT TIP

If you have an animated camera, you can have it in a scene file by itself and reference that into your working scene. This is very handy if you have an animation with many characters that must have multiple scene files composited together in post. The camera animation will always be consistent, and you can edit it in the camera's scene to have it update in all your other scenes.

2 When you start a new scene, reference your characters rather than importing or simply resaving the character's file. Go to File > Create Reference and navigate to the character file. It's a good idea to have the character rigs copied into the project directory beforehand as well.

3 You can also load a reference as deferred in the Create Reference options. This creates the reference but does not load it into memory yet. This is helpful if your rigs are complex and you want them available but not currently using resources and slowing down performance.

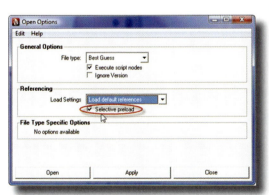

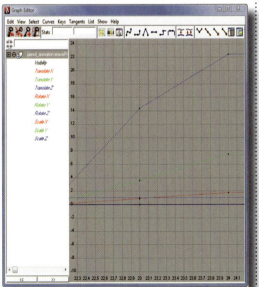

5 If you are opening a scene file but only need certain references at the moment, you can load specific ones. In the File > Open > Options dialog, check the Selective preload button and click Open. This will bring up a window to choose which references are initially loaded.

6 You can reference things that are animated, but you can't edit the animation in the current scene. Curves from referenced files will be dashed lines and unselectable. To edit these, you must open the actual referenced file or import them into the scene permanently.

11

Creating a Shot Camera

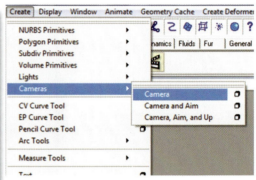

1 Open shotCam.ma and go to Create > Cameras > Camera. A standard camera is the one used most often, and will be sufficient for most animation tests and shots you'll do.

THE CAMERA IS ONE OF the most important entities in any animation. It dictates what you animate and how you animate it. Throughout your animation career, you can bet on hearing the phrase "animate to camera" regularly. A test or shot will be approached completely differently depending on how the camera is positioned. Because of this, it should always be the first thing you create for any animation project. You'll most likely make some adjustments later, but getting it in the ballpark to begin with will form the basis of the decisions you make about staging, composition, acting choices, and more. While a complete myriad of artistic reasons for camera choices are beyond the scope of this book, we'll touch on some basics that can inform your further study of these concepts, as well as some technical tricks.

4 You can also click on the camera icon in your perspective window and choose Panels > Look Through Selected. If you don't see a camera icon at the origin, check that Show > Cameras is checked.

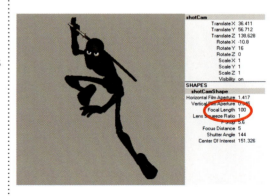

7 If needed, adjusting the focal length can get you the look and staging you want. It's represented in millimeters, and 35 is your standard film camera. Higher values reduce the depth and make the image flatter.

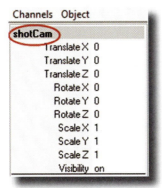

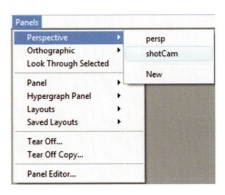

2 The camera will be automatically selected after it's created. Click on the name "camera1" in the channel box and rename it to something more descriptive, such as "shotCam".

3 There are several ways to change the viewport to your camera. The first is in the viewport menu Panels > Perspective where you'll see your camera name.

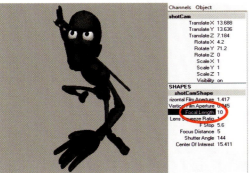

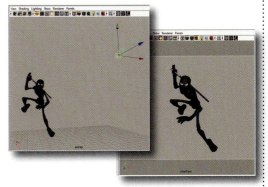

HOT TIP

You can undo and redo camera moves in the viewport using the bracket keys **[** and **]**.

5 You'll then see the name "shotCam" in the viewport and can navigate to position it just like a normal perspective window. To select your camera to adjust attributes in the channel box, just click the Select Camera button in the shotCam's viewport menu.

6 For fine tuning you can have both windows open, and move the camera in the perspective window while keeping an eye on the shotCam. This is great for making small adjustments to your composition.

8 Lower values will widen the depth, but can also create very noticeable distortion if the subjects are too close. In the end, it depends on the purpose of the shot. For standard animation exercises, sticking with 35mm is usually a safe bet.

9 When you've got the angle you want, highlight the channels, right click, and choose "Lock Selected". This will prevent accidental moving of the camera. If you need to change it later, simply repeat and choose "Unlock Selected". The channels are gray when locked.

Quick Selection Sets

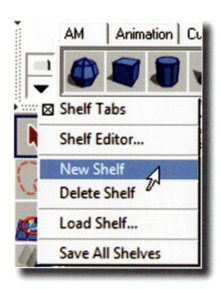

MANY ANIMATORS TAKE ADVANTAGE of the free character rigs available on the internet for personal work and improving their skills. However, the majority of these characters tend to not come with GUI interfaces for selecting their controls. Perhaps you'll be working in a small studio where the work is shared between a small group of people, making such "luxuries" low on the priority list. Whatever the reason, having to constantly select the individual controls to key your character is an instant animation buzz-kill. Fortunately, Maya has quick select sets that we can use to quickly build selection buttons in any manner we like. Then in the following cheat, we'll check out creating icons for your own custom GUI shelf.

1 Open QuickSelectSets.ma. To start, let's create a special shelf tab to keep all the controls we create for the Goon Rig organized. Click the down arrow next to the shelf and select New Shelf. Name it "GoonSel".

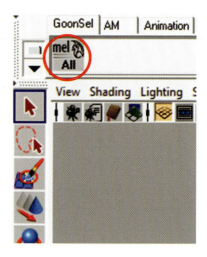

4 With all controls selected, go to Create > Sets > Quick Select Set. In the dialog, name the set "All" and click the Add to Shelf button. It will appear in the GoonSel shelf and clicking that will select all the controls.

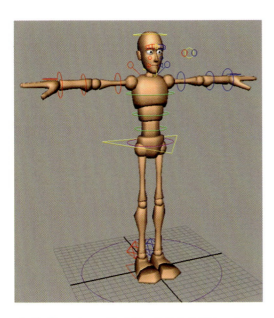

2 You'll now have a blank "GoonSel" shelf. Click on it so it's currently active. First we'll make an "All" set to select all controls of the rig. Switch to perspective view.

3 Starting at the base, carefully select each control of the rig, including the face controls. Be very thorough, as forgetting one will create headaches later and cause you to redo or edit the set. Don't forget the eye controls!

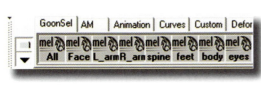

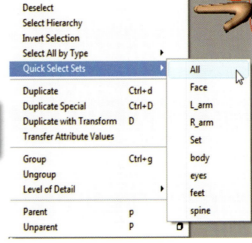

5 Repeat those steps to create buttons for any selection combinations you need.

6 The sets can also be accessed from a menu. Go to Edit > Quick Select Sets to see them.

Quick Selection Set Icons

CREATING QUICK SELECTION SETS makes managing a rig's controls multitudes easier, and we can increase their usability to make them even more user friendly and intuitive. Adding icons to your selection set buttons will make things faster and more pleasant to work with. This cheat explains how to create them for not only your selection sets, but for any other custom shelf button you create. We're using Maya's default rendering options, because they work fine for these purposes and save us the additional steps of setting up a render.

While using a 2D graphics program to edit the icons is beyond the scope of this book, you can use anything you like as long as it can save 32x32 bitmaps (.bmp). You can also forgo using Maya's renders and simply design your own icons however you wish, if you're feeling so inclined. And just in case you're not interested in getting too involved with things outside of animating in Maya right now, I've included the icons used in this cheat on the DVD so you can get them plugged in right away.

1 Open QuickSelectSetsICONS.ma. I'm going to use renders of the character for the icons. Position the view appropriately for the button, and click the render current frame button.

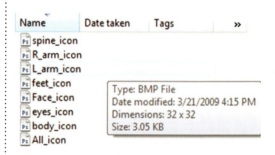

4 Icons must be 32x32 resolution and in .bmp or .xpm format. Create your own using whatever method you prefer, or you can find mine in the chapter's directory in the Images folder.

7 Click Save All Shelves when you're finished, and you'll have an appealing, professional-looking selection shelf to make selecting controls much easier.

2 Default renders should work fine for these purposes. In the Render window, go to File > Save, and select any format appropriate for the photo editing software you use.

3 Create renders for each icon, focusing on the body part it's for. Here I rotated the hand for a better silhouette so it's more clear as a tiny icon.

Experiment with orthographic views to get the best icon silhouette. The front view in particular works very well in a lot of situations. Don't be afraid to move parts to slightly unnatural poses to get something easily readable. For the feet icon, the foreshortening would make it unclear, so I rotated them out for an easy to see icon.

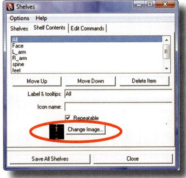

5 To add the icons, click the down arrow next to the shelf and go to Shelf Editor...

6 Select the button you wish to add the icon to. Then select Change Image and browse to the icon you want. I also deleted the text for Icon Name so it doesn't appear over the pictures.

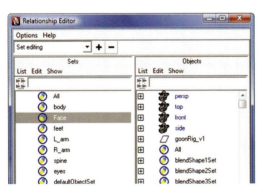

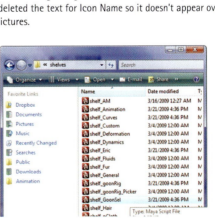

8 If you need to edit your Quick Select Sets, go to Window > Relationship Editors > Sets. This self explanatory editor lets you manipulate the set's members however you like.

9 Finally, the shelf file is found in the Documents (or on your Mac HD) > maya > 2010 > prefs > shelves folder. You can copy the shelf and your icons (wherever they are located) to move them to another computer.

Creating Shelf Buttons

ANY ACTION YOU CAN DO IN MAYA is really a MEL (Maya Embedded Language) script command that happens behind the scenes. Maya makes these commands easily accessible through the Script Editor, and this is one of the main reasons it's such a powerful and customizable software package. Fortunately, you don't need to know how to script MEL to employ it in making tedious actions, well, un-tedious. You can extract a script by simply doing an action in Maya, taking the code generated by the script editor, and saving it as a button on the shelf to greatly speed up your workflow.

In this cheat we'll learn several different ways of making shelf buttons. You'll be able to take these tips and make any action or series of actions into a single click button. Whether it's 2, 5, or 25 clicks, it'll be just one when we're through.

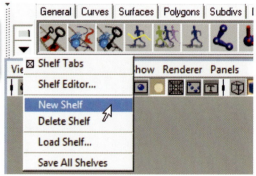

1 Open the Goon Rig. First we'll create a shelf to put our custom buttons on. Click and hold the down arrow next to the shelf and select New Shelf.

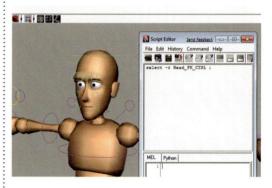

4 On the Goon Rig select the head control. Notice the MEL script for doing this action appears in the Script Editor.

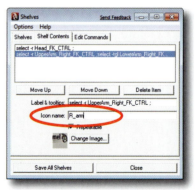

7 In the drop down menu where you created the shelf, select Shelf Editor. Here you can place text on the button to remember what it does. Select the script you want, and then type a short name (no spaces) in the Icon Name field.

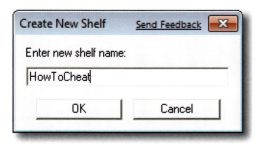

2 Enter a name for the shelf and click OK. A new blank shelf tab will appear.

3 Now we need to open the Script Editor to see the scripts Maya is executing when we select our controls. Press the lowest right hand corner button to bring it up.

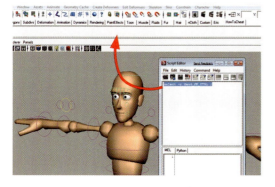

5 Highlight the code and middle mouse (MM) drag it to the shelf. Select MEL in the dialog that pops up, and a generic shelf button will appear.

6 Clicking the button will now select the head. Shift select multiple controls, highlight all of the MEL script, and MM drag it to the shelf to make a button that selects multiple controls.

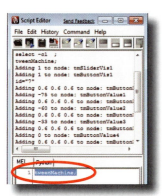

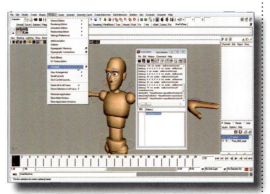

8 To make a shelf button for a script you've installed (see the next page for more info), simply type the name of the script's MEL file (noting caps) in the bottom section of the script editor, and MM drag it to the shelf.

9 Hold Shift ctrl alt and then select any menu item to automatically make a button for it. This is great for things like playblasts and constraints that we use often.

Using MEL Scripts

THERE ARE THOUSANDS of freely available MEL scripts that you can use to make Maya easier to use and more powerful. Scripts can range from doing things as simple as rearranging the interface, to exceptionally powerful tools that add new functionality and features. As you go through your animation career, you will no doubt build a library of scripts that are indispensable to your workflow.

I've included a number of my favorite scripts with this book, but before we can use them, they need to be placed into the appropriate locations. You can keep MEL scripts anywhere, but then the entire directory is required to run it and requires more effort to stay organized. There are default locations we can place the scripts, however, where Maya will automatically look whenever we type a command. This way we only need to type the name of the script to run it for the first time and can quickly add it to the shelf for future use. We're going to add the Tween Machine script in this cheat, and learn how to use it in a later chapter.

1 When you download or add any script, it first needs to be saved into MyDocuments/maya/2010/scripts on PC, or User/maya/2010/scripts on Mac. Copy the tweenMachine.mel and xml_lib.mel files from the included CD into your scripts directory. This script needs two files, but most are only one.

4 If you open the Script Editor, you can see the commands you typed have been recorded. You can highlight the script and MM drag it to the shelf to create a button to run it.

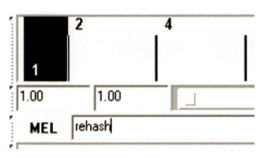

2 If you try to run the script now, Maya won't see it
because it only parses the scripts at startup. To tell it
to look at the directories again, in the command line at the
bottom left type 'rehash' and press *Enter* . Nothing visible
will happen, but now the script will be available.

3 Still in the command line, type the script file name
tweenMachine exactly and press *Enter* to run it. The
interface will appear. To run any script you add, simply
type the exact file name, including caps, after rehashing (or
restarting Maya).

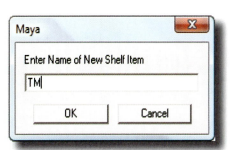

5 An alternate way to save the script to the shelf is, in
the Script Editor, select the text and go to File > Save
Script to Shelf...

6 This method automatically opens up a naming dialog so
you can name the button without having to open the
Shelf Editor.

Creating Hotkeys

Pretty much everything in Maya is customizable, and as your workflow develops, you'll find that you can set up Maya to work the way you want it to. One of the most powerful speed-enhancing methods is the use of hotkeys (known as keyboard shortcuts in other circles). Maya's hotkeys can go beyond single commands as well, being able to run entire scripts or generate custom context menus, depending on your needs. Since we've learned how to incorporate scripts in previous tutorials, let's use the Script Editor to help us create a hotkey to do an action that you'll repeat uncountable times in your animation career: playblasting.

1 Create a new scene and open the Script Editor. Go to Window > Playblast to run a playblast. It doesn't matter that nothing is happening; we just need Maya to generate the playblast MEL code.

4 In the Script Editor, highlight the playblast MEL code (from "playblast" to the ";") and MM drag it into the Command field in the Hotkey Editor.

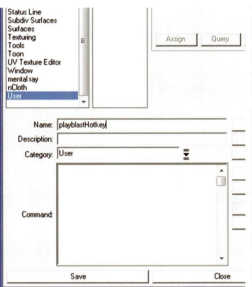

2 Go to Window > Settings/Preferences > Hotkey Editor. The left panel contains sorting categories for all the hotkeys. Since we're making a custom one, select User.

3 Click the New button on the right side to create a new hotkey. Enter a descriptive name, keeping in mind the Maya naming rule of no spaces.

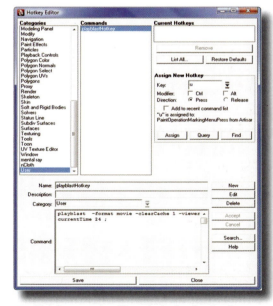

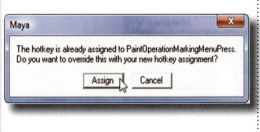

5 Click Accept and you'll see the hotkey listed under Commands. Now we can assign it to any key we like. I'm using u, since its default is not a command I use as an animator.

6 Maya will warn you that you're changing an existing hotkey, which is fine. Click Assign and now whenever you want to playblast, simply press the **U** key.

HOT TIP

You can use the Query button in the Hotkey Editor to see what a particular key is currently assigned to do. You can also use the modifier checkboxes to create commands that use the **ctrl**, **alt**, and **Shift** keys.

Proxy References

1 Open the KungFuHouse.ma file for a high-res model of a house. Change Maya's menu set to Polygons to get access to the modeling menus.

ONE OF THE MOST FRUSTRATING obstacles in animation is a heavy scene. If it has too many characters, complex pieces of geometry, props, or anything else that taxes your system's resources, you can find yourself unable to scrub efficiently. Needless to say, this isn't the ideal way to work, so let's look at a way we can make any scene geometry we're using as efficient as possible. We can use Maya's primitive geometry shapes and referencing to create stand-ins for high res geometry that needs to be seen while working, just not in all its detailed glory. Then when it's time to render or playblast, you can swap them out for the full versions with a couple of clicks.

4 Create more cubes and position them with the sections of the house. Use exactly what is necessary to convey the basic shapes. I've colored the cubes here so you can see how I built the approximation over the model.

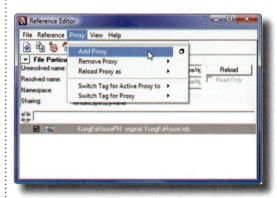

7 In the Reference Editor, select the referenced house and choose Proxy > Add Proxy. Select the proxy file you created and you'll see the proxy icon appear next to the reference.

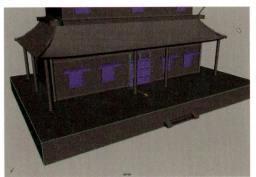

2 Go to Create > Polygon Primitives > Cube. It will be hidden by the house, so switch to the scale tool using **E** and scale up the cube until it can be easily seen over the house.

3 This will be the stand-in for the house's foundation, so using the move **W** and scale **E** tools, position the cube so it more or less lines up with it. It doesn't need to be perfect; just get it reasonably close.

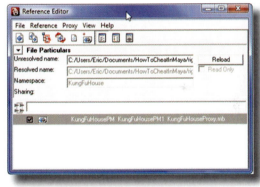

HOT TIP

You can use any of the Polygon Primitive shapes for proxy geometry. All of them are very simple and fast in the viewport.

5 Select just the cubes you created and go to File > Export Selection. Name the file KungFuHouseProxy.

6 Open a new scene without saving the changes, as we need to reference the KungFuHouse to use the proxy feature. Reference the KungFuHouse.ma file into the scene and then open the Reference Editor (File > Reference Editor).

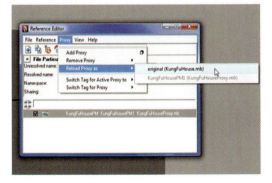

8 You can now easily switch between the original and proxy as needed by going to Proxy > Reload Proxy and choosing the file you want to display. This enables you to use fast proxies while animating and then switching to the full models for playblasts or rendering.

9 Proxies can be as broad as necessary. If this house was way in the background, a simple cube for the entire thing might be sufficient. Use only the amount of detail you need.

Opening Maya Files

I KNOW THE TITLE OF THIS INTERLUDE may seem a bit ridiculous. After all, if your computer knowledge is at the level of needing a tutorial on opening a file, you're probably not quite ready for computer animation yet. But I wanted to touch on an important cheat (and this one really is!) that may not be readily apparent if you're new to Maya and/or computer animation.

The fact is, scene files in Maya are not backwards compatible, at least not by default. To get around this, you can usually go to File > Open > Options and check "Ignore Version". This will work for many cases, but there are seemingly random times that it doesn't. In these situations, you may need to resort to a little trick that's been passed down over the years to open Maya files in previous versions than they were created in.

There are two types of Maya files, .mb (maya binary), and .ma (maya ascii). Maya binary files are smaller and faster to open and save, but are made up of 0's and 1's. In other words, there's nothing a human being can do to look at and understand them. Maya ascii files contain the same data, but do so using text. Lots and lots and lots of text. They're larger and a bit slower, but the good news is you can open them up in a simple text editor and make changes to it outside of Maya.

If you're using a previous version of Maya to work with the files in this book, this is what you'll need to do to get them working if the "Ignore Version" option doesn't come through :

Open the Maya file in a simple text editor (not word processor) like Notepad. There will be a wall of text, but we only need to worry about a few select spots. I've circled these points of interest in the screenshot. We're looking for the three places where the file declares which version it was made with.

You can see the places where Maya 2010 is declared above. In these three spots, simply change them to your Maya version, such as 2009 or 2008. Keep the quotations, and don't alter anything else. In the last spot, keep the "x64" if you're using a 64-bit version of Maya. It should look like this:

Save the file as scenename.ma (make sure it doesn't save as a .txt file) and now your file should open in a previous Maya version. Bear in mind that no matter what you do the Animation Layers chapter files will not work properly in any version before 2009, as that's when this feature was added.

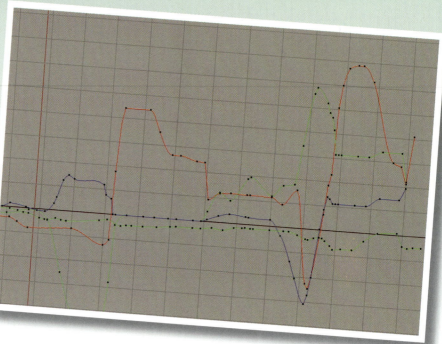

■ Splines can wrangle you, or you can wrangle them. Not into being wrangled? Keep reading! (And I just won a bet to use "wrangle" in a caption three times.)

2 Splines

SPLINE CURVES, or just "splines" (or even just "curves"), are the lifeblood of computer animation. They're a surprisingly efficient and comprehensive method of representing motion. Much of your time animating will be spent perusing these little red, blue, and green intertwined curves, so it makes sense to get comfortable with them. This chapter is all about facilitating your comfort.

Opening the Graph Editor to what looks like a spaghetti dinner gone bad can be intimidating, but we'll make understanding splines a quick study. We'll go through the simple concepts that make reading them easy and so powerful. Then some cheats on editing splines will have you wrangling them under control in no time. Get ready to meet your new best friends in animation!

DOI: 10.1016/B978-0-240-81188-8.50002-3

How Splines Work

UNDERSTANDING HOW SPLINES display their information is the key to making them work for you. Some beginning animators are intimidated when they see all those intertwined curves, but the ideas behind them are really quite straightforward. It takes a little practice to make it second nature, but only a few moments to really grasp the concepts we'll go over in this cheat. In no time, you will find that they are a surprisingly elegant way of working with your animation, and understanding them thoroughly will quickly create a noticeable improvement in your work.

The main idea with splines is that they represent changes in value over time. As the curve travels to the right, frames are ticking by. As the curve raises and lowers, it's an increase (traveling up) or decrease (traveling down) in the value of the attribute. If the curve changes direction, as it does at the middle key in the following diagram, the attribute it represents will change direction.

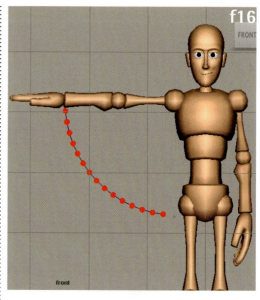

1 Open HowSplinesWork.ma. From f01–f16 the character is raising his arm. Take note of how even the movement is. Every frame the arm moves up the same amount.

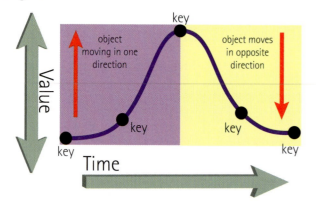

The thing to remember, and where it's easy to get confused, is that up and down do not necessarily correspond to up and down for what you are seeing in the viewport. That may seem counter-intuitive at first, but it has to do with how the character rig is set up and there are many possible scenarios with that. For some attributes, like translate Y, the curve will actually look like what the body part is doing, but most don't. The thing to take from this cheat is that up and down are simply changes in value, not a direct visual correlation to what you see in the viewport.

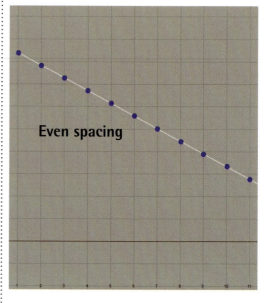

3 If I plot each frame along the curve, we see that they are all equidistant, just like the spacing tracked in the viewport. (Some curve colors in this chapter were changed in Photoshop for better clarity on the page.)

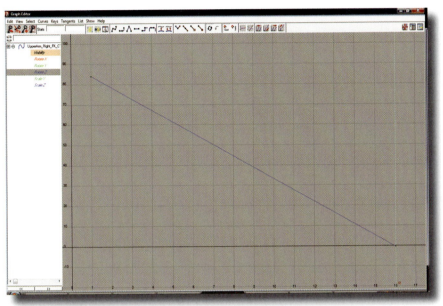

2 Open the Graph Editor and look at the upper arm's rotate Z curve. Notice that it's a perfectly
straight line. This corresponds to the even spacing of the motion we see in the viewport.

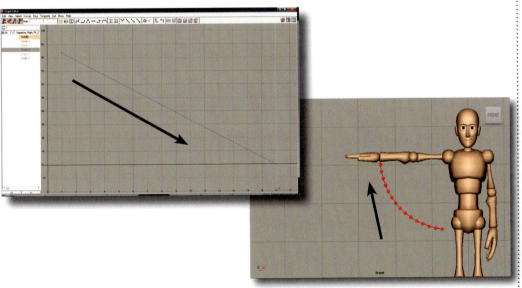

4 Also notice that the curve is travelling downward while his arm is raising. Remember that we
said the up/down curve direction is simply a change in value, not a direct representation of
what happens in the viewport.

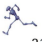

How Splines Work (cont'd.)

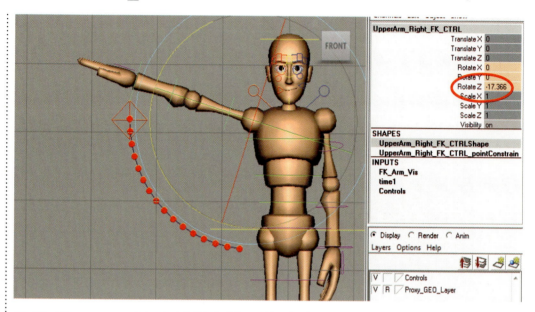

5 Select the upper arm control and rotate it in Z while watching the channel box value. Notice that rotating the arm up makes rotate Z increase in negative value. This has to do with how this particular character was rigged and is why the curve travels down, since down is an increase in negative value in the Graph Editor. Undo the movement you just did.

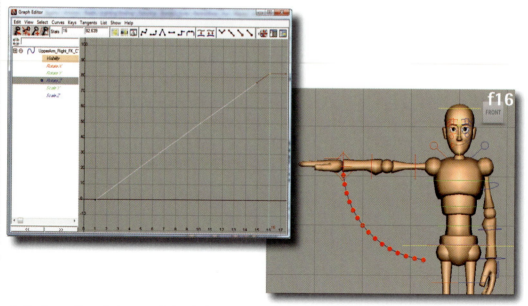

8 Continue making adjustments to the keys in the curve and watching the animation until you're comfortable with the concepts. Here I switched the positions of the keys and now he does the opposite motion.

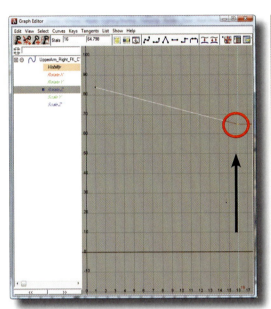

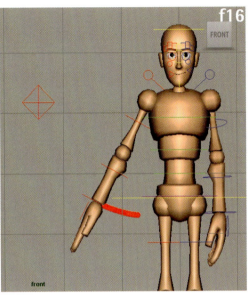

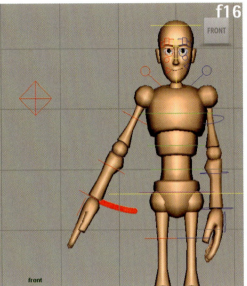

6 In the Graph Editor, select the key at f16. Use the Move tool **W** and **Shift** MM drag it upwards so the curve's angle is much more shallow. Shift dragging with the Move tool will constrain movement to either horizontal or vertical motion, whichever you do first.

7 Since the curve travels downward a much shorter distance, therefore increasing negative value only a little, his arm now moves up only a short distance. Tracking the motion shows us how much tighter the spacing is.

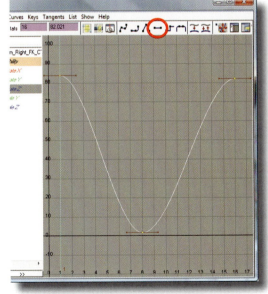

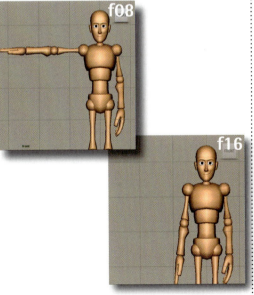

9 Hold **I** and middle click the curve at f08 to insert a key. Select the entire curve and press the flat tangents button. Then use the Move tool to MM drag f08's key down and f16's up to look like above.

10 From f01–f08 the arm travels up. When the curve changes direction, the arm travels back down.

Splines and Spacing

L ET'S TAKE A MORE IN-DEPTH look at how changes in our spline curves affect the spacing of a motion. If the curve's direction over a given range of frames is mainly horizontal, the value is not changing much. Therefore the attribute will be moving very little in the viewport.

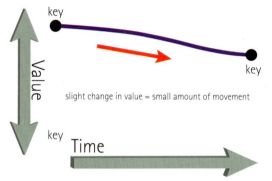

slight change in value = small amount of movement

If the direction over the frame range is predominantly vertical, a larger change in value is happening and the movement will be bigger.

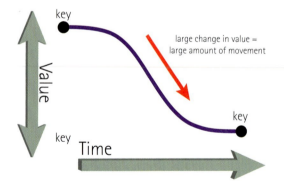

large change in value = large amount of movement

Finally, if the curve is perfectly horizontal for a frame range, that curve's attribute will hold perfectly still, as there is no change in value. We'll try some things in this cheat that will make these ideas perfectly clear.

Throughout this exercise, we'll make some pretty stark changes in the speed of the movement while never changing the amount of frames (timing) it happens over. Timing and spacing are intertwined, but problems in spacing tend to be less forgiving than the amount of frames you're using.

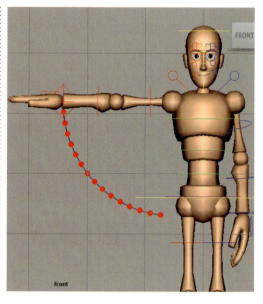

1 Open TimingSpacing.ma. We'll start with the upper arm moving up with linear, even spacing. Open the Graph Editor and select the right upper arm's rotate Z curve.

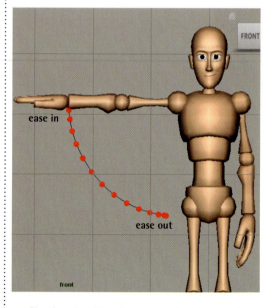

3 Play the animation and notice how the movement is much smoother. There is an ease-out when the arm starts moving, and an ease-in to where it stops.

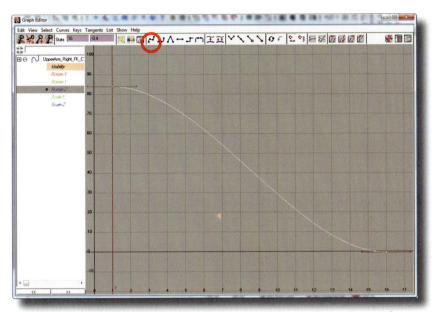

2 Select the entire curve and press the Flat Tangents button. The curve's shape will change from a straight line to a smooth S shape.

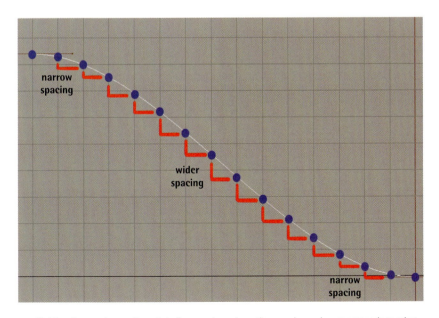

narrow spacing

wider spacing

narrow spacing

4 Plotting the spacing on the rotate Z curve shows how the curve's spacing corresponds to what we see in the viewport. The arm moves shorter distances in the beginning and end and wider in the middle.

HOT TIP

To track the spacing of a movement, many animators use dry erase markers right on their monitor. If your monitor is an LCD, put clear plastic over it to not stain the screen, and press very gently. CRT monitors should be fine as is since they have glass screens.

Splines and Spacing (cont'd)

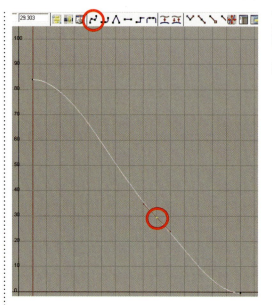

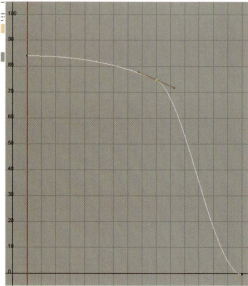

5 Go to frame 10 and set a key on the right upper arm. Select the key you just set in the Graph Editor and click the Spline Tangent button if the curve is not smooth.

6 Use the Move tool **W** and **Shift** MM drag the key up so it's a little under the value of the first key. MM drag the key's tangent handle to get a shape similar to this.

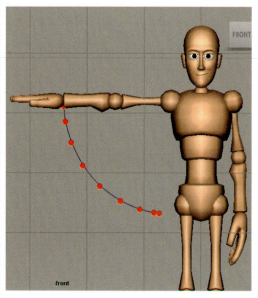

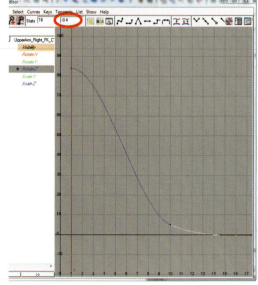

9 Now the opposite happens, where the arm moves quickly at the beginning, and eases in to the end pose more gradually.

10 Select the last key at f16 and look at the value field. In my case it's -0.4.

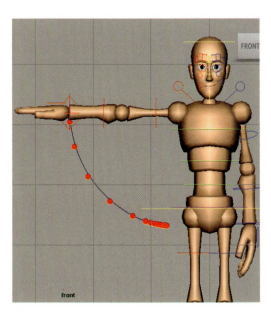

7 Play the animation and see how much we've affected it. The arm moves very little during the first 10 frames since the spacing is so close. The value changes very little until f11, where the wide change makes it move quickly.

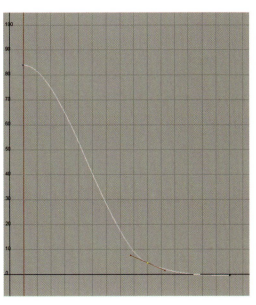

8 Edit the key at f10 so it's close to the value of the end key.

HOT TIP

We'll go over spline technique in later cheats, but it's good practice to avoid letting curves drift past the value of a key where it changes direction, like in step 11. Curves that do this are much more trouble to edit predictably.

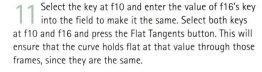

11 Select the key at f10 and enter the value of f16's key into the field to make it the same. Select both keys at f10 and f16 and press the Flat Tangents button. This will ensure that the curve holds flat at that value through those frames, since they are the same.

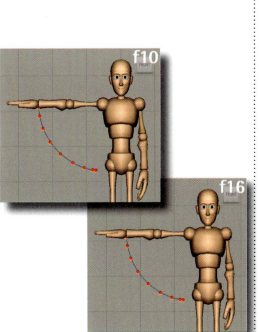

12 Now the arm travels with an ease out and ease in from f01-f10, but holds still until f16. Since there is no change in the up or down of the curve while the frames tick by, the arm holds still.

Tangent Types

TANGENTS AND THE TYPES AVAILABLE in Maya are the other side of understanding splines. If you've used graphics programs like Illustrator, tangents will be familiar to you. They're the handles that exist around a keyframe and are used to adjust the curve's angle and direction before and after the key. As we've just seen in the previous cheats, the curve's slopes have a profound effect on the animation's spacing, so having a solid grasp on how tangents work is invaluable.

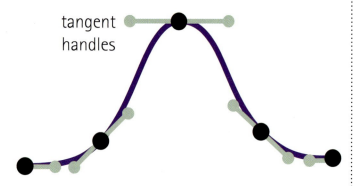

tangent handles

Maya has several different tangent types, which are really just preset angles for the handles (albeit useful ones). The handles are completely customizable, and Maya's tangent types are mostly a starting point. Using only the "out of the box" tangent types tends to make the motion look very CG and uninteresting. However, knowing which ones will bring you most of the way to your desired result will go a long way towards speeding up your workflow. Let's take a look at Maya's tangent types and what sorts of situations they're best for.

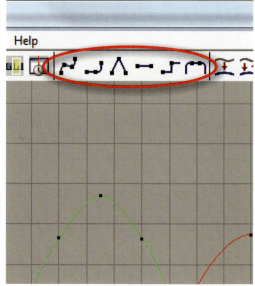

1 The tangent type icons are along the top of the Graph Editor. Simply select any or all keys and click whichever type you need.

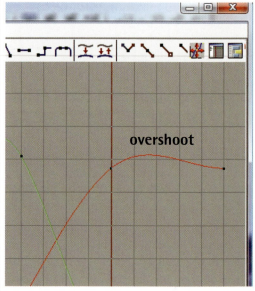

overshoot

4 Spline tangents will make a smooth transition between keys and don't flatten out. They're great for keys that are transitional (going the same direction each side of the key), but with extremes (keys that the curve changes direction at) they can overshoot, which is difficult to control reliably.

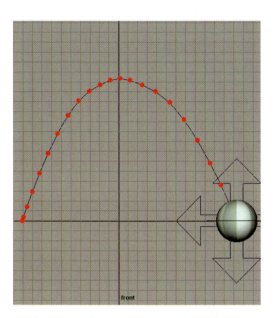

2 Open TangentTypes.ma. In the front view we have a very basic animation of a ball going in an arc.

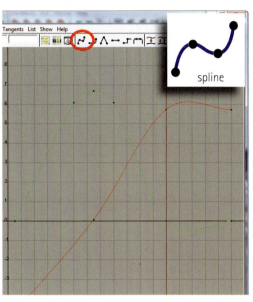

spline

3 Select the ball control (Show > Nurbs Curves in the viewport menu if you don't see it) and open the Graph Editor. Select all the curves and click the spline tangents button. Notice how the ends of the curves become straight.

HOT TIP

Once you're refining an animation, you usually won't use one tangent type for all keys, but rather the appropriate type for the particular keys and situation you're working on.

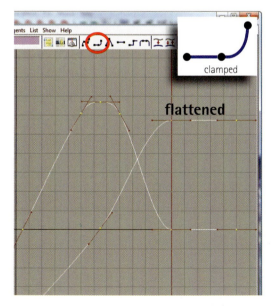

clamped

flattened

5 Select all the curves and press the clamped tangents button. Clamped are almost the same as spline tangents, except they will not overshoot on adjacent keys that are the same value or very close in value. Notice that the overshoots from before are now flat.

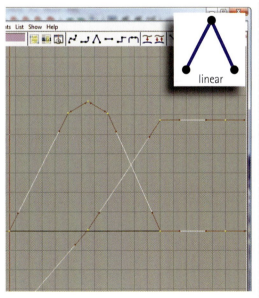

linear

6 Next press the Linear Tangents button. Linear tangents simply make a straight line from key to key and therefore make very sharp angles and transitions.

Tangent Types (cont'd)

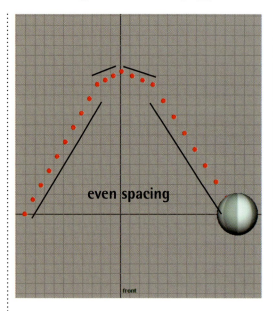

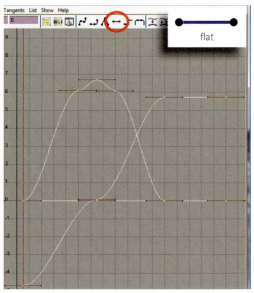

7 Notice the spacing in the path of the ball is even between each key. Linear tangents are good for times when an object is traveling and then impacts another object at full momentum, such as when a ball hits the ground.

8 Next are flat tangents, which make a plateau at each key. They're common at the extreme keys, where a curve is changing direction, easing in and out of the key. In transitional keys, they will make the object slow down and then speed back up mid-path, which is often (but not always) undesirable.

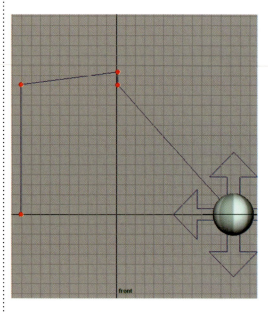

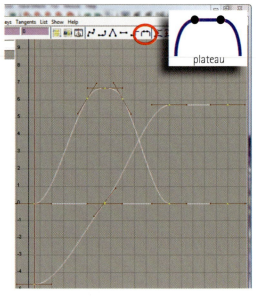

11 We see here that the ball pops to each position when it gets to that frame. Stepped keys are most commonly used for blocking in full animations, and for attributes that need to change over a single frame, like IK/FK switching or visibility.

12 Finally we have plateau tangents, which are almost identical to clamped in that they won't overshoot, and will flatten out extreme keys. The main difference is that they also flatten the start and end of the curve as well.

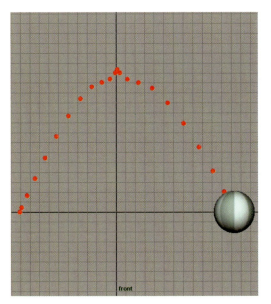

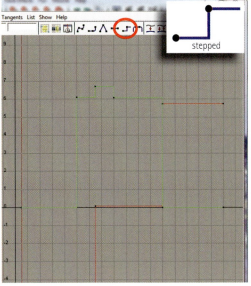

stepped

9 Notice the spacing on the ball easing out and in to each key. Flat tangents are a good starting point for keys you want ease outs and ins on. They will also hold flat through keys of the same value and never overshoot.

10 Next are stepped keys, which do not interpolate at all. They will hold still until the next key frame. Because of this they create these stair-like keys.

	spline	Smooth interpolation, good on transitional keys where curve is the same direction on both sides, tends to create overshoots in the curve
	clamped	Smooth interpolation, doesn't overshoot keys with close or identical values, first and last keys in curve are splined, good for moving to spline mode from stepped keys
	linear	Direct line from key to key, makes spacing between two keys perfectly even, sharp angles in curves, works well for keys where an object is meeting another at full momentum, some use for blocking to avoid any computer-created eases
	flat	Creates plateaus at keys that are perfectly flat, automatically puts an ease-out and ease-in on a key, never overshoots, good for keys at extremes (where the curve changes direction) and keys where a value needs to hold through frames
	stepped	No interpolation between keys, simply holds until the next key frame, commonly used for pose-to-pose blocking, attributes that you want to switch over 1 frame such as constraints, IK/FK, creating camera cuts, etc.
	plateau	Same as clamped, except first and last keys in the curve are flat

13 To recap, here's a chart of some common uses for different tangent types. To reiterate, these are just starting points that may be helpful, and not rules by any means.

Tangent Handles

NOW THAT WE HAVE A GOOD UNDERSTANDING of Maya's tangent types, we can look at customizing the handles to create any type of curve we want. Maya's tangent handles offer the ultimate flexibility of any animation/graphics programs, so we should obviously take advantage of this power. Keep thinking about the spacing you want for your animation and how a spline should look when it has that spacing, and use the handles to make it happen.

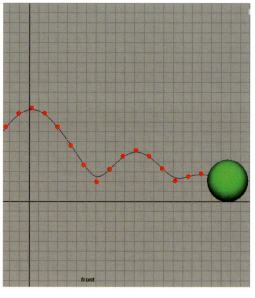

1 Open TangentHandles.ma and you'll find a simple bouncing ball animation. Select the ball control and open the graph editor.

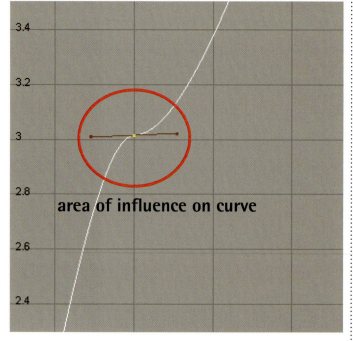

area of influence on curve

There are two types of tangent handles: weighted, and non-weighted. We'll go over them in this cheat, but they're really just styles of working and all up to preference in the end. Everything we talk about here are simply ways to get differing levels of control using the tangent handles. Note that I didn't say more control! Any curve shape you can get using handles you can also get by using more keyframes. At the end of the day, it's up to you and how you like working, so experiment with everything. My philosophy is it's best to get a handle (ahem) on all of the tools available, and then pick the best one for the job at hand.

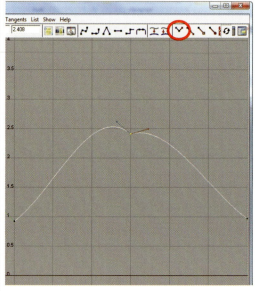

4 Select a handle and press the Break Tangents button. The left handle will turn blue, indicating they are now independent and you can rotate them individually to get any curve shape you want.

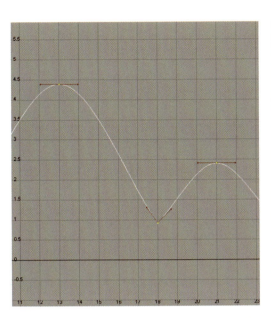

2 Select the translate Y curve and examine the tangent handles. They are currently non-weighted handles, which means they are all the same length relatively and have the same amount of influence on a curve.

3 Select the Move tool **W** and select any handle. MM drag it to rotate it. These handles are unified, which means they are attached and act as a single piece when moving either of them.

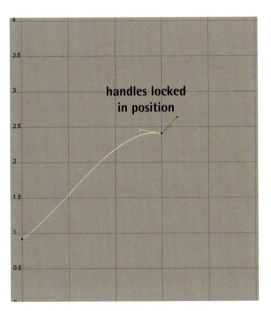

handles locked in position

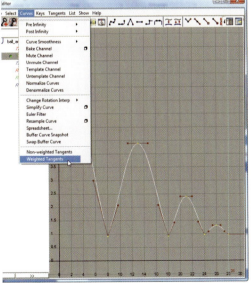

5 You can break tangents, position them, and then press the Unify Tangents button to lock them in that shape. They will then rotate as a single unit again. You may get erratic curve behavior if you do this with a very sharp angle, however.

6 Undo all your edits and select the entire translate Y curve. In the Graph Editor, go to Curves > Weighted Tangents and the handles will change.

Tangent Handles (cont'd)

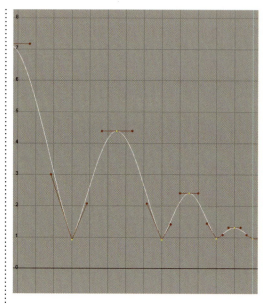

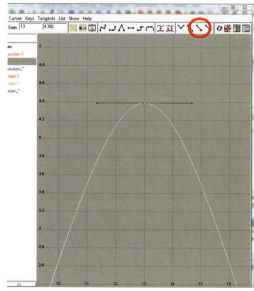

7 Weighted tangents have differing lengths that depend on the distance in value between the keyframes. The longer the distance, the longer the handle, and the more influence it will have along the curve.

8 You can break and manipulate the handles just like with non-weighted, but you have an additional option with weighted tangents. Select a key and click the Free Tangent Weight button.

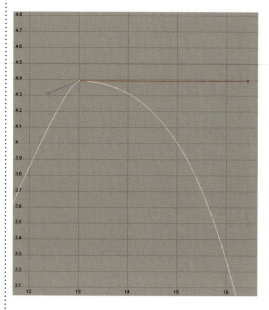

10 You can even break the tangent handles as we did before to create any shape of curve possible.

11 Continue to experiment with the tangent handles and learn how to create the spacing you want using them.

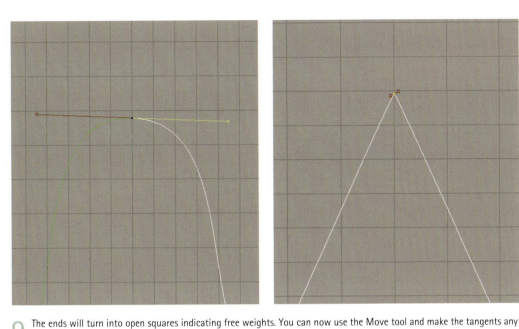

9 The ends will turn into open squares indicating free weights. You can now use the Move tool and make the tangents any length you wish, increasing or decreasing the amount of influence they have on the curve.

Handles Pros
- Keeps curves less cluttered with fewer keys
- Powerful curve shaping options
- Curves scale in time more accurately
- Good for subtle spacing adjustments without adding density
- Create sharp angles with fewer keys

Handles Cons
- Adjusting adjacent keys can affect spacing
- Some shapes not possible without keys
- Too few keys tends to feel floaty
- Can be more difficult for other animators to edit if necessary
- Less control over larger spacing areas

Keys Pros
- Exact, value isn't affected by adjacent keys
- Complete control, any shape possible
- Clearly readable in Graph Editor
- Simple to work with, not complex
- Easy to edit by other animators

Keys Cons
- Curves can get very dense and more difficult to make changes to
- Scaling time can be less accurate if you need to snap keys to frames
- More control usually translates into needing more keys

12 Remember that using handles is just another way to approach animating, not something you need to do or should never do (depending on whom you talk to). Some animators never use tangents and only set keys, others use broken weighted handles all the time, but many use both methods when necessary. It's up to you in the end, but here are some factors to consider with the various methods. Ultimately, choosing the best approach for the task at hand will ensure that everything stays as simple as possible.

Spline Technique

Y OU NOW HAVE a good grasp on the capabilities splines have and how you can approach using them, so let's go over some things that can tighten up your spline workflow. We're all about making things easier here, and there are a few tendencies splines have that can sabotage that. Having good spline technique means you have control, and that means you're making the animation look the way you want, not the way the computer happens to do it.

As I've said before, none of these things is really a rule (except for the spline overshoots; it's hard to find any advantage for them) and there will be situations where actually doing them may be the best approach. But those are the exceptions and for general guidelines, especially if you're still becoming acclimated with splines, this cheat will go a long way towards helping you get ahead.

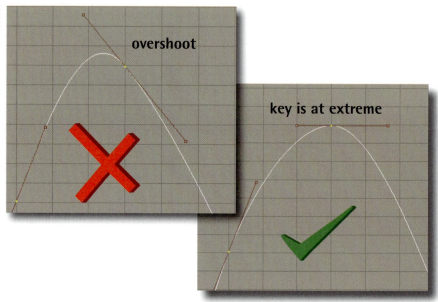

1 Open SplineTechnique.ma and select the ball's move control. Look at the translate Y curve at f12. F13 is the extreme key, but the tangents are making f12 a higher value, also known as an overshoot. Use flat or linear tangents at extremes and adjust the eases to what you need.

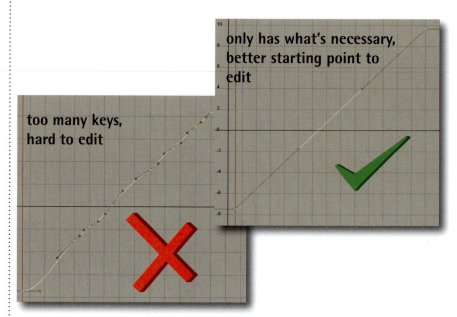

3 Look at the Translate X curve. Often when setting keys on all controls, we can get a lot of redundant keys. Splining can turn these curves into a wobbly mess. Only use the number of keys you need and make sure the tangents are the way you want them. Too many keys makes changes very difficult. Since this curve should be a smooth translation, we can delete almost all of these keys.

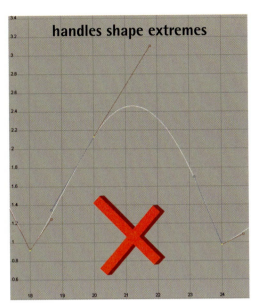

handles shape extremes

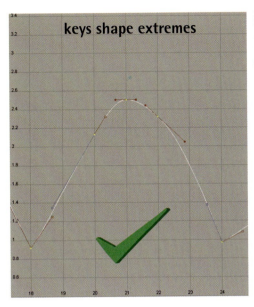

keys shape extremes

2 At f21, there's another type of overshoot, where the curve was shaped this way purposely with tangent handles. While this may look fine in the viewport, it's definitely not the best way. When the extremes have keys representing them, it makes things clear, easy to edit, and the values can't be changed without our knowing. With any kind of overshoot, moving an adjacent keyframe or handle can change where your extreme is. As much as we all love Maya, we don't want it making these kinds of decisions for us!

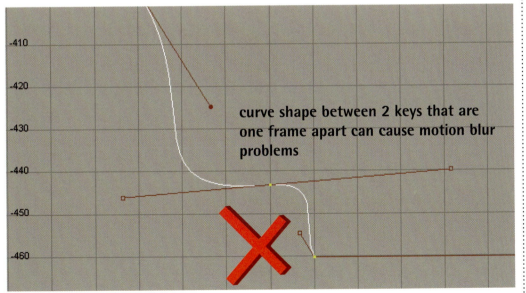

curve shape between 2 keys that are one frame apart can cause motion blur problems

4 Look at f24-f28 on the Rotate Z curve. Extreme angles are sometimes necessary, but if you need sharp angles, you're better off using keys than handles. Handles change when you shift keys around, but keys will always hold their value. It's good to avoid even 1-frame glitches like f27-f28 that aren't seen in the viewport. Some studios use motion blur that looks inbetween the frames and will give strange results at render time with curves like this. This can actually be used to make motion blur look the way the animator wants, but unless this is intentional, don't do it!

Spline Reference

WE'VE SEEN THAT SPLINES are simple tools, yet capable of describing any movement to pinpoint accuracy. It takes some practice to make looking at them second nature, and as you keep animating, you'll get better at reading them. One thing you may not realize at first is that reading splines is just recognizing common shapes. An ease-in will always look pretty much the same as far as the general spline shape goes. The size and angle of the shape will simply determine how big (or small) of an ease-in it is. You know when a circle is a circle regardless of how large or small it is. It's really the same idea.

The file for this cheat, SplineReference.ma, contains 6 spline shape examples that you can use as a reference for common animation spacings. Every 50 frames has a separate animation and description. Move the time range slider to start at frames 1, 50, 100, 150, 200, and 250 to see each one. The upper arm's Rotate Z curve has the animation. Memorizing these shapes will make looking at the Graph Editor an enlightening experience, rather than a puzzling one. Happy wrangling!

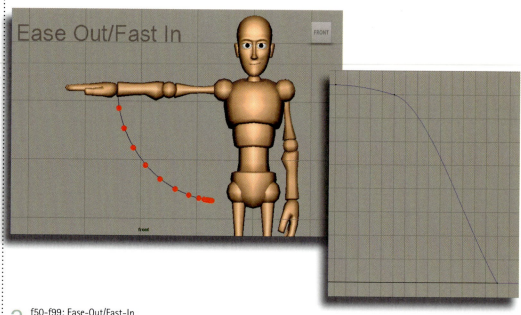

2 f50-f99: Ease-Out/Fast-In

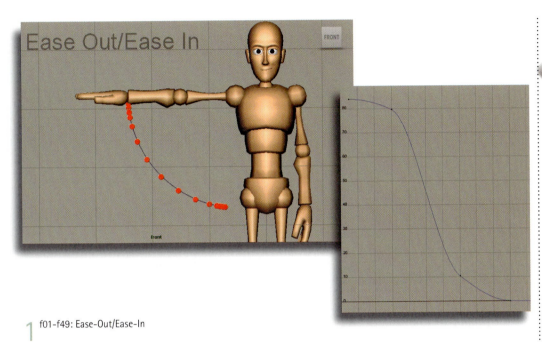

1 f01-f49: Ease-Out/Ease-In

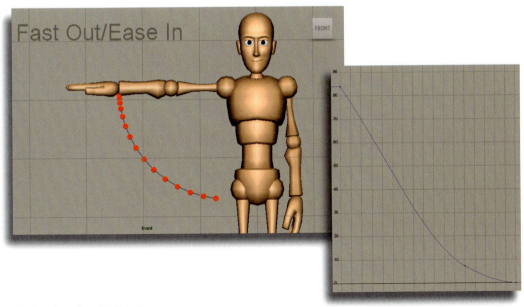

3 f100-f149: Fast-Out/Ease-In

Spline Reference (cont'd)

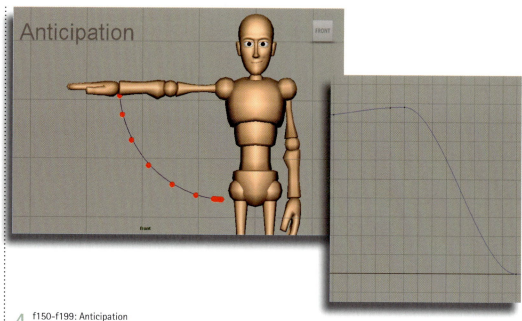

4 f150–f199: Anticipation

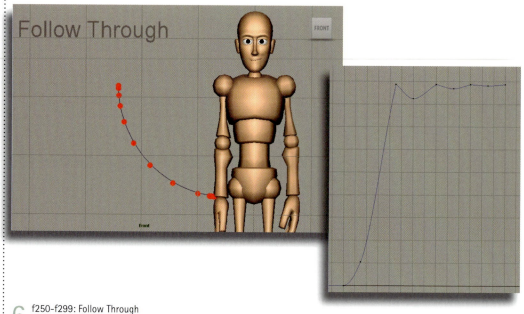

6 f250–f299: Follow Through

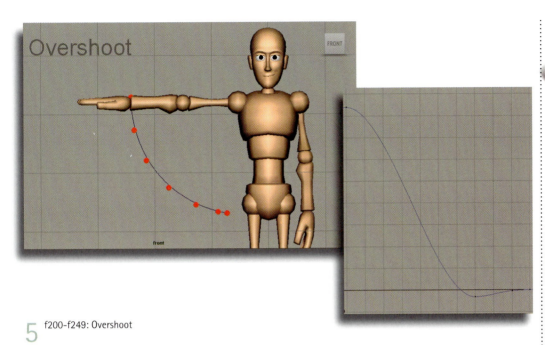

Overshoot

FRONT

front

5 f200-f249: Overshoot

HOT TIP

Linear tangents
are a great
starting point
for any key
where an
object is hitting
another and
ricocheting
off of it, such
as when a
bouncing ball
hits the ground.

Graphics Cards

MAYA IS AN INCREDIBLY POWERFUL software package, and all of that power requires significant hardware to take full advantage of it. Many new animators jump headfirst into Maya without realizing that it has a very specific qualified hardware list when it comes to graphics cards (you can find it at Autodesk's website). The list is actually pretty small, and is limited to high-end workstation cards like Quadro and FireGL cards. These cards are professional grade and priced as such. Needless to say, they won't be found in any computer you buy off the shelf at an electronics store.

But it's not all bad news for animation students, hobbyists, and starving artists. As far as animators go, we really don't do anything with Maya that requires Open GL and hardware rendering. It's more than possible to use Maya for animation with an average consumer-level gaming card, and thousands do everyday (myself included, at least at home).

The key to happily animating without workstation cards is research. When considering what card will work best for you and your budget, spend a lot of time searching online forums and sites for others' experience with Maya and the cards you're considering. A little bit of research can save you countless hours of headaches and bizarre, unsolvable display issues as you narrow down the consensus of what cards are the most reliable.

When you use cards that aren't on the qualified hardware list (which is obviously not recommended by Autodesk, but unavoidable for many of us), you may find Maya behaving strangely, both consistently and intermittently. Some common issues that happen are:

- blank viewports, particularly when switching with the spacebar
- manipulators disappearing
- image planes zooming at different ratios from the viewport
- not being able to select objects in the viewport and Graph Editor

Those are some common ones, but really anything is fair game. Sometimes updating the graphics card drivers can alleviate problems, but other times there's nothing to be done except tolerate the issues (often an animation buzz-kill) or

replace the card. Fortunately, if you need to do this, there are plenty of inexpensive cards that will dramatically improve your working conditions. Again, it comes down to doing the research.

In my personal experience, I've found that Nvidia's GeForce cards are generally the least problematic. That's not to say you can't use another brand, but personally, I've always been able to use GeForce cards for animating without major issues. Make sure you avoid using Intel Accelerated Graphics cards (the type that are integrated with the motherboard) with Maya at all costs, as you are virtually guaranteed problems with them. In my Maya tech support experience, those cards make using the software productively virtually impossible.

Even with a well-recommended card, you may run into the occasional glitch here and there, but if you've done your homework, there shouldn't be anything that isn't easily workable. Read up on others' experiences with different driver versions available for your card, as a specific version can make all the difference in the world. When you find something that works for you and your particular machine, stick with it!

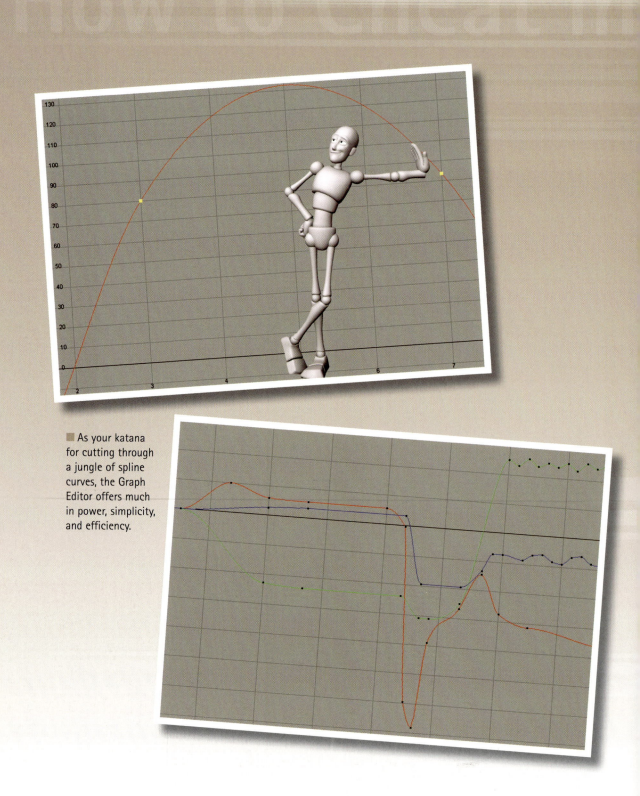

■ As your katana for cutting through a jungle of spline curves, the Graph Editor offers much in power, simplicity, and efficiency.

54

3

Graph Editor

MAYA'S GRAPH EDITOR is easily its most powerful
and most used tool for animating. It's likely that you
will spend much of your time working with it, so it's
a no-brainer that we learn all the ins and outs of this
fantastic editor.

We spent the last chapter understanding splines, and now
we'll learn how to use the Graph Editor to interact with,
edit, and manipulate them.

DOI: 10.1016/B978-0-240-81188-8.50003-5

Graph Editor Windup

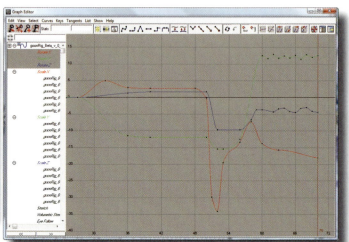

BEFORE WE LAUNCH INTO all the cool stuff the graph editor has in store for you, let's go over the basics of using it!

1 Selecting a control initially displays all curves for its attributes. Selecting attributes in the left panel displays only those selected curves. You can drag select or **Shift** select for sequential attributes, or **ctrl** select for multiple, non-sequential ones.

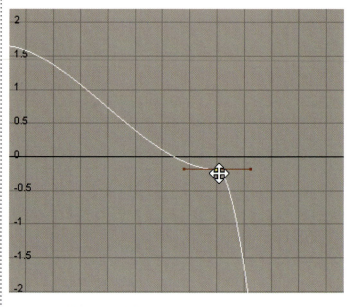

3 The Move **W** and Scale **R** tools work in the graph editor. Once selected, the middle mouse button will drag or edit the curves or keys selected.

2 **Shift** **alt** and right mouse dragging horizontally expands or contracts the frame range of the graph in view, while dragging vertically contracts/expands the value range.

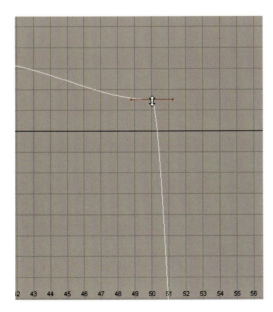

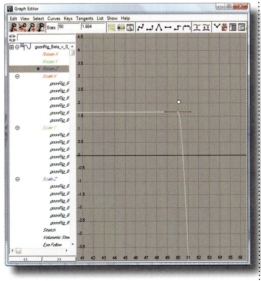

4 **Shift**-MM dragging will constrain the movement horizontally or vertically, depending on which way you initially move the mouse.

5 If you get a circle when trying to edit, it just means you have the Select tool (**Q**) active and need to select an edit tool such as the Move or Scale tool to do an edit.

Visual Tools

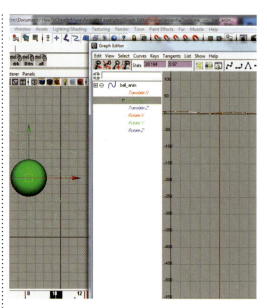

T HE GRAPH EDITOR IS FULL of goodies, and some of the most important ones let you view the curves in the most efficient way for what you're doing. Whether you need to type exact values, search for keys that may be running amiss, compare drastically different curves, or want to isolate specific attributes, the graph editor can accommodate you. In this cheat we'll use a simple bouncing ball animation to test out the options the graph editor gives us for ogling curves.

1 Open visualTools.ma, switch to the front camera, and open the Graph Editor. Select the ball's move control and its curves appear. Clicking on the attributes in the left panel isolates them, but some of the curves are difficult to see.

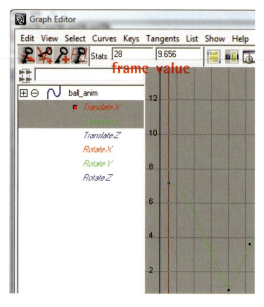

4 The Stats fields show the frame and value (respectively) of the selected key, which is useful for typing in precise frame numbers or values. You can also use **ctrl C** to copy and **ctrl V** to paste values of one key to the fields for another key or curve.

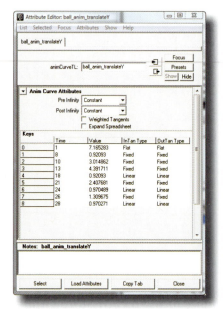

5 If you need to do precise entering of values for multiple keys, you can select curves and choose Curves > Spreadsheet. This gives you values for every key on the curve. You can use copy and paste here, and even change tangent types.

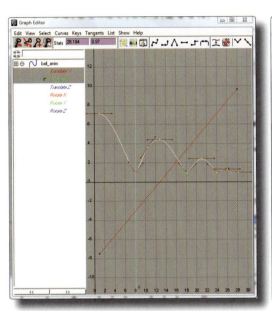

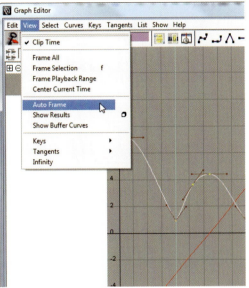

2 Select an attribute and press **F** to focus on it. If multiple attributes are selected, Maya will fit both of them into the available graph space.

3 Enabling View > Auto Frame will automatically focus on any attribute(s) you select, without having to hit the **F** key every time.

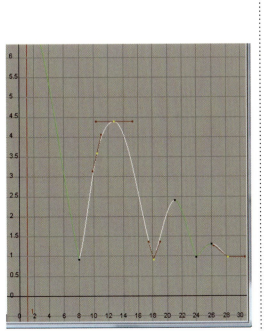

6 On the Translate Y curve, select the key at f10. You'll see in the stat field that the current frame is 10.472. In the course of scaling keys or editing them, we can end up with keys that are between frames.

7 Select the Translate Y attribute and go to Edit > Select Unsnapped. All the keys that are not on exact frames will be selected. You can select multiple or all attributes as well. Go to Edit > Snap and the selected keys will be moved onto the nearest frame.

Visual Tools (cont'd)

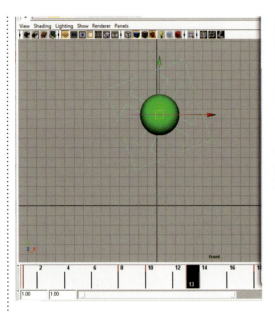

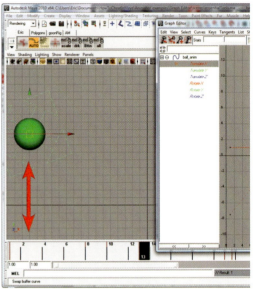

8 The ball is traveling in X as it bounces, but sometimes it's helpful to watch an animation without one of the attributes playing. Select the Translate X channel in the graph editor and go to Curves > Mute Channel.

9 You may have to pan the camera to see it, but now the ball no longer moves in X and simply bounces in place. Muting will put the value at its start point, but this can be changed.

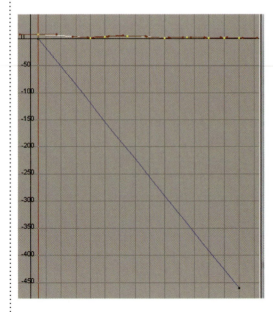

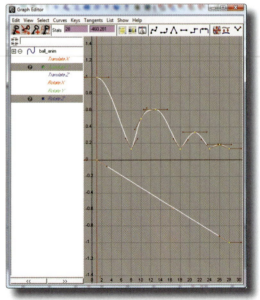

12 Select the Translate Y and Rotate Z channels. Sometimes you'll want to edit curves while comparing to others, but it's difficult because they are in completely different value ranges. Here, we can't see any of the shapes in the Translate Y curve.

13 Select the curves and go to Curves > Normalize Curves. Now they are both displayed relatively within a –1 to 1 range and easily comparable and editable. To go back to normal, select Curves > Denormalize Curves.

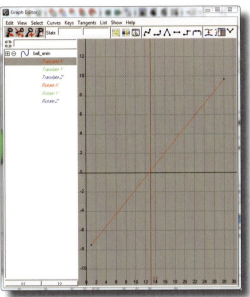

10 The original curve is now dotted, indicating it's muted, and there's a new, temporary flat curve. This curve can be MM dragged left/right (not up/down) to shift where the ball holds in Translate X. This is handy when the initial value is not ideal to hold at throughout the animation.

11 To unmute, select the channel, and go to Curves > Unmute Channel. Everything will go back to normal. If you get the error "no curve selected to unmute" (a glitch), just select a different channel, re-select the first one, and try again.

HOT TIP

Having an attribute labeled "awesomeness" is considered awesome in most animation circles.

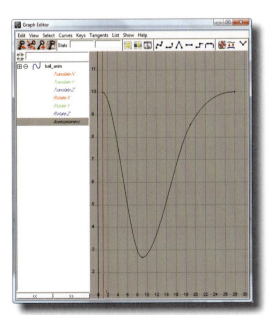

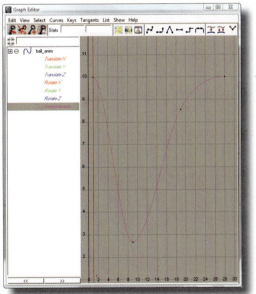

14 Extra attributes beyond the standard Rotate, Translate, etc. are colored black, but you can change that so they stand out better. On the ball is an attribute called "awesomeness," which doesn't do anything and is just for example's sake. Select the awesomeness curve!

15 Edit > Change Curve Color lets you pick any color you like for the curve. Now it will stand out when looking at multiple curves simultaneously. To remove it, just select and choose Edit > Remove Curve Color.

Working with Keys

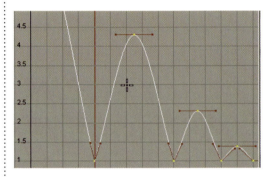

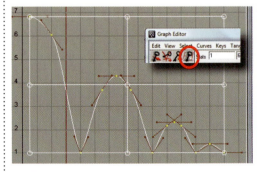

I N ADDITION TO its visual advantages, the Graph Editor offers some methods of working with keys that you can't get in the timeline or Dope Sheet. There are often times when we know the general shape of the curve we want to create, but setting keys and then dragging them to create that shape is time consuming. The Add Keys tool allows us to simply click keys where we need them and very quickly create a curve that can be tweaked for the results we want.

There will also be times where you want to add a key into a curve. Simply setting a key works, but the key is created with whatever Maya's default tangent is set to, which can alter the curve more than you want. Setting a key and editing the tangent is a lot of unnecessary work, so Maya offers the Insert Key tool, which can be called upon instantly.

Finally, the Lattice Deform Keys tool lets you make some very interesting adjustments to the overall curve that would be fairly time consuming otherwise. It's not a feature you'll use every day, but it's another option available in your library of techniques.

1 Open workingWithKeys.ma for the start of a bouncing ball animation. Currently we have it translating in X, but no up or down. Select the Add Keys tool in the Graph Editor. Then select the Translate Y attribute and select the first key.

4 Without messing up our Translate Y curve, we need some extra keys at the peaks for a little extra hang time. Select the curve and hold down the **I** key. The pointer will become a crosshair indicating the Insert Keys tool is active.

7 While it's not the most commonly used feature, the Lattice Deform Keys tool can make interesting results in certain situations. Select a curve and click the Lattice tool to surround it with a grid.

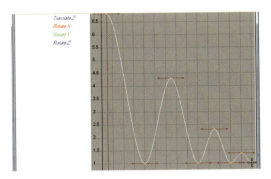

2 Middle click in the graph to add keys. In about 10 seconds I have the general shape of the curve and am ready to refine it.

3 Converting the bottom keys to linear tangents gets us most of the way to a bouncing ball.

HOT TIP

Maya has a type of keyframe called Breakdown keys, but they're not breakdowns as animators traditionally understand them. They're simply keys that maintain an exact ratio between the previous and following key. This can put them between frames if the other keys get moved. Generally speaking, most animators just use Maya's regular keyframes for everything.

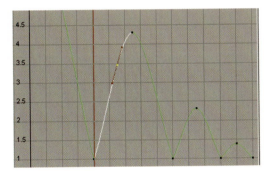

5 Middle clicking on the curve while holding down **1** inserts a key without messing up the shape.

6 A few more tweaks and we have all the translation for a bouncing ball in about a minute.

8 Adjusting the points and lines lets you manipulate the overall shape of the curve. This can be useful for adding some texture into your animation, although on a broad scale.

9 Double clicking the Lattice Deform Keys tool button brings up the options where you can specify more divisions to increase the precision of the control.

Value Operators

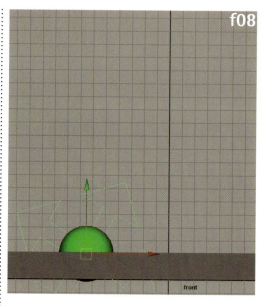

THERE ARE OFTEN TIMES when we need to make specific changes in value to many keys at once. For instance, we might want to see what a walk looks like if we increase the spine's Rotate X by 20%. Or we need to quickly scale down a curve's frame range to 33% of its current value. Though you wouldn't know it by looking at them, Maya's stat fields can do calculations that you can use to quickly make precise mass edits on multiple keys. By using a set of value operators, we can get results fast, without clicking on and manipulating tools. Sounds like a great addition to the cheating portfolio, eh?

The value operators are as follows:

+=value Add

-=value Subtract

*=value Multiply

/=value Divide

So if we wanted to add 5 units in value to the selected keys, in the Stat value field we would type +=5 and hit Enter. To increase them by 20% type *=1.2 and so on. This cheat will walk you through using value operators in several different situations.

1 Open valueOperators.ma for our familiar bouncing ball animation. There's a ground, but the ball is bouncing too low, about 1 unit or so, and intersecting it.

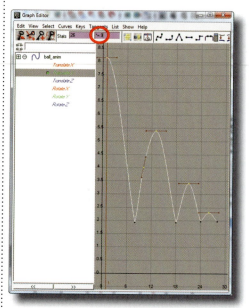

4 Let's bring the peaks of the Translate Y down 10%. Select the keys when the ball is in the air, and type *=.9 to reduce the value by 10%

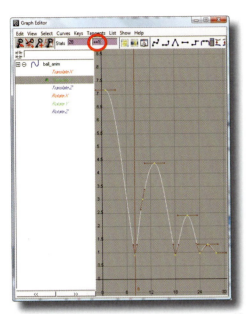

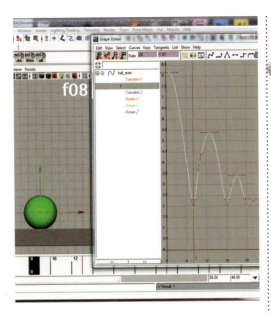

2 Select the Translate Y curve in the graph editor, and in the value field type +=1 and hit enter. This adds 1 to every key selected.

3 Now every key is 1 unit higher and the ball lines up with the ground.

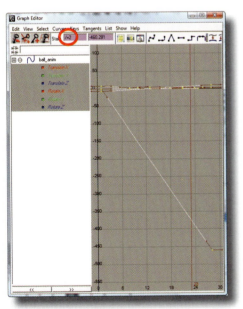

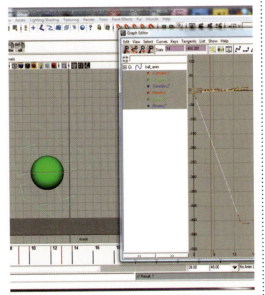

5 We can scale the time for keys as well. Select all the curves for the ball and in the frame stat field, enter /=2 to divide by 2 and cut the frame numbers the keys happen on in half. The animation plays twice as fast now.

6 You can also use -=value to subtract. Remember that all the operators work for both frame and value stat fields.

HOT TIP

Infinity in the Graph Editor refers to what Maya does before a curve starts and after it ends. There are several options, but the default is Constant, which means stay at the first or last keyed value. For Cycles, usually Cycle or Cycle with Offset is used.

Buffer Curves

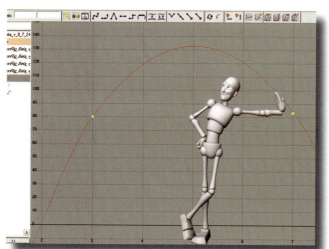

ANIMATION IS RARELY a linear process, and oftentimes we need to compare different ideas to see what works best. Looking at variations saved in different files is a hassle and inefficient, so Maya offers buffer curves in its graph editor functionality. We can have two different versions of any curve and switch back and forth between them instantly. For times when we're not sure if we like a certain movement over another, this allows us to experiment without having to redo or lose work.

Buffer curves are best for trying out variations on one or a few attributes. While it's possible to use them on a whole character, there's not a definitive interface for working with them. Switching between many attributes can make it easy to lose track of what you're looking at. Animation Layers are a much better approach for working with variations on a bigger scale, and they're covered in Chapter 11. But when it comes to comparing variations of an attribute or two, nothing beats buffer curves and their efficiency.

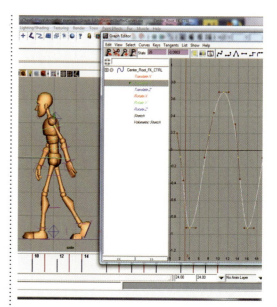

1 Open bufferCurves.ma, which has the Goon doing the walk from Chapter 8. Select the body control's Translate Y curve.

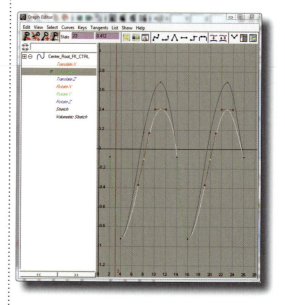

4 Move some of the keys around and you will see a gray curve in the background with the shape you locked in to the buffer. Now you can edit the curve as normal, keeping the buffer version intact and referencing it if necessary.

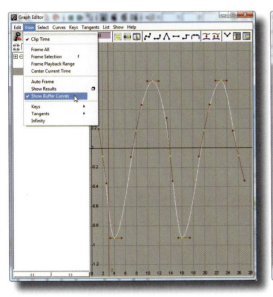

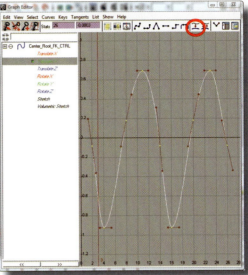

2 Buffer curves are not visible by default, so go to View > Show Buffer Curves. You won't see anything change yet, as both versions of the curve are currently the same.

3 With the curve selected, click the Buffer Curve Snapshot button. This locks the current version of the curve in the buffer.

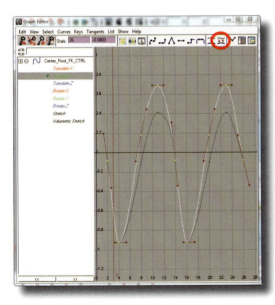

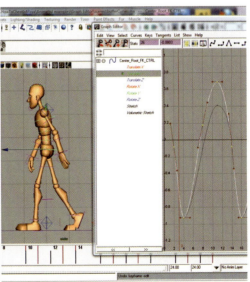

5 Press the Swap Buffer Curve button to make the buffer curve active. The version you were working on goes into the buffer and you can edit the previous version.

6 Use the different curves to compare varying amounts of up/down in the body. If the buffer curves get distracting, or you're finished working with them, just go back to View > Show Buffer Curves to toggle them off.

Using Video Reference

EVERY EXPERIENCED ARTIST USES REFERENCE when creating work, regardless of the medium. From painters to sculptors to draftsman, all must look at how something truly is in order to interpret, recreate, and make art that an audience will respond to. As animators, video reference proves an invaluable tool for analyzing physical motion, generating ideas, and crafting a performance.

The reason for reference is simple: either we don't really know how something looks or moves, or we have a compressed idea in our minds that is more efficient than accurate. That's how our brains work to store information, and we can often mistake knowing the essence of something for completely understanding it.

What do I mean by that? Think of a particular car, say a Volkswagen Beetle. Most everyone knows what those look like. Most people could draw something impromptu that represents a Beetle if asked and be recognized by others as a Beetle. But if you needed to create an accurate drawing or 3D model, almost nobody (except maybe Beetle engineers) could do it without referencing one. There are so many details: the outlines the doors make, the height of the wheel wells, the angle of the mirrors, how many segments in the hubcap, etc. Our brains are not designed to easily store extremely detailed information; rather it keeps iconic representations that enable us to quickly recall and associate.

Betty Edwards wrote a fantastic book called *Drawing on the Right Side of the Brain* in which she talks about a phenomenon where pretty much everyone who isn't trained in drawing draws things in a similar way. When asked to draw a house, most drew variants of a square with a triangle on top and squares for windows and a door. A tree was a simple cloud shape with a rectangle on the bottom. Once Edwards instructed people how to use their eyes to draw what they are actually seeing, rather than what their brain is recalling (in its icon-heavy efficiency), the difference in their draftsmanship is utterly remarkable.

As animators, video reference provides a basis that we can use to understand how someone really stands up from sitting on the ground, or how their brows furrow when they're upset. If you don't use reference, or only use it occasionally, making it

an essential part of your workflow will dramatically increase your work's quality and authenticity.

Some animators fear that using video reference is cheating (yes I realize the irony in this book, of all things) or that simply copying a video of something isn't being artistic. This can definitely be the case if we're just using reference as a frame-by-frame dictation. In actuality, it's simply a tool, one of many, that we can use in creating something original and unique.

When I use video reference for an acting piece, I'll do dozens of takes acting out the line, trying different approaches and gestures and combinations of ideas. When I go back and study them, never do I end up with a single take that has everything I want in the animation. I'll take bits I like from one and place them with a gesture I like for another, thinking about how these movements are justified in the motivations of the character. Using a composited performance, along with thumbnails, studying other sources like movies, comic books, art, etc., you can come up with something unique that has nuance and detail, and isn't simply a rehash of a clip you made with your webcam.

Most of the larger studios have dedicated rooms for filming reference, but smaller ones often won't. For these cases I have a cheap, portable HD camcorder with its own screen that I take to work. I also have a miniature tripod to set it up on. When I need to create some reference, I can go outside, down the hall, or wherever to get what I need.

When doing an extended acting animation for *Bioshock 2*, there wasn't a dedicated reference filming room. So I, like the other animators, would go in a corner with the video cam, and act out the scene while listening to the dialogue on my iPod. It wasn't a state-of-the-art editing suite workflow, but it got the job done.

A colleague of mine told me of how he would film acting reference in an empty conference room that didn't have any playback equipment. He had the audio file looping at his desk, and once he got to the room he'd have a fellow animator call that room's phone from his desk. The other animator would place the phone next to the speaker at his desk, and he'd put it on speaker phone in the meeting room. He would then act out the line in front of a camcorder to film his reference. That's dedication! To go to such lengths to capture video reference underscores its importance to the animation process. Now get filming!

■ Making changes, tracking arcs, working with multiple pivots, using the timeline, and much more are discussed in depth in this chapter.

4
Techniques

FOR EVERY ANIMATOR there are a variety of techniques that are used throughout the animation process. As you develop your skills, a portfolio of mantras that you call upon regularly will also develop; your kung fu, so to speak.

This chapter contains a wide selection of very useful tools and techniques for animating. While creating a piece of animation, you may call upon some of these techniques dozens of times, others only once, but all of them will make a regular appearance in any animator's workflow. Prepare, grasshopper, for efficiency lies within...

DOI: 10.1016/B978-0-240-81188-8.50004-7

AutoKey

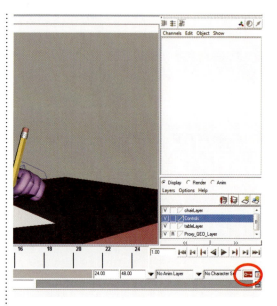

1 Open AutoKey.ma. The quickest way to turn AutoKey on or off is the button in the bottom right corner. Make sure it's red to indicate AutoKey is on.

HAVING TO PRESS THE **S** KEY incessantly while animating does two things: gets tedious, and it wears out your **S** key. So in the interest of preventing tedium and extending your keyboard's life, let's look at the different ways we can use Maya's AutoKey. This feature eliminates most of your manual keying, and while it's pretty straight forward, it works great with the Hold Current Keys option, which is easy to overlook.

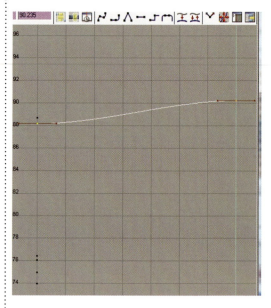

4 Looking at the Graph Editor, we see that there are keys on all the hand attributes at f01, but only on Translate Y at f08.

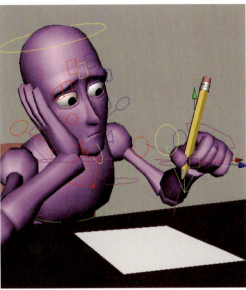

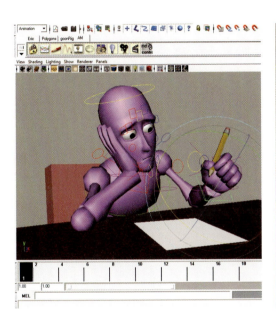

2 There are currently no keys set on the character; he's just posed. Grab the left hand and move it, and you'll notice no key is set. AutoKey only sets keys on controls when you've manually set a key on it first. Undo the move and set a key on it by pressing **S**.

3 Go to f08 and move the hand in Translate Y. Now a key will be set, but only on Translate Y. By default AutoKey only sets a key on the attributes that are changed, not the entire control.

HOT TIP

You can manually key just the Translate, Rotate, or Scale attributes by pressing *Shift* **W**, *Shift* **E**, or *Shift* **R**, respectively.

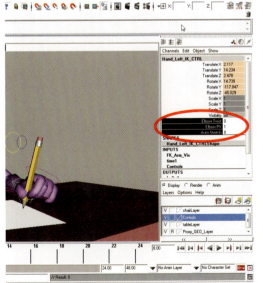

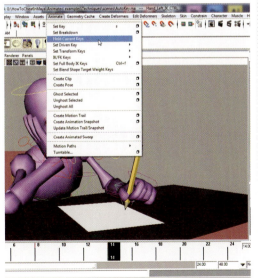

5 In the channel box, select the last the attributes on the left hand control, right click, and choose Delete Selected to erase all keys on this channel.

6 Move to f14 and go to Animate > Hold Current Keys. When using AutoKey, you may want to keep some attributes unkeyed, yet still set a key on all keyed attributes. Using this menu option will set a key on all keyed attributes of a control, but not on unkeyed ones.

Timeline Techniques

T HE TIMELINE is the interface element you will use more than any other when animating in Maya. It has a lot of functionality beyond scrubbing, but its simple appearance can hide how powerful it is. There are lots of edits you can do without ever leaving it, from copy and pasting keys, to reordering them, setting tangent types, even playblasting is readily available. After working through this cheat, you'll have some timeline chops that will serve you as long as you animate.

We're going to use a simple animation of the Goon doing a take. We have three basic poses and right now that's all they are: poses that interpolate to each other. Let's use some fancy timeline editing to make it less poses and more animation.

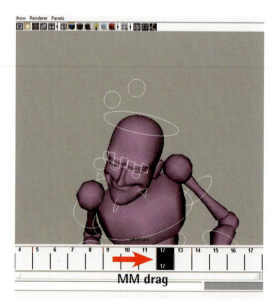

3 Now he doesn't move to the anticipation pose until f05, but he needs to hold there also. MM drag from f09 to f12 and set a key to copy that pose also.

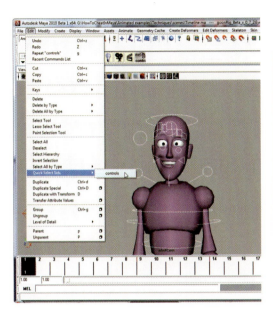

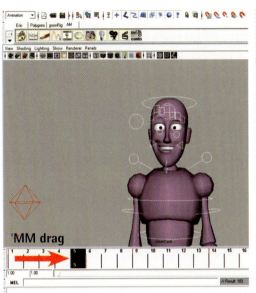

1 Open Timeline.ma. The first pose needs to hold a few frames longer before the anticipation pose. Go to Edit > Quick Select Sets > controls to use a predefined set to select all of the Goon's controls.

2 In the timeline MM drag from f01 to f05. The animation doesn't change like when you scrub normally. MM dragging holds the frame on wherever you started, so it's a quick way to copy poses. Set a key at f05.

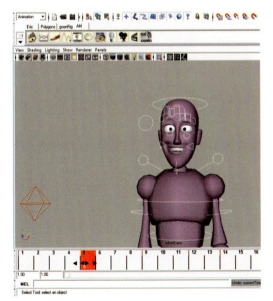

4 It's looking better, but let's make the transition into the anticipation a little snappier. *Shift*-click f05 and will turn red.

5 Click and drag on the two center arrows to move the key to f06. Now the transition is only 3 frames, which feels better.

Timeline Techniques (cont'd.)

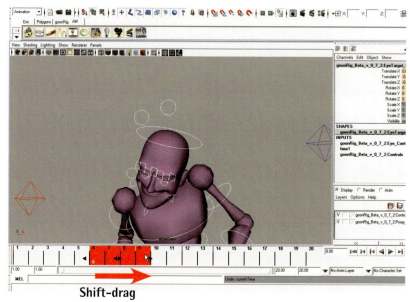

Shift-drag

6 He hits the anticipation pose very hard, so let's cushion him hitting that pose. **Shift** drag from f06 through f09 to highlight them red.

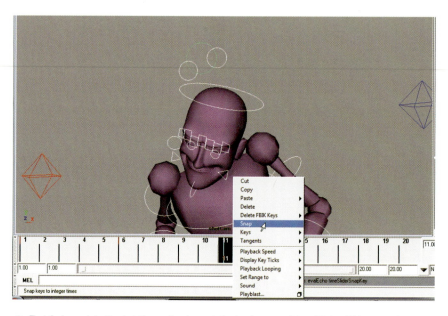

8 That feels much better, but the scaling has put the key between f11 and f12, which can make refining more unpredictable. Right click on f11 and choose snap to snap the key to the closest frame, which puts it back on f11.

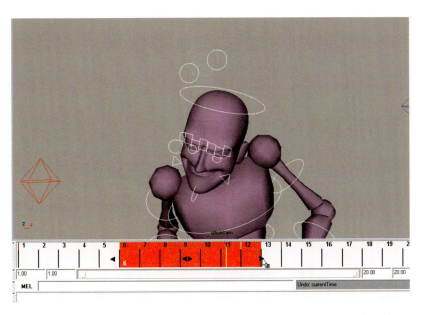

7 Grab the end arrow and drag it through f12 to scale the keys' values out and ease-in to the anticipation pose.

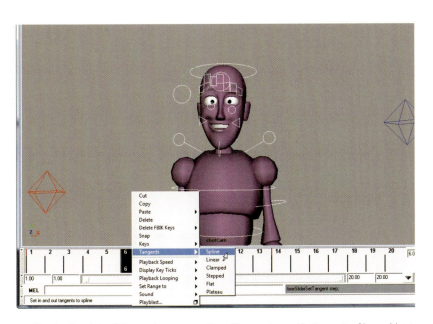

9 The timeline right click menu has many options. You can change the tangents of keys without the graph editor, playblast, adjust playback speed, display options, and more. Use these for speeding up your workflow considerably.

<div style="border:1px solid">HOT TIP</div>

The timeline is where you can activate sound for dialogue animations. Import the sound file through the File menu, right-click on the timeline, and select the sound to activate it during scrubbing and playback.

Figure 8 Motion

'LL ADMIT IT: the first time I needed to do a figure 8 movement for an animation assignment, I was completely stumped. I put my brain into overdrive and came up with elaborate technical solutions involving Maya's motion paths and constraints and probably a dozen MEL scripts (OK, slight exaggeration). When someone finally explained the real solution to me, I was dumbfounded at how simple it was. Lesson learned. And to this day there are plenty of times that the figure 8 concept comes in very handy. If it's not for an outright figure 8 movement (such as the hips and hands in walk cycles), I often add it in subtle amounts for texture in head shakes, hand trembles, and much more.

We'll learn this handy concept by doing a simple animation of the Goon Rig doing his best grooving Stevie Wonder head motion. Then the next cheat will show you how to copy the curves onto the body to offset and really get him into the zone.

1 Open Figure8_start.ma and switch to the shotCam camera. The character is already staged, posed, and ready to go. Switch your tangents to flat in the animation preferences.

4 At f12, rotate the head to the opposite side and set a key. He should now have a constant nodding "no" motion.

2 The key to easy figure 8's is first doing a simple side-to-side movement. At f01, rotate the head to screen left and set a key.

3 Go to f24 and set another key to have the same pose at that frame.

A figure 8 motion is simply just an arc where the side-to-side movement is offset from the up-and-down movement.

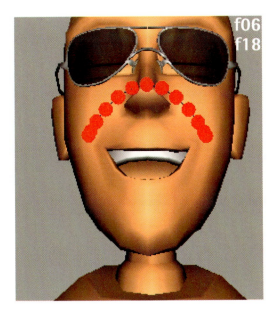

5 Go to f06, halfway through a nod, rotate the head up in X, and set a key only on that channel. Repeat the same thing at f18, keying only the X channel. His head should now nod back and forth in an arc.

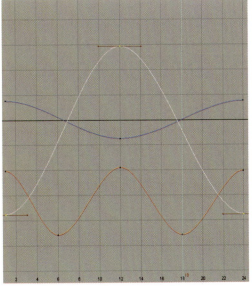

6 In the graph editor your curves should look similar to this.

Figure 8 Motion (cont'd)

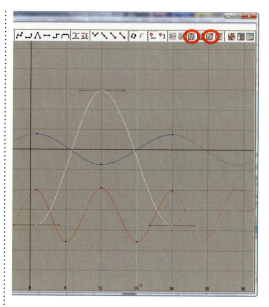

7 Select all the rotate curves and press the Cycle Infinity buttons in the Graph Editor. If you have View > Infinity enabled, the dotted curves will show you how the curves loop.

8 Reduce the frame range by 1 frame using the range slider. By looping from frames 1-23, we eliminate the duplicate frame at f24 that would give the animation a slight hitch in its motion.

f01
f24

f12

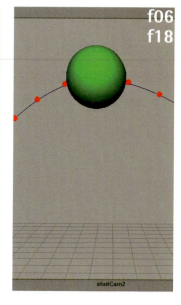

f06
f18

11 Switch to the shotCam2 camera for a ball to translate. With the Translate X, key the ball on the left side on frames 1 and 24.

12 At f12, halfway between, key it on the other side.

13 At frames 6 and 18, halfway through each direction, key the Translate Y upward to create the arc movement.

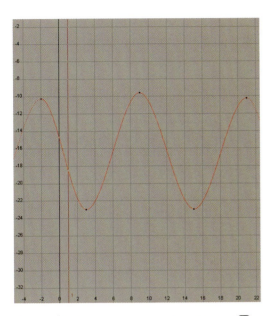

9 Select the Rotate X curve and with the Move tool **W**, shift it 3 frames earlier to offset the up-and-down motion.

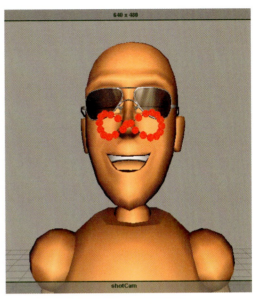

10 Play the animation and he will now be moving his head in a figure 8. I tracked the tip of his nose to show the path of the movement. We used rotation in this example but it works the same with translation.

HOT TIP

This cycle method is good for learning the technique, but it probably won't help much if you need a figure 8 motion in the middle of an animation. Just keep in mind offsetting the up/down with side/side and it should be easy to key in anywhere.

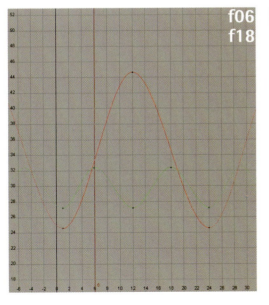

f06
f18

14 Select the curves and make them cycle. Then make sure the frame range is 1-23.

15 Shift the translate Y 3 frames earlier and you have your figure 8 motion. You can now work with the curves to get the arcs exactly the way you want them.

Copying Curves

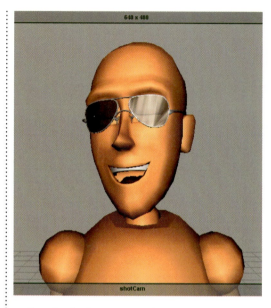

C OPYING DATA GOES BACK goes back to the earliest functionality of computers, and it is alive and well in computer animation. Maya's curve copying abilities are rather extensive, and it offers many options of how we can shuffle animation data around to save time and effort. We're going to build on the previous exercise and apply the curves on the character's head to his neck and body to make him much more, well, animated.

As we'll see in this cheat, copying isn't only for putting the same curve on another control. Any attribute's curve can be copied to any other attribute. This is great for taking a curve that is similar in shape to what we want on another control (even if it's a rotate going to a translate, for example) and using it as a starting point. Tweaking a curve can be much faster than positioning the control and setting keys. Faster = good.

1 Open CopyingCurves_start.ma for the completed exercise found in the previous cheat.

4 Select the neck control. Before we paste these curves, go to Edit > Paste > options box. Set the Time range to "Clipboard" (to use the curves we just copied), Paste Method to "Replace," and Replace Region to "Entire Curve." Then press Paste Keys.

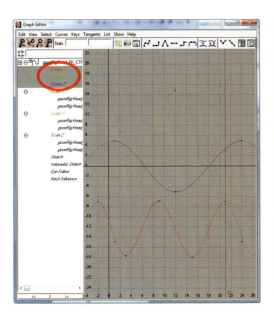

2 In the graph editor, select the Rotate X, Y, and Z attributes for the head control. Be sure to select the attributes in the left panel, not the curves themselves.

3 Go to Edit > Copy in the graph editor menu to copy the curves.

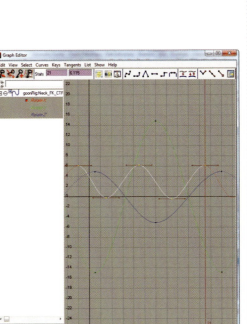

5 The curves will automatically be placed on the same attributes they were copied from if nothing is selected in the graph editor. They've been copied to the neck, but now his head is back a bit too far.

6 I moved up the entire Rotate X curve to bring his head forward and then scaled the whole curve down. Now his movement is bigger but not too much.

Copying Curves (cont'd.)

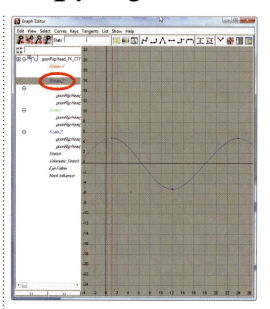

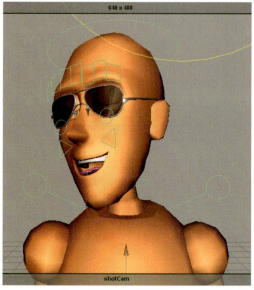

7 Let's use some of these curves to add side-to-side movement on the chest. The head's Rotate Z curve has a similar contour to what we can start with, so select the attribute in the graph editor and go to Edit > Copy.

8 Select the chest control and set a key at f01. Since we'll be putting the head's Rotate Z on the chest's Rotate Z and Rotate Y, we need to be able to select those attributes in the graph editor. Without a key they won't appear.

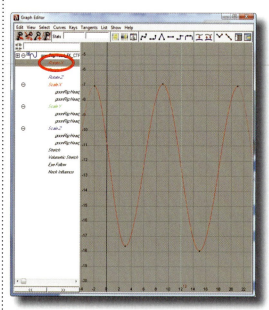

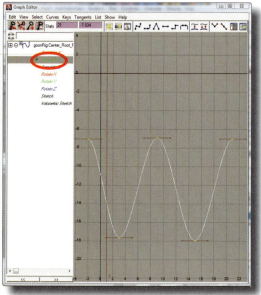

11 Finally, let's add some bounce on his body. The curve most similar to what we want is the head's rotate X, so select the attribute and copy the curve.

12 Select the body and set a key at f01. Select its Translate Y attribute and paste the curve onto it. He'll move out of frame because of the values, so let's quickly tweak this curve.

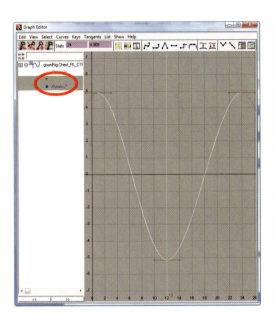

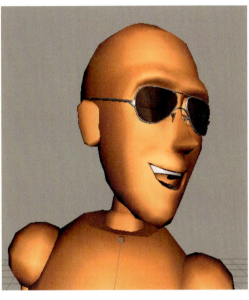

9 In the graph editor, select the chest's Rotate Y and Z attributes and go to Edit > Paste. The curve will be put on both attributes.

10 I shifted both curves 1 frame earlier for a little offset, and scaled them up. Now his movement is much more energetic.

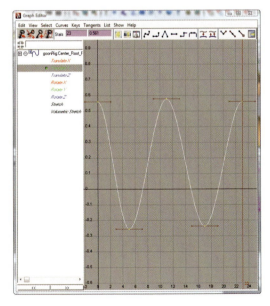

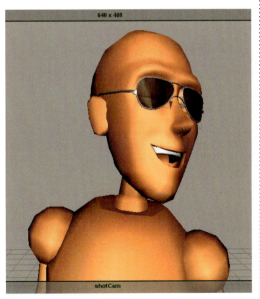

13 I edited the curve so it starts on f01 and his bounces stay in frame.

14 The animation can be refined a lot from here, including adding some bounce in the shoulders, but now you see how we can quickly get a smooth starting point simply by copying curves and not doing any character positioning.

Tracking Arcs

I N ORDER TO GET APPEALING, polished animation, it's a good idea for the motion to travel in pleasing arcs. After all, it is one of the 12 animation principles! There are a variety of options available to us to do this in Maya, from built-in features, to MEL scripts to old-school dry erase markers. Any of them is great if it works for you.

We'll look at how to do this using Maya's built-in motion tracking in this cheat, but also try some of the other solutions and see what you like best. Websites like creativecrash.com have a number of scripts that can track arcs if you search through them. You may also opt for additional software solutions, such as Annotate Pro, to draw over your viewport digitally.

You can also go old school and simply draw on your monitor with a dry erase marker. If you have a CRT monitor, drawing should easily wipe off since the screen is glass. If it's LCD, however, you should put some clear plastic over the screen to avoid the possibility of permanently staining it. Also be sure to press as gently as possible on an LCD screen so you don't damage it.

1 Open TrackingArcs.ma and look through shotCam2. Select the ball and in the animation menu set (press F2 if necessary) go to Animate > Create Motion Trail > Options.

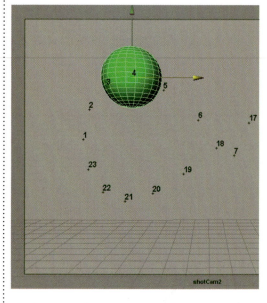

4 With Always Update on, as soon as I move the ball (with AutoKey on to change the keys), the trail will update instantly. Note that if you have a complex character rig, this option could make your computer very slow.

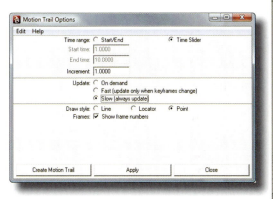

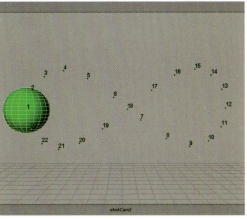

2 Set the options to what you need. An increment of 1 will plot every frame. If your computer is fast you can set update to Slow, and I find the Point style easiest to look at.

3 A very handy motion trail appears, giving you a great overview of your spacing and arcs in the viewport.

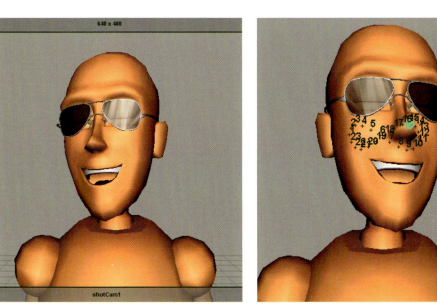

5 Switch to shotCam1. Sometimes it's hard to select what you need to track, particularly if the character's geometry is locked by the setup artist. In cases like these, you can create a sphere, parent constrain it to the rig, and track that.

6 Here I positioned a sphere at the tip of the nose, parent constrained it to the head control, and tracked it. Now it's easy to see the arcs in the head.

IK and FK

ALMOST ANY RIG that is intended for character animation will have the arms and legs available in two modes, IK (inverse kinematics) and FK (forward kinematics). Many animators have a mode they prefer to use when either is viable, but there will often be times when you have to use a specific mode, at least for part of the animation. If your character is going to plant his hand on something to support his weight or push or pull it, you will have no choice but to use IK arms if you want acceptable results. Switching between the modes can seem tedious at first, but when you understand how switching works, it's really quite simple.

For a quick refresher, FK (forward kinematics) means that the position of the hand (or foot) is dependent upon the joints leading up to it. This is how our bodies work in the real world. To reach up and grab something with your hand, your shoulder must rotate, taking your upper arm with it, which takes your forearm with that, which takes your hand up to the object. You can't raise your hand without at least raising your elbow, and so on. With FK, if you move the character's body, it will move the arm as well. This works well for things like walks and gesturing, but not for pulling or pushing things.

IK (inverse kinematics) is the opposite. The hand is positioned on its own, and Maya figures out where the rest of the arm would be angled based on that. You can think of the hand almost as a separate object that's tethered to the body. If you move the body, the hand will stay where it is, making it ideal for pushing or pulling. This way we can work on the body animation without losing the positioning of the hand.

1 Open IK_FK.ma. The left arm is currently in FK. Rotating any of the body controls brings the arm along with it.

4 When Chest Influence is 0, the FK arm will follow with translation of the body, but not rotation. Some animators prefer this because you need to do much less correction on the arms if you change the body.

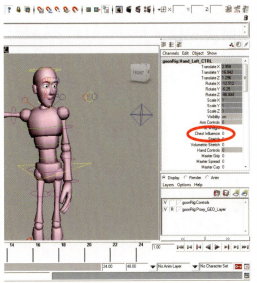

2 Undo the body rotation and put the left arm in any pose you wish. Again, the arm will follow along with anything we move in the body and spine.

3 Undo everything and select the hand control. In the channel box is the Chest Influence attribute. Change it to 0. The arm may jump slightly when you do this, which is normal.

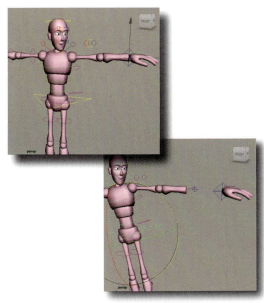

5 Undo everything. Select the hand control and set the IK weight to 1 (100%). The arm will move to the IK control and is now an IK arm. Move the body and the hand will stay in place no matter what you do.

6 On the IK control if you set Auto Stretch to 1, the geometry will stretch between the hand and body, rather than separating at the wrist.

IK/FK Switching

W HEN PLANNING AN ANIMATION, an important step is determining if it's best to use IK, FK, or both at different times. When we need to use both, switching between them in a way that's smooth and seamless is the key to quality work. While some animators may dread this element of animating, when you keep in mind how switching works under the hood, it's very straightforward.

One way to help make switching easier is to think of each mode as a separate arm (and in some rigging methods this is actually the case). When you're in FK mode, think of the IK as another invisible arm holding at it's last keyed position (or default if you haven't used it yet). In IK mode, the FK arm is invisibly following along with the body. I find thinking this way makes switching between them less esoteric and more predictable.

While it's possible to blend into the other arm over several frames, I believe it's almost always best to do the switch over a single frame. When you blend, there are frames where the geometry is partially following both arms, so both controls affect the geometry to varying degrees. This makes it difficult to be precise in both posing and timing. It can work, of course, but I always prefer complete control at every frame.

Some rigs (such as the Goon) do have IK/FK snapping, which makes life much easier by automatically lining either arm to the other. Many rigs don't, however, and you just have to pose the switching frame manually. We'll go over both methods so you're fully prepared for either case.

To use the Goon's FK snapping, you need to install the goonRig Shelf, included on the CD. The ReadMe will walk you through adding it to your shelf.

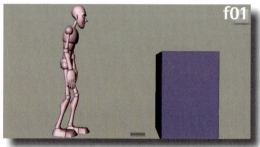

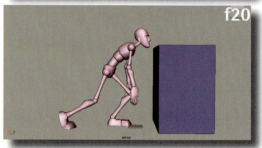

1 Open IKFKswitching_start.ma. There's a simple blocking animation of the character standing, then stepping to push the box. The arms aren't animated yet and they start in FK.

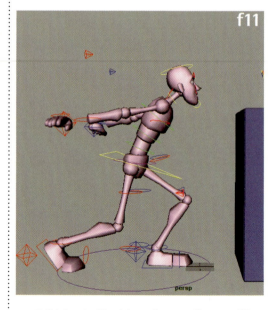

4 At f11, key the IK weight attribute at 1 (for 100% IK). The arms will snap back to where the IK arm skeletons are located.

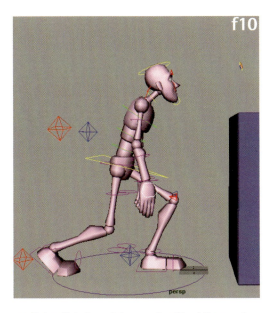

f10

2 First we'll do the switch manually without the snapping tool. F11 is where the switch to IK will happen, so select the hand controls and move to f10.

3 At f10, in the channel box, right click and choose Key Selected on the IK weight attribute. This keys it again at 0 so we hold in FK up to f10.

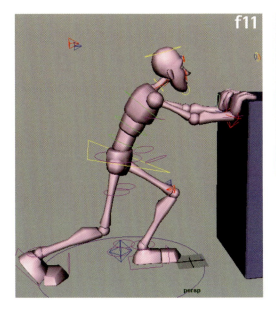

f11

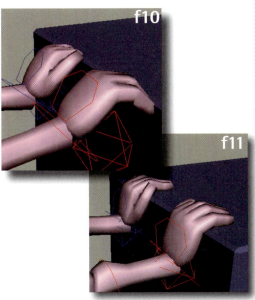

f10

f11

5 At f11, pose the IK hands and fingers on the box. Use the shoulders to help you get a good pose. When doing a switch, it's helpful to first establish the pose you're switching to, rather than basing it off of the transition into the pose.

6 At f10, key the FK arms and pose them going into the IK pose. Try to ignore the fingers and just focus on the palms since we'll need to edit them again anyway. It won't be perfect yet, since we'll also have to adjust the IK pose again in a moment, so just get it in the ballpark.

IK/FK Switching (cont'd)

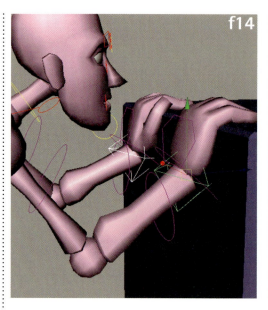

f14

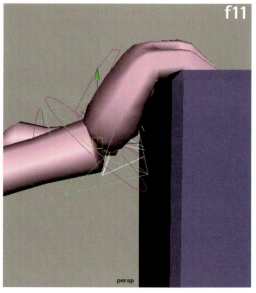

f11

7 Now that the transition is better, we can improve the contact point. Right now his hand just kind of sticks to the box and we don't feel it compress into it. Select the IK controls and set a key at f14 to set the same pose a little later.

8 Go back to f11 and pull the IK controls away a bit and rotate them down slightly. Again, focus only on the palm and don't worry about the fingers yet. Make the palms ease in nicely to f14 to give a feeling of them pressing.

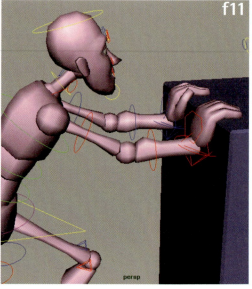

f11

11 Open IKFKswitching_snapping.ma and run the GoonRig picker from the goonRig shelf. In the utility tab we have the Match FK buttons.

12 At f11, select all the FK arm controls and set a key. Click the Match FK button for each arm and Maya will line them up exactly where the IK arms are. Toggle the IK weight attribute to 0 and back to 1 to see that it is indeed exactly lined up.

f08

f11

persp

f14

f19

9 With the press working better, now is a good time to rough in some finger poses and have them trail the palms pressing for some overlap.

10 You probably noticed that once you get the switch frame, the rest is just normal animating except you're switching between two different types of controls. Now let's look at how snapping can save us some work.

HOT TIP

In most FK to IK switches where the hand is planting on something, take care that it just doesn't stick and remain frozen on the object. The hand should feel organic and that the flesh is slightly squishing against it.

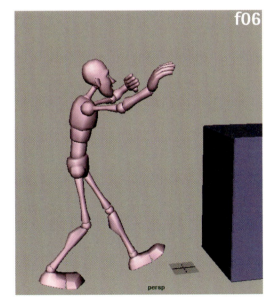

f06

persp

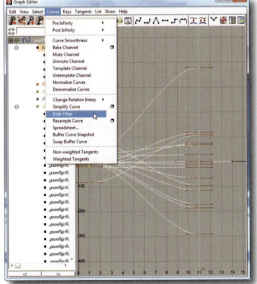

13 We have one problem when we move from the starting pose into the push: his arms go crazy. This is because of gimbal lock (see chapter 6 for details), which can happen from how I posed the arms at f01 and how Maya posed them when it snapped the arms to match the IK pose.

14 To fix it, select all the FK arm curves in the graph editor and use Curves > Euler Filter. Now his arms interpolate to the push pose the way we'd expect and we can continue to refine the animation from there. Chapter 7 is all about gimbal lock if you want more info.

Character Sets

DURING PART OR ALL of their animation process, some animators like to use Character Sets, which are basically selection sets you don't need to select to key. They're kind of a legacy feature, as they've been around since the earlier versions of Maya, but a number of animators still find them useful. Personally, I think they work best in situations where you have to do a lot of keyframing on specific channels of a control, such as the fingers, and for that they can be handy. In this cheat we'll look at how to create and edit character sets.

1 Open CharacterSets.ma. The Character Set selection menu is at the bottom right, next to the Auto Key button. Click the arrow next to it and select "spine."

2 Without selecting anything, press S to set a key. This set contain the spine controls, so they will automatically be keyed with any ke Notice their channels are yellow, indicating they are connected to a se

5 With the arms set selected, setting a key will now key all the controls. Open the Animation Preferences and turn on AutoKey if it isn't already. On character sets, set to Key all attributes.

6 Now adjusting any of the arm controls will set a key on all the other arm controls automatically. This can be handy for blocking if you make a set for all controls.

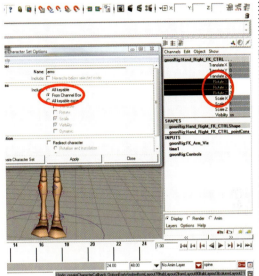

3 Let's create a set for the arms. Select all the arm controls and in the Animation menu set go to Character > Create Character Set > Options box.

4 In the options, name the set "arms" and select "From Channel Box." Highlight the Rotate XYZ channels in the channel box, and click Create Character Set.

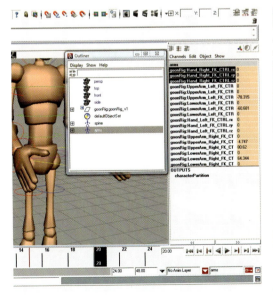

7 To remove attributes, go to Window > Outliner and select the set you want to edit. The attributes will appear in the channel box. Select the attributes you want to remove and go to Character > Remove From Character Set.

8 To add to a character set, have it enabled in the list, select the objects/attributes you wish to add, and go to Character > Add to Character Set.

Multiple Pivot Points

ONE ISSUE THAT CAN ARISE when animating props is needing different pivot points at different frames. Being able to rotate an object from other pivot points when you need to makes animating much easier. While it is possible to key the pivot point of an object to different spots during the animation, this method is difficult to make changes to and keep track of. It also does not give a clear indicator, such as a channel box attribute, that the pivot point is being animated. Instead, we're going to use grouping to achieve the control we need and make animating multiple pivots more straightforward.

Grouping is basically parenting your object to an invisible object that can be moved, rotated, and translated just like any other object. You might think of it as a container for an object or objects. We can define the pivot point of the group wherever we like, and we can nest groups as many times as we need to get the number of pivots we require.

group 2 pivot

object pivot

group 1 pivot

group 1 container

group 2 container

The important thing to remember is once the groups are created, always animate from the top group down. In other words, the last group we create (the highest in the hierarchy, group 2 in the above diagram) is the first one we animate. Also, once you "leave" one group and move to the next one down for the next pivot point, you cannot go back to the previous one at a later frame. You must plan ahead beforehand so you don't animate yourself into a corner.

It may sound a bit precarious, but this cheat will give you all the info you need to have as many pivots as your heart desires. Always be sure to plan your animation first, determine how many pivots you need, where you need them, and the order in which they happen. For this animation, the shuriken will be flying through the air, so we will need to first animate it from its center, meaning that's the last group we will create for it. It will then stick into a wall with one of the tips. The shaking from hitting the wall will resonate from that tip, so that's where the other pivot will be, within the first group.

So in a nutshell, create the groups working backwards from the end of the animation. Animate them starting at the top group (the last one you create).

1 Open MultiplePivots_start.ma and go to Window > Hypergraph:Hierarchy to open the hypergraph. This editor displays objects' hierarchies (what they are parented to). Currently the shuriken is by itself.

2 Select the shuriken and press ctrl G to create a group node and put it inside. You can see in the hypergraph it now appears underneath the group object, meaning it's the child and the group is the parent.

HOT TIP

Never use grouping on a rig, as adding a parent–child relationship can break it. Only use it on props and simple objects. If you need this type of pivot control in a character, it must be built into the rig specifically.

Multiple Pivot Points (cont'd)

3 Rename the group to reflect what pivot you're animating by *ctrl* double clicking the name. Again, we're creating them backwards from how we'll animate them, so this is the tip.

4 With the tipPivot group still selected in the hypergraph, select the Move tool and press the Insert key. This goes into pivot mode (the arrowheads disappear). Move the pivot to a tip and press Insert again to exit pivot mode.

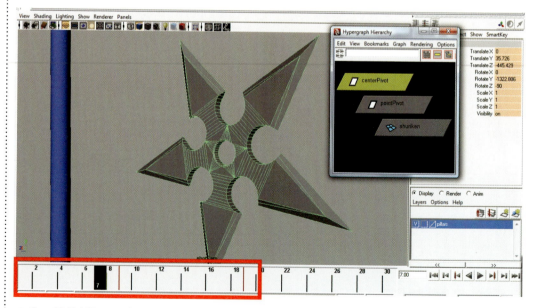

6 Open MultiplePivots_end.ma to see how the animation works. The centerPivot group is animated from f01 to f19. As stated before, the last group that's created is the first one that's animated. As the frames progress and the pivots change, you simply work your way down that list, and never go back to a pivot after the following one has been keyed.

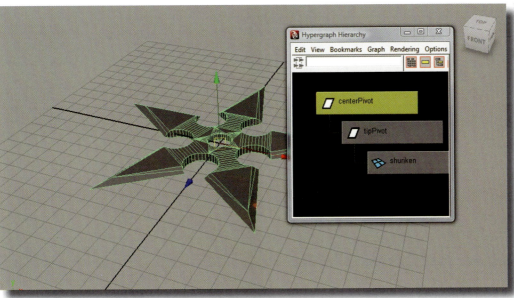

5 Making sure that the tipPivot group is selected, press **ctrl** **G** again to create another group at the top of the hierarchy and rename it to centerPivot. This is the center of the object that we will animate first, flying through the air. We won't change the pivot on this one since it's already where we need it to be.

HOT TIP

You can use grouping to scale sets and scenery, provided they are just models and not rigged. Simply select everything, group it, and use the scale controls on the group to make it fit your character.

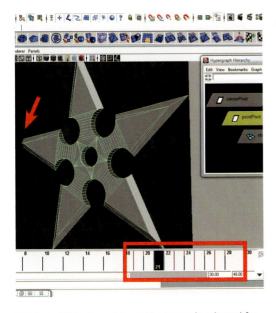

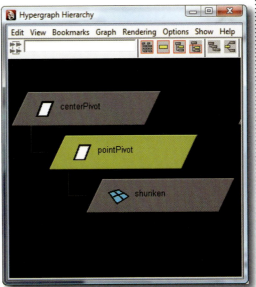

7 From f19 to the end the tipPivot group is animated for the residual energy from hitting the wall.

8 When animating multiple pivots, it's easiest to use the hypergraph to quickly select the group you want to animate. You can also select the object and use the up/down arrow keys to move through the hierarchy.

Re-Blocking

T IS INEVITABLE, IT IS YOUR DESTINY... As an animator the time will come (and regularly at that) where you'll need to make changes to work you've already started refining. It can be frustrating when it happens, but it's one of the tiny cons to the major pro of having the coolest job in the universe. Doing a re-block in the middle of an animation is just an occasional fact of life for an animator. The key to making changes smoothly is knowing how to save what you can, when to shuffle around poses that can be salvaged for other spots, and not allowing the new stuff to derail what's already working.

We're going to look at a sort of test case where we take something that's already in the refining stages of animation, and insert another acting beat into it. We'll start with a simple take animation, and imagine we've been given the direction to have him see a spider first, which then makes him do the take.

As we expand this animation, we'll also use it in the polishing chapter to learn other techniques, such as texture and moving holds.

1 Open MakingChanges_start.ma. We have a simple animation of the Goon doing a take, and we need to add a spider coming down screen left, which he sees and does the take from there.

4 He'll be looking at the spider when he starts the anticipation, so that's a good spot to begin. Select the spider, move it into position at f40, and set a key.

2 The first thing we need to do is expand the frame range. Click in the Display End field and enter 70. Typing a number greater than the whole range here automatically expands the entire range.

3 Go to Edit > Quick Select Sets > controls to use the predefined selection set to select all his controls. Select all the keys from f06 on, and move them to start on f50.

f50

f01

5 At f50 alter his pose to make him calmly looking at the spider.

6 Let's keep his eyelids low until he does the actual take, so select the two eye controls. MM drag to f01 and set a key to copy the eye pose.

101

Re-Blocking (cont'd.)

7 Alter his mouth pose to give him a smug, semi-vacant expression. This will add some variety when he changes to the smile when looking at the spider, and hopefully make it funnier.

8 We'll have him hold while looking at the spider for 10 frames for a delayed reaction. Select all controls, and in the timeline MM drag from f50 to f40. Set a key to copy the pose.

11 On the spider, MM drag from f30 to f17 so he has a 7-frame drop down.

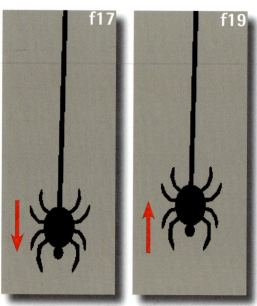

12 Rekey the spider at f19 with the same pose as f17. Then go back to f17 and lower him a bit more. This will give him a little overshoot when he hits the bottom.

9 MM drag from f01 to f30 and key all to hold the first pose for 30 frames.

10 Select the spider and at f10, translate it up out of frame and key it.

HOT TIP

Here's a good trick when you need to insert new material into an already refined animation: isolate the sections that won't change by inserting keys (hold *I* and middle click) in the graph editor on all curves before and after where the change happens. Then delete all keys in between the sections to give yourself some working space. Inserting the keys makes sure any new poses you'll add won't affect the animation you don't want to change.

13 To finish this re-blocking, we just need to make him looking at the spider at the end. At f58, move the eyes to a better position.

14 With a minimum amount of work, we are able to make this animation much more interesting than its previous version. It's now ready for some more detailed refining with the face and overlap. See the Polishing chapter to keep working on it.

103

Spotlight: P.J. Leffelman

P.J. LEFFELMAN IS THE ANIMATION LEAD at 2K Marin on *Bioshock 2*. Prior to that he was a Senior Animator at LucasArts. His first foray into animation was at DNA Productions where he worked on *The Ant Bully* and two Jimmy Neutron TV specials, *The Jimmy Timmy Power Hour 2* and *3*.

WHAT'S A TYPICAL DAY LIKE AS A LEAD ANIMATOR ON A AAA GAME?

Every day is different, which is one of the things I enjoy so much about my job. I view my job as keeping things flowing so that everyone else on the animation team can do their jobs to the best of their abilities. That can mean that occasionally I don't get to animate as much as I'd like but I get to participate in different parts of the production process. Aside from working with the animators on a daily basis, the closest thing that happens on a daily basis is working with the game designers and engineers to make sure that they're getting what they need from us and vice versa.

WHEN DOING ANIMATION FOR GAMES, WHAT DO YOU NEED TO FOCUS ON TO BE SUCCESSFUL?

The thing that makes successful game animation in my mind is that the animation is efficient. Since gameplay is directly affected by our work, we have to work within constraints that make the game fun. Strong, readable poses that have really dynamic timing is what I enjoy seeing the most as both an animator and as a game player. A fine line that we have to constantly be aware of in games is how far to push personality and uniqueness in our gameplay animation. While it's of course important to convey as much personality as possible, if you veer too far away from the beaten path just in order to make a statement with the character it can very easily be lost in the fray of the game. For example, when we were working on an enrage animation

for one of our characters who is a teenage girl, we tried a variety of actions all centering around her specific character. We tried to stick as close to an angsty, pouty teenager as we could, and from an animation perspective it worked great. However, in the game it was very difficult to read the action that this character was doing because it was so atypical and so far from cliche. We eventually tried a simple "Grrrrrrrr, I'm the Hulk and I'm mad" animation and it immediately telegraphed what we were going for.

WHAT IS YOUR TYPICAL WORKFLOW FOR A SHOT?

I always start every shot with as much research as possible. If it's a gameplay animation, I talk with the designers to find out what their gameplay goal is with the action. I follow that up with the engineers to find out if there are any oddities in the system that I need to account for. If it's a scripted scene, I talk with the level designers and artists to find out what they know in order to make sure we're all on the same page and that we're taking into account all of the wacky things a player in a game can do. After I know how my work is going to be working in the game, I start thinking about how the character would perform the action and if that's consistent with what other people have been doing with the character. If it's a locomotion animation, I tend to just act it out and shoot video of it. If it's a combat animation, I'll look up some video of fight scenes or a particular martial art to come up with a more unique or interesting looking attack than I would do on my own. Once all of my thinking has been done, it's just a matter of animating the shot. Gameplay animations are generally 20-40 frames long, so a few poses later, you can test the animation out in the game to see if it's hooking up properly and is worthwhile to take past blocking. I'll get feedback from my co-workers and after that, it's just a matter of putting in the breakdowns and making it look pretty.

WHAT ARE THE DIFFERENCES BETWEEN ANIMATING FOR FILM AND GAMES?

I think the biggest difference is that film has a luxury of time that games don't have. The animation in games needs to be more direct in order to make the game fast and fun to play. For example, an attack animation in a game generally needs to get to the hit frame within 5-7 frames, which doesn't leave a whole lot of room for anticipation. This forces a style where you have very fast, dynamic animations that have a more drawn-

out settle. Another difference is how animations hook up. In film you have to worry about how your shot segues across a cut with the animator before and after you. In games, more often than not, your start pose has to be your end pose as well. So you have to come up with a fluid and natural way for that to happen, which can be pretty difficult at times.

Another big difference is that games are far more collaborative when it comes down to the individual animator's role. It's expected that a game animator talks with the designers or the engineers when they come across a problem. They're expected to attend meetings where they have feedback on parts of the game aside from the animation. When I was in film, it was very much get a shot from layout, animate it, hand it off to lighting and that's the last I ever heard about it. In games, ideas are bounced around a lot more freely given the iterative nature of the process. If you can't work in a group setting, it's very difficult to work in games.

WHAT'S THE MOST CHALLENGING THING YOU'VE ANIMATED AND WHY?

It's the shots that look the easiest that always end up being the hardest. There was one shot on *The Ant Bully* that wasn't anything special, just a wasp flying toward the camera with the other characters on his back. Dailies after dailies, I couldn't hit the path that the director was looking for. There were some layout changes that made me rework the shot a couple times as well. Eventually I got the shot done through persistence. The weird thing about the shot is that the characters on the wasp's back never made it past a blocking plus stage. However, since they really weren't the focus of the shot, it didn't matter too much.

HOW DO YOU APPROACH FINDING THE BEST ACTING CHOICES FOR A CHARACTER?

Just like everything else in animation, it comes down to research. You need to gather all the information that you can that tells you about the character, where he's been, where's he's going, what his goals are, things of that nature. You then take all of that information and distill it down to something that you can relate to, drawing on the various experiences you've had in your life. Drawing inspiration from how other people have handled a similar acting challenge is a good place to start, but a lot of why animators animate is to get to act and show their unique take on a situation. If you can take a situation and realistically place yourself in it, and if that lines up with the director's vision, then you're in good shape.

The other thing that should be encouraged more is to check in with other people. Choose a co-worker who impresses you and ask her how she would work through the shot. Everyone around you has an individual take that's worth considering and he or she may offer an acting choice that you just wouldn't come up with. Whether or not you someone else's idea in full, in part, or not at all, it will help you to look at things from other people's perspectives.

HOW DOES MOTION CAPTURE FACTOR INTO YOUR WORK?

We used motion capture for one of the characters in our game. Ultimately, though, we ended up redoing most of the gameplay critical animations by hand. The gameplay is directly affected by our animation so if a character is moving too slowly, it's way easier to adjust hand-keyed animation over mocap. Mocap is great for getting something that looks more or less complete really quickly. However, if you're trying to force it to be something different, like slowing it down, changing poses, altering the acting, then it's really best to just hand animate it.

What mocap excels at is capturing ambient human behavior. If we need a variety of idling behaviors, it's far quicker to capture people actually milling about than it is to shoot video reference and try to layer in all of the subtlety that people inherently have.

WHAT ADVICE DO YOU HAVE FOR SOMEONE WHO WANTS TO WORK AS AN ANIMATOR IN GAMES?

One big thing that someone should realize is that you don't have to be a video game nerd to work in games. There are people at both ends of the video-game-playing spectrum at work. What everyone shares is a desire to work together to make a really fun and entertaining experience.

On the animation front, we're looking for people who are just good at what they do. If you are great at acting, we'll find a use for you. If you are great at physical action, we'll find a use for you as well. If you are really technical, we'll find a use for you. If you're a rocking 2D animator who hates computers, we'll find a use for you as well. A shorter way of saying all of that is that we're not looking for any specific quality in an animator. We're looking for people who have good ideas and do good work. If you can bring that and you're up for learning how your skills can work in the game we're working on, quite likely you'll get a job offer.

■ Constraints can get a bad rap sometimes. Once you understand the nuts and bolts and how to think about them, they become a great tool in creating more expressive animation.

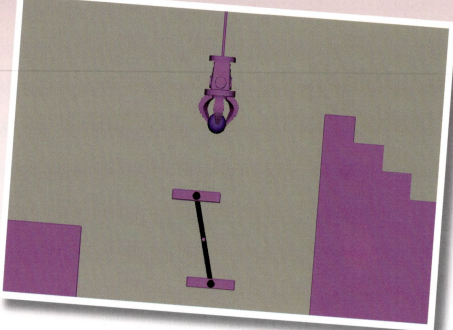

5

Constraints

SOONER OR LATER every animator must have a character interact with a prop, and that means we need to work with constraints. They can seem a tad complicated at first, but once you understand how they work, you can design a constraint system that is simple and flexible. The next few cheats will tell you what you need to know about constraints as an animator. Then we'll look at some tools that will make constraining a breeze. I've also included some in-depth video tutorials on the DVD, as the easiest way to learn constraints is to observe them in action.

DOI: 10.1016/B978-0-240-81188-8.50005-9

Parenting

NOVICE ANIMATORS SOMETIMES confuse parenting and constraining. These two processes behave somewhat similarly, but are quite different under the hood. First let's look at how parenting works.

Parenting is essentially indicating the center of an object's universe. By default, an object created in Maya exists in 3D space, and the infinite area inside the viewport is its central universe.

When we parent an object to another object, (referred to as the child and parent) we are making the child object's central universe the parent object, instead of the 3D space. The child can still be moved independently, but its location is defined by where it is in relation to its parent, not where it is in space.

Think of it like this: you are currently parented to the earth. If you are sitting at your computer reading this book, as far as you're concerned, you're not moving. If you get up to get a soda from the fridge, you would say you've moved to a new location. Now think beyond earth and consider your position in the galaxy. When you're at your computer thinking you're not moving, you actually are moving through space (at 65,000 mph!) because the earth is moving through space and you are on it. It's your own perspective that you're not moving, but in relation to the entire universe, you are. This relationship of you to the earth to the galaxy is respectively the same as a child parented to its object in Maya's 3D space. Let's observe this in Maya.

1 Open parenting.ma. Here I've created two spheres, and right now they're independent of each other. We can see in the hypergraph (Window > Hypergraph) that they're side by side, indicating two separate objects.

4 This is also indicated in the channel box, where we see that although nothing has changed in the viewport, the little sphere coordinates and scales are different to reflect the new relationship.

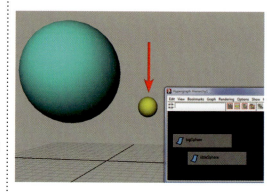

7 Use the Move tool again to translate the little sphere.

2 Notice the coordinates for the little sphere in the channel box, indicating their position in world space. Move the little sphere and you will see these coordinates update accordingly.

3 First select the little sphere (the child), then the big sphere (the parent), and press **P** to parent them. We can see in the hypergraph that they are now connected. We've created a hierarchy. The little sphere now uses the big sphere as its reference point.

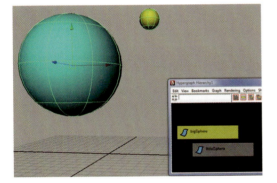

5 Move the big sphere using the Move tool **W**, and the little sphere follows accordingly, maintaining its position.

6 If we look at the little sphere's coordinates in the channel box, they're still the same. Its reference point of moving is only in relation to the big sphere, just like our intro example: our perception of moving is related to the earth, rather than the universe.

8 Now the translate channels for the little sphere change, because it's in a different position relative to the parent.

9 What's this have to do with animating? Knowing the difference between parenting and constraining will help you make a flexible system when using props with your characters. Next we'll look at how constraints work, and then how to use these methods together.

Parent Constraints

Parent Constraint

Translate Data →

Rotate Data →

Character's Hand · · · · · · Prop

CONSTRAINED OBJECTS are fundamentally different from parented ones in that they still ultimately reference their position from the origin. They simply get their translate, rotate, and/or scale information told to them by their master object. Think of it as a direct line from the master object's attributes into whichever attributes are constrained (which can be any or all of them) into the target object. When we have constrained a prop to a character's hand, it isn't actually "stuck" there; it just receives the same location information, which makes it follow along.

Because of this direct line, we can't move constrained objects because they're hardwired to the master object. We can turn the constraint off (using what's called the "weight"), but if it's on, the constrained attributes cannot be altered independently of the master object.

We can see that there is sort of a yin/ yang balance with parenting and constraints. Parenting cannot be turned off or on over the course of an animation, but you can move the child object independently. Constraints can be turned on or off yet are locked to their master object while on. In setting up effective constraint systems, we can use the strengths of each to get the results we need.

1 Open parentConstraint.ma. There are many types of constraints but as an animator, you'll probably use parent constraints most of the time. Parent constraints connect the translate and rotate attributes, and the constrained object behaves as if it were parented, except for being able to move it independently.

4 In the hypergraph, notice that the objects stay disconnected, and we see a constraint node appear. This is connected to the box, because it looks at the translate and rotate data of the cone, and tells the box to do the same.

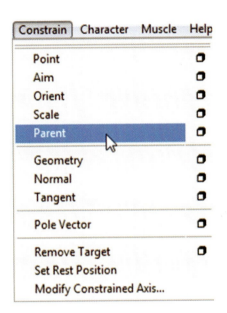

2 In this scene we have two independent objects, a cone and a box. Go to Window > Hypergraph: Hierarchy. Notice how they are not connected like in the previous parenting example.

3 Constraint selection order is the opposite of parenting, where the master object is selected first. Select the cone, then the box, then in the Animation menu set go to Constrain > Parent. The names can make things confusing, but keep in mind this is a constraint, so you are not actually parenting these objects.

Constraint weights are used when we need to have an object constrained to different objects at different times in an animation. For instance, if we had a character throw a ball to another character who catches it, the ball would need to be constrained to their hands at separate times. We set keys on the weights to tell Maya which constraint to use at a given time. It's also possible (but not common) to have multiple weights on. Two objects at 100% influence would keep the object halfway between both of them. We'll look at weights later in the chapter.

5 In the channel box the box's Translate and Rotate channels are blue, indicating they're constrained to something. If you click on the box_parentConstraint1 node, you'll see "Cone W0." This is the weight, or how much the constraint is affecting the object. 1 = 100% influence.

6 Translate and rotate the cone and the box follows. Notice how it maintains its position relative to the cone. This is why it's a parent constraint, because it assumes the pivot point of its master object, just like in a parent-child relationship.

113

Constraining a Prop

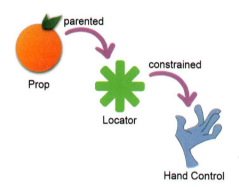

parented

Prop

constrained

Locator

Hand Control

W E'RE GOING TO USE both parenting and constraining to get the most flexibility in animating our props. Instead of just constraining the prop itself, we're going to constrain a locator that has the pencil parented to it. A locator is simply a blank object that you can translate, rotate, and scale. Not only does this create insulation between the rig and prop, but it also gives us the flexibility to reposition the prop and animate it. We're using the benefits of parenting and constraining in conjunction to make animating flexible and easier.

This approach can be very handy if you want to make some adjustments to a prop after you've already constrained and animated with it. Then we'll see how this can allow us to animate the writing movement of the pencil while keeping it in sync with the moving hand.

In a nutshell, the pencil is parented to the locator, which is constrained to the hand. Parenting the pencil lets it follow the locator, but still allow us to keyframe it. Since the locator is constrained to the hand, it follows how we want it to, while still giving us control to animate the pencil movement and keeping it isolated from the rig.

1 Open propConstraintSTART.mb. Go to Create > Locator and move it in the area of the prop. If you can't see it, make sure Show > Locators is enabled in your viewport menu. Use the Scale tool **R** to make it larger.

4 Select the pencil, then the locator, and press the **P** key to parent them. Moving the locator will now move the pencil. Using the locator, position the pencil in the character's hand. Keep in mind where it will pivot from between the fingers.

114

2 In the perspective view, position the locator at the pivot point where the character will hold the prop and where the fulcrum of movement will be. It doesn't have to be mathematically exact, but get it as close as you can, being sure to check the position from all angles.

3 Select the pencil and press **W** for the Move tool. Then press the Insert key on the keyboard to go into pivot mode. Hold down the **V** key and middle click the center of the locator to snap the pencil pivot to it. It may help to press **4** to go into wireframe mode to do this. Press Insert again to return to the normal Move tool.

HOT TIP

When creating any constraint system, it helps to diagram it on paper first. Just diving into Maya and parenting and constraining with reckless abandon can make things very confusing very quickly. Think about what you need to accomplish, where you need control, diagram it, and name your props and locators appropriately. Remember, disorganized constraining will make animating more difficult and ultimately affect your work negatively.

5 Select the hand control, then the locator, and go to Constrain > Parent. The channels on the locator will turn blue, indicating a constraint.

6 Now when we translate or rotate the hand, the pencil follows along. We can now easily animate the hand and arm writing. For the subtle movement of the pencil, we can simply key the pencil itself (perhaps with some subtle animation on the fingers as well).

Constraint Weights

1 Open constraintWeightsSTART.ma. In a viewport menu, go to Panels > Perspective > shotCam to see the camera for the animation. If you like, press the viewport's Film Gate button to frame the animation more accurately.

WHEN WE'RE USING PROPS and objects in our animations, there will be times when things need to be constrained to multiple characters. If a prop is passed between two or more things, it will have to be constrained to all of them at some point in the animation. To tell Maya which constraint we want active at a specific time, we need to use the constraint's weight attribute.

It may be helpful to think of the weight as an on/off switch. Every time we constrain an object to something else, a weight attribute for that particular object is automatically created in the constraint's node in the channel box. Then we simply need to key it at 1 (on) and 0 (off) at the appropriate times.

In this simple animation of one hand giving another a pencil, we're going to see how to switch the constraint weights over one frame to get a seamless transition.

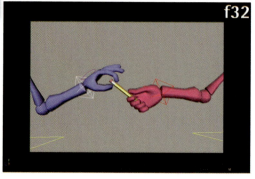

4 Go to f32. This is the pose we want to constrain the pencil to the hand on, as it will take control of it from this point on. Select the blue hand IK control, then the pencil control, and go to Constrain > Parent Constraint.

7 Go to f33, and then switch the weights values to the opposite, turning off the pink hand constraint and turning on the blue hand's. Select both weights, right click, and Key Selected.

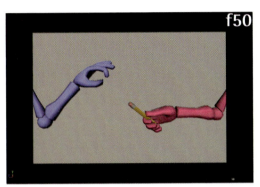

f50

2 Scrubbing through the animation, we can see that the hands go through the motion of giving the pencil, but the blue hand doesn't actually take it. Right now there is only a parent constraint on the pencil for the pink hand.

3 In the Layers panel, turn on the Controls layer to see the rig controls. Select the control on the pencil and click on pencil_anim_parentConstraint1 in the channel box. Here we can see the weight attribute for the right hand since it's constrained to it.

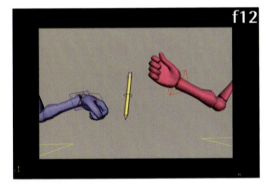

f12

5 You'll see the new weight for the left hand created in the channel box, but now the pencil floats between both hands. This is because both weights are on, therefore pulling the object equally to keep it exactly between them.

6 Select the pencil control. At f32, set the Hand Left weight to 0 (off). Then select both weights, right click, and choose Key Selected to set a key on both weights. If you scrub through now, the pencil stays with the pink hand the entire animation again.

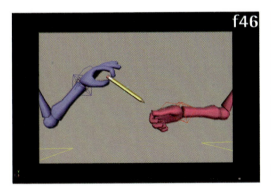

f46

8 The pencil should now get taken by the blue hand after f33. On your own projects, remember to design your animation so you have the right pose to pick up a prop and make the switch look natural.

f37

9 You'll notice that the pencil goes through the pink hand's fingers after it is taken. Once we have the constraint working properly, its much easier to animate the fingers following the pencil as they let go. Open constraintWeightsEND.ma to see the final result.

HOT TIP

Constraint weights don't have to be switched over one frame. They can blend over however many frames you want by simply setting the weight keys farther apart. Then the constraint will gradually drift into the next one. You can even edit the blend's curve in the Graph Editor. For animations like this one, that obviously wouldn't work, but for situations without obvious contact changes it can be handy.

Animating with Constraints

THERE WILL INEVITABLY be situations where the easiest way to animate something is to keyframe it at certain places, and constrain it in others. Maya makes this simple with an attribute called "Blend Parent" that we can key on and off depending on what we need at a given moment. When Blend Parent is set to off (0), Maya will ignore any constraints on an object and follow the keyframe data. When Blend Parent is on (1), it will ignore keyframes and conform to any constraints currently active. The best part about Blend Parent is it's created automatically whenever you set a key on a constrained object, or constrain something that already has keyframes set on it. When either of these situations happens, Maya creates a pairBlend node that allows us to switch between the two modes (or even blend somewhere in between, hence the name...).

Many times, I find animations that need this approach are simplest when done in a rather straight-ahead fashion. That isn't to say the animation isn't planned out --it most certainly is-- but I've always found keeping track of things easiest if the constraints are done during the blocking process. We're going to take that approach here, where we'll start by animating an object (OK, it's a bouncing ball, animation's "Ol' Bessie"), constrain it to a platform, then keyframe it again, constrain it to a claw, and finally keyframe it through the end. Sounds complicated in theory, but this exercise with a living ball as our character will show you how simple it really is.

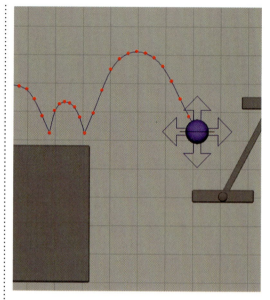

1 Open ballCourse_constraints1.ma and switch to the front view. I've done some preliminary animation of a ball hopping over to a platform, which is also animated. Scrub through and you'll see that the ball doesn't follow the platform after frame 41.

4 At frame 41, right click on the Blend Parent attribute and do Key Selected to set a key on it. This ensures that we will be at 1 (on) at the frame where we want the ball to start following the platform. The channel will turn orange once you set the key.

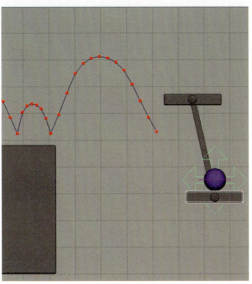

2 Select the platform the ball is on, then the ball move control, and in the animation menu set go to Constrain > Parent Constraint. Notice that our channels turn green, indicating both keyframe and constraint data, and the Blend Parent attribute automatically appears.

3 Scrubbing through the animation, we see that the ball now follows the platform, but stays there the entire time. Because Blend Parent is on (1), Maya ignores the keys and follows the constraint. We need to key it on at frame 41, but have it off up until then to see the animation.

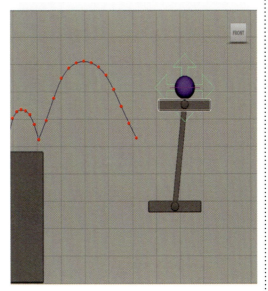

5 Go to the frame before, frame 40, and set Blend Parent to 0 (off). Right click it and key selected again. Since this will be the first key for Blend Parent, all the frames up to it will be off as well.

6 Scrub again and you'll now see that the ball is once again animated until frame 41, where it follows the platform perfectly.

Animating with Constraints (cont'd)

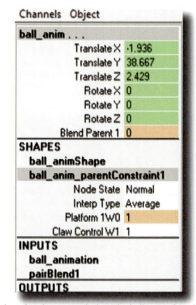

7 Open ballCourse_constraints2.ma. This file has everything we've just done, as well as the blocking animation to get the ball up to where the claw grabs it. Scrub through to frame 88.

8 Select the claw control, then the ball control, and go to Constrain > Parent Constraint. Notice in the channel box that we get a Claw Control W1 attribute. Remember that these weight attributes tell Maya which constraint is currently active.

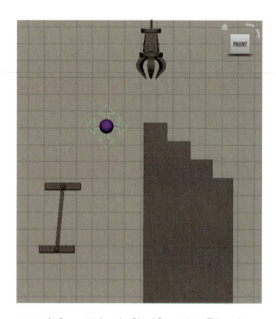

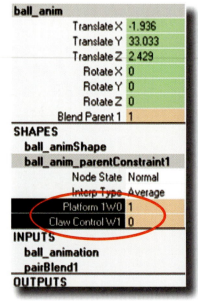

11 At frame 88, key the Blend Parent to 1. This makes it switch on over 1 frame, making our transition seamless. The ball still doesn't follow the constraints properly though, as we need to set keys on the weights to tell Maya which constraint we want active.

12 At frame 41, RMB > Key Selected the Platform weight to 1, and the Claw Control to 0. The ball will snap back to the platform. However, it should follow the claw at frame 88, so the weights need to change there.

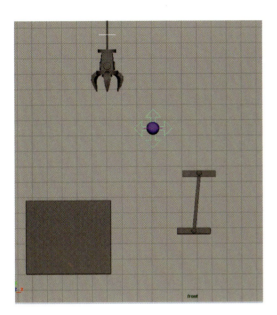

9 If you scrub, you'll notice the ball acting strangely at the constrained parts of the animation. This is because since both constraint weights are on, they both pull at the ball equally.

10 First let's key the blend parent so the ball follows the constraints at frame 88. Go to frame 87 and RMB > Key Selected on the Blend Parent attribute. This sets another key at 0 to hold it there from frame 75.

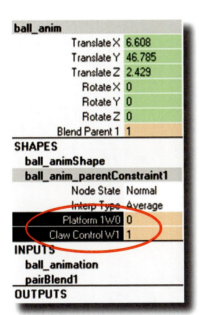

13 Set a key on both weights at frame 87 so this value holds until we need it to change. Then at frame 88, key the weights at the opposite values, the platform to 0 and the claw control to 1.

14 Now the ball stays with the platform when it's supposed to, and follows the claw after frame 88.

121

Animating with Constraints (cont'd)

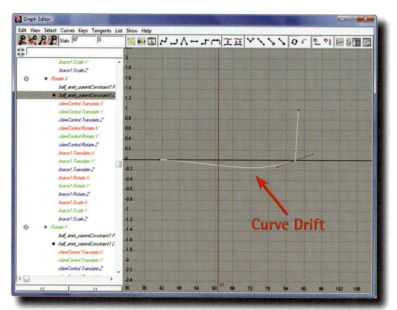

15 If you notice the ball behaving strangely during the constrained sections, check the graph editor. If the curves for the blend parent or weight attributes have any drift in them, they will mess up the constraints. Be sure to zoom in and check the curves closely, as they can look flat zoomed out.

17 Open ballCourse_constraints3.ma and it will have everything we've done, along with the final blocking animation of the ball being released and bouncing down the stairs. We can't see it however, because we need to key Blend Parent off once more to tell Maya to once again use the keyframe data on the ball.

16 If you find this happening, simply select the curves and set them to flat, linear, or stepped tangents using the buttons at the top of the graph editor. Any of these tangent types will work for this purpose. See the Splines chapter for more details on how the different tangent types work.

HOT TIP

You can set the options for a parent constraint in Constrain > Parent > options. Here you can tell Maya to only constrain specific axes, if you only need certain ones for your animation.

18 At frame 112, key Blend Parent to 1 to hold it through that frame; then key it to 0 at frame 113. Scrubbing through you should see the ending blocking animation. We now have blocking of all the animation, including the constraints. If you have more constraints in an animation, remember to always have the active one's weight keyed at 1, and all others at 0. Always set a redundant key at the frame before the weights and Blend Parent change to hold the current state up to that point. Remembering those two steps will get you through any number of constraints, no matter how many there are!

Doing Personal Work

AS YOU GROW AS AN ANIMATOR, you will likely develop a laundry list of things you want to animate. Perhaps a particular dialog clip inspires you, or you always wanted to animate a giant spider destroying a city (hey, it's nothing to be ashamed about). Even if you are working on projects that you totally love, there will be things in completely different styles or veins that intrigue you. This is good, as it gives you plenty of fodder for personal work-- that is, things you can work on in your spare time.

Work when you're not working? Of course! After all, if you don't love what you're doing, then you wouldn't be an artist. Naturally, I'm talking about doing this with a balanced perspective. Finding a happy medium between hard work and relaxation is key to enjoying what you do. But spending a few hours a week on something you work on just for you can be a tremendous benefit to your skill and knowledge.

Personal work can be done in a variety of forms, and it's important to mix it up enough to give yourself a broad range of self-education and growth. Some projects should be short, simple tests of a concept. These are things you could finish in a day or a few days. They're generally not finished works you would show, but just things to try something new. This could be anything from challenging yourself to come up with 10 different blinks, to animating pieces of a wall breaking open, to a slick camera move you saw in a film, to any small idea that you will find useful in the context of a larger project. If you're working on a short film, these can be tests of stylistic ideas or pieces of shots you know will be challenging to animate on the full project. We all know that our first attempts at something are never our best.

Another idea for doing personal work is recreation of another animation. While not something you want to do all the time, this exercise can be a phenomenal learning tool. It doesn't have to be extensive either. Take one or two seconds of a character animation from an animated movie and using your own rig, do your best to recreate it exactly. I'm not talking rotoscoping, but having the clip next to you, constantly checking it and analyzing what each body part is doing. You will be amazed at how this makes you look at something in depth and in a completely

different way. All of the master artists learned partially from imitation, and animators should be no different. Or if you want to practice staging and composition, take a clip from a movie you like, set up the characters, and copy a sequence of shots using simple geometry and placing the characters. A simple layout pass emulating great directors and editors will teach you multitudes.

Finally, there is the personal work that is full animation tests. Dialog clips for acting shots, physical animation tests, anything that requires a lot of work and can potentially go on your reel falls under this category. Rare is the animator who feels like they get enough of the types of shots they love to do at work, so this is where you can have total freedom to do what you gravitate towards.

Make sure your tests are varied, and not all of the same type. Variety will keep your mind engaged and prevent you from falling into a rut.

Doing personal work will help you grow and develop your own style of workflow and technique. And if you're not working as an animator yet, this is the only way to get there! We're at the point where enough people do animation well that studios aren't impressed by the standard animation tests everyone does in school. To stand out from the reels filled with bouncing balls, a character lifting something heavy, and walk cycles, you need to have a portfolio that shows the same concepts that these tests do, but with things that excite you and show your unique vision as an artist. Keep working, and those little tests and experiments will quickly add up to some serious knowledge and experience.

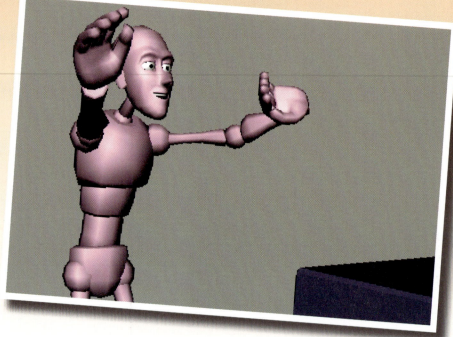

If you've experienced the pain of gimbal lock in the past, put those dark days behind you. We'll not only learn exactly what gimbal lock is, but also how to never let it possess (as in a poltergeist-ey kinda way) your rigs again.

6
Gimbal Lock

EVEN A BRIGHT STAR in the creative universe like animation has its dark nemeses: things that conspire to rob you of your inspiration and turn your artistic endeavor into a hair reduction session. One of the most common technical gremlins an animator has to deal with from time to time is gimbal lock. It's derailed many animations, and it just may have its sights set on yours next...

But so what! You've got this book, and in this chapter all the secrets of gimbal lock and how to combat (and better yet avoid) it lie within. Put the following tools in your shed and leave behind a life of keyframing in fear.

DOI: 10.1016/B978-0-240-81188-8.50006-0

What Is Gimbal Lock?

EVERY ANIMATOR CAN TELL YOU what gimbal lock does to their animations: during playback arms suddenly go crazy, wrists can spin like a top, heads can go exorcist on you. You check your keys and everything appears to be in order. The poses look fine, but between them the animation you knew and loved has become something else entirely. Something... evil? What's going on?

Gimbal lock can happen on anything that can rotate on all three axes: X, Y, and Z. It's not a bug in Maya; it happens in all 3D software, and in real life with things such as robotics. It's a result of mathematical calculations when using Euler (pronounced "oiler") interpolations. We don't need to know what those are, save for the fact that they're why we can use splines and the Graph Editor and why they visually represent what we see in the viewport. Maya has other rotation solutions available that don't gimbal lock (called Quaternion) but that works differently and therefore the Graph Editor no longer makes visual sense in regards to animation. So as animators, we must use Euler rotations if we want to use splines in any capacity whatsoever.

For rotation in the three axes to be mathematically possible with a manipulator, there must be a hierarchical order to them. Anything you can rotate in X, Y, and Z in Maya has a rotation order. It can be set to any combination of the three axes, but it always works the same way. The last axis is the top of the hierarchy:

Rotation Order: XYZ
hierarchy starts with last axis (Z)

You can think of it as X being the child of Y and Y being the child of Z. The last axis will always rotate the other two with it as if they were one piece:

Z axis affects X and Y

Rotating the middle axis will bring the first axis along with it, as if they were a single piece:

Y axis affects X

Rotating the first axis moves only that one:

X axis affects none

If the rotation order were different, say ZXY, it would work the same way starting with the last axis, which is Y. Rotating Y would also affect X and Z, and rotating X would affect Z. Let's see these two rotation orders in Maya.

1 Open WhatIsGimbalLock.ma. There are two cubes. The first has its rotation order set to XYZ, the second to ZXY.

2 We'll go over why in the next cheat, but for now we need to set the rotation mode to Gimbal. Hold down the e key, and then click and hold in the viewport. When the marking menu comes up, drag over to Gimbal and release the buttons.

3 Select the XYZ box and rotate the Z axis. You can see how X and Y come along for the ride.

4 Undo the rotations to 0, and then rotate Y. The Z axis stays put, but X follows along.

What Is Gimbal Lock? (cont'd)

5 Undo to 0 again and now rotate X. Both the Y and Z axes stay put.

6 Undo to 0 and go back to the Y axis. Rotate it 90 degrees and notice that it now lines up with Z. That's gimbal lock. The X axis is gone and the cube can only rotate on two axes now.

f06

9 Between the poses, however, the arms literally flip out. Instead of simply moving into the f11 pose, they flip upward almost over his head, and the left wrist twists into a broken pose.

10 Select the right upper arm control at f11 (make sure you're in Gimbal mode as in step 2) and you'll see that the axis is pretty much locked. When this happens, Maya has to twist the arm all around to work through the lost axis and land at the keyed pose.

7 Whatever the rotation order is, the middle axis is the one that can cause gimbal lock. We can see here that rotating X about 90 degrees on the other cube causes it to lock. Experiment with the rotation of the two boxes until you fully understand how rotation order hierarchy works.

8 To see the effects gimbal lock can cause, open GimbalLockedArms.ma. The arms have only two keys on them, the starting pose and pushing pose.

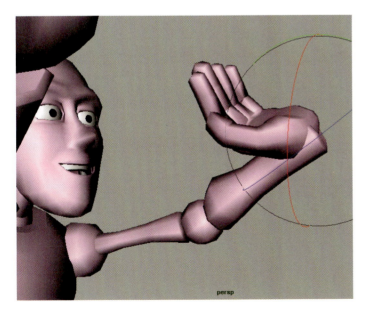

11 It may seem a little strange that setting as few as two keys can cause such ridiculous behavior, but we'll see how this is all based on the rotation order. Next we'll talk about why we changed the rotation mode and why you may have never seen gimbal lock happen on your rotation axes (but have possibly seen the effects of it).

Rotation Modes

W E KNOW NOW WHAT gimbal lock is, but you may have been animating in Maya for awhile now and never seen an axis disappear like in the previous example. It's possible to have experienced the joint flipping gimbal lock causes, yet your rotate manipulator had all three axes readily available. This is because Maya offers several different rotation modes to help make working simpler (visually): Local, World, and Gimbal.

Gimbal mode is the only "real" mode, in that it's showing how the rotations are actually happening. Local and World modes can be thought of as skins for Gimbal mode. They appear to keep all three axes available to make them easier to work with, but underneath the hood they're actually rotating in Gimbal mode. So it can appear to you that you're only rotating one axis, but Maya may be rotating two or all three behind the scenes to give you what you're asking for. And remember that no matter what mode you're in, the graph editor's curves will always show rotation in Gimbal mode.

Local mode rotates all three axes together, so it appears that your rotation always stays lined up. This is the default mode and it's very useful once you understand what it's doing and when it's a good time to use it.

World mode always keeps the axes oriented to world space. It's not usually used for animating unless there is no other easy way to get what you need.

Switching back and forth between the modes can really help with your workflow. This cheat will get you fully up to speed.

1 Open RotationModes.ma. Press **E** for the rotate manipulator. In the upper right corner, press the Tool Settings button to change the channel box to the Tool Settings panel.

2 Under Rotate Settings, select Local.

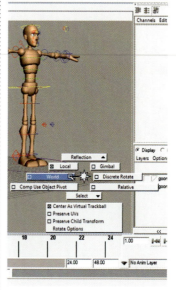

5 To switch rotate modes on the fly, hold down e, click and hold in the viewport, and select the mode you want. Switch to World mode and set the box rotate XYZ attributes to 0.

6 In World mode the axes will never change no matter how you rotate the object. Just like Local mode, Maya is using all three axes underneath to get the results.

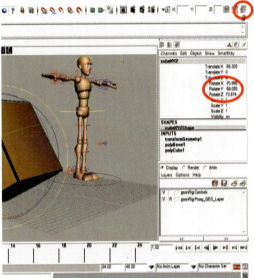

3 Select the XYZ box. Remember from the previous cheat that the middle axis in the order is the one that will lock. Rotate in Y -90 degrees, and you will see that this doesn't happen in Local mode.

4 Press the Channel Box button to switch back to the channel box. Rotate in Z and watch the rotate attributes. Even though we're only moving one axis, Maya is changing all three. Underneath Local mode, Maya is rotating the axes it needs to orient the object how you're really telling it to.

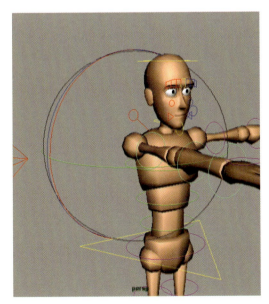

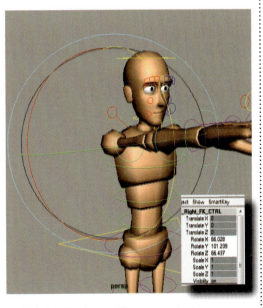

7 Set the Rotate mode to Gimbal. Select the right upper arm on the Goon character and rotate in Y 90 degrees. If we started with a pose where his arms are in front like this, we've already gimbal locked. This is how we can get gimbal lock withe only two poses.

8 Switch to Local mode. Maya is now allowing you to rotate in Z, but is doing a lot of crazy rotations underneath. Notice I've only rotated up in Z a few degrees, but both X and Z in the channel box have moved 66 degrees.

6

Setting Rotation Order

WE NOW UNDERSTAND rotation in Maya, so let's see how to put it to work for us. One of the most effective things you can do to combat gimbal lock is set your rotation orders when you're doing technical preparation for an animation. So the phase where you're deciding IK/FK, how you're setting up constraints, etc. is also the time to think about rotation orders of any three axis control. It's important to do it here because you can't really change it once you've started animating without using scripts or redoing the animation.

Figuring out the rotation order to use really depends on the actions you need to do in the animation. When you're planning and analyzing the movement you're going to animate, you can look at the movement to see which axis is rotated the farthest, which is the least, and base the order you choose off of that.

This cheat will walk you through doing that with our pushing example, but here's how it works: figure out which axis you're going to move the farthest. Usually anything that you need to rotate at least 90 degrees to start with will be something to consider. For this example, let's arbitrarily say it's X.

Then figure out which rotation will move the least. It may seem a little esoteric to think about this, but it will pay dividends later. If you've planned your animation properly, it should be fairly straightforward. Let's say we find that's it's Z.

Remember that the middle axis is what will Gimbal lock, so that's where the least rotated axis should be. The main axis is the last one, so that's where the most rotated will go. To recap this example:

Most rotated = X
Least rotated = Z

We should set our rotation order to **YZX**.

A couple times practicing and it will be second nature. This example is obviously a simple one, but its principles hold true for any animation.

1 Open RotationOrder.ma. This is our familiar push example with the arms zeroed out to default position. Thinking about the poses we need for this animation, the first one has the arms rotated down in Z almost 90 degrees.

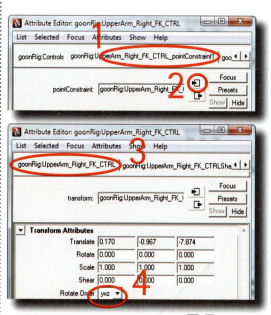

4 Select the upper arm control and press **ctrl** **A** to bring up the attribute editor. Find one of the tabs whose name ends in pointConstraint1 and press the input node button.* For the UpperArm_Right_FK_CTRL tab, find the Rotate Order menu and select YXZ.

2 Set your Rotate manipulator to Gimbal. Testing it out before I key the arms, the second pose has Z still about 90 degrees, and Y will be about 65 degrees. X has not been rotated at all.

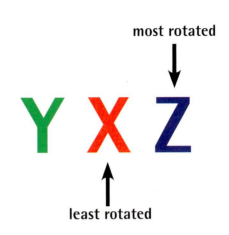

most rotated

Y X Z

least rotated

3 Since Z is our most rotated axis and X is our least, YXZ is a good rotation order for the arms in this animation.

5 When I rotate the arm down almost 90 degrees in Z, we still have all our axes intact.

6 Better yet, when I go to the second pose, I still have all of my axes, and no gimbal lock whatsoever.

*You want to set this order on whatever the control is. Because of how this rig was constructed, we needed this step. For most free rigs, you should be able to simply select the control.

Zeroing Out Poses

ONE OF THE BEST HABITS to really make instances of gimbal lock minimal is zeroing out your poses when blocking. When the rotations keep picking up from the previous ones while posing, the values will accumulate inefficiently over time. If there are quite a few poses, odds are by the end things will have been rotated significantly more than necessary. More rotations = more chances of gimbal lock. This is just due to the visual nature of how animators work. We should be concerned with how things look, not how values are accumulating. Nevertheless, we've seen that this technical side can have a great impact on our work.

When you zero out poses, you simply start every new pose by setting the three axis controllers' Rotate XYZ back to zero. By doing this, you aren't stacking rotations on top of each other, and Maya can interpolate between keys much more efficiently. It might seem like a bit of a hassle if you're not used to it, but after blocking with it a few times, it will become second nature and save you an amazing amount of unnecessary work overall. Sounds like good cheating to me. Best of all, if you don't much care for working in Gimbal mode, you can do this in Local mode and simply work in that the whole time.

If you're a bit skeptical on the impact this trick can have, check out this cheat. We're going to fix gimbal-locked arms completely with it. No setting rotation orders, no Euler filters, nothing except your zero key. Enjoy this classic home remedy for gimbalis lockitis.

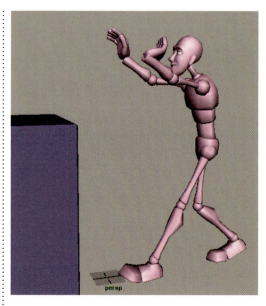

1 Open ZeroingOutPoses.ma and put the rotation manipulator in Local mode. We have our earlier example of gimbal-locked arms and wrist going crazy in the transition.

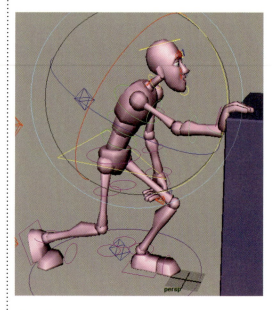

4 At f11 rotate the right upper arm into the pose and set a key. Even though you're in Local mode, always rotate only one axis at a time to maintain efficiency.

2 Go to f11 and select both upper arm controls and the left wrist control. Delete the keys on them by *Shift*-clicking f11 in the timeline so it turns red. Then right click and choose Delete.

3 The arms will drop down into their f01 pose, although the fingers and elbows still have their keys, which is fine since they're not three axis controllers.

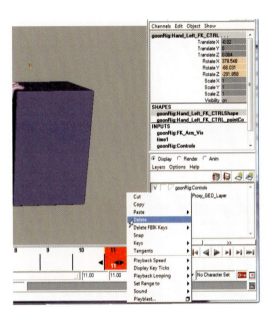

f06

5 Do the same for the left upper arm and wrist. Again, rotate only one axis at a time. Make this a rule in your workflow.

6 Check the transition and notice that the arms now move like we expect them to into the f11 pose. There's no flipping or strange movement. Remember, we didn't change the rotation order. Zeroing out poses is probably the most powerful prevention of gimbal lock!

Gimbal Lock

Euler Filter

MAYA IS EQUIPPED WITH A GREAT TOOL for dealing with gimbal lock called the Euler Filter. While its use is so simple that making a cheat about it is borderline insulting, we can expand upon "choose this option in the Graph Editor" and learn a bit more about what's happening when we animate. And, there will be times where the Euler Filter doesn't work. If it's your first and only line of defense (which the previous cheats have now prevented), you can end up having to deal with a lot of unnecessary frustration.

If you've used any of the other gimbal-preventing techniques we've learned, then the Euler Filter will almost surely work if a control locks up anyway. Without those other methods, there's a distant possibility that it won't do anything. At that point, the usual options are frame-by-framing keys to work through it brute force, or starting over if you're not too far along. As we'll see in this cheat, you can also attempt to manually work the curves out of gimbal lock, provided things aren't too complicated.

This chapter contains quite a few approaches to working through gimbal lock, and doing all of them would definitely be overkill. Truth be told, zeroing out poses and the Euler Filter are probably all you'll ever need to never lock again. But everyone works differently and you may find occasional situations where the other methods are better suited. When we have plenty of tools to choose from, it makes all of our work easier. Live lock-free and prosper!

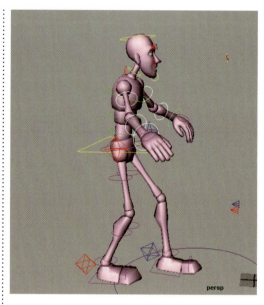

1 Open GimbalLockedArms.ma. Select both upper arm controls and the left wrist control.

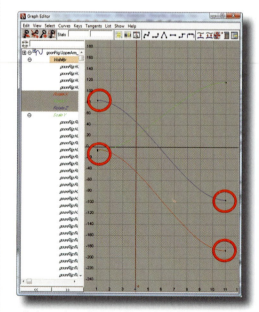

4 Undo to where the arms flip, and select the right upper arm control. Look at the Rotate X and Z curves and see that they're moving to about the opposite values, even though we don't want that in the animation. Gimbal lock often has this 180-degree flipping of values in the curves.

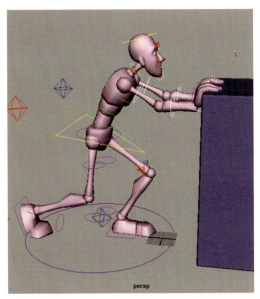

2 Select all of the rotation curves. In the graph editor use Curves > Euler Filter.

3 The curves will be rearranged into a more efficient order and the arms no longer flip.

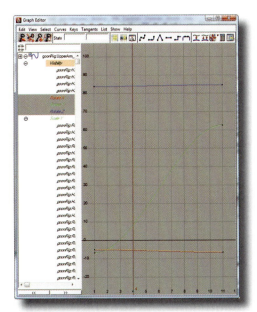

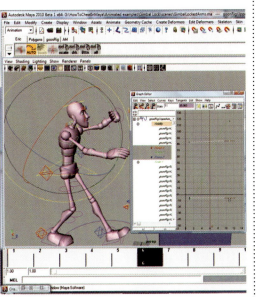

5 Repeat the Euler Filter and notice that it pretty much just eliminated this reversing of values in the curves. Values like 100 and -100 can look identical in position in the viewport, which is why it's hard to notice gimbal lock during stepped blocking.

6 If the Euler Filter doesn't work, search out 180 degree flips and manually drag them (while watching the viewport) to the same value range. If the animation isn't too far along, you can often fix the locking. Practice with this simple example to get the feel for it.

Keeping Perspective

THE JOURNEY OF AN ARTIST is never an easy one. Throughout everyone's career there are high and low points, successes and failures, lessons gifted and lessons learned in the aftermath of a storm. These things are unavoidable, but it's our perspective that can allow us to rise above them or let them chip away at our love of creating until we're that animator who spends every day complaining about making cartoons for a living.

Perspective is everything, because it's the lens through which we interpret our experiences, and on which we base our responses to them. If you're in the early steps your artistic journey, then the perspective you choose will determine how quickly you learn, how soon you find success, and most important, how much you enjoy doing what you're doing. If you've been on this journey for a long time, perspective will create how much you hunger to keep pushing yourself, your graciousness for your success, and most important, how much you enjoy doing what you're doing.

I've been a musician for longer than I've been an animator, but I've found you only need to find one artistic philosophy that works for you, and it will apply to any art form you partake in. Allow me to share some ideas that continue to stick with me in the hopes that maybe a few of them will resonate with you.

"Process Is King"

Nothing changed my outlook more than choosing to enjoy the process of animating rather than focusing on the goal of having a nice shot at the end. If we animate because animating is fun, and not because we want a test everyone will ooh and ahh at, I think the chances of ending up with both increase dramatically. Why animate characters at all if it's not fun to actually do it? If you focus on a list of goals you want, you can end up reducing your art to keeping score and tracking statistics of success versus failure. When I focus on the process of creating, enjoying it, and seeing where it leads me with no expectations, I end up looking back at all the goals I passed without even realizing it.

"Art Is a Triangle"

Understand that there is a triangular relationship with any piece of art. There

is the work, the artist, and the audience. As an artist, you can never have the relationship with your work that the audience does. You know what the idea started as, what was difficult to achieve, what was cut out, what was changed, and every minute detail of the process of creating it. Because of this, your view is somewhat skewed. It may feel like the audience sees the things you do, but they don't. How could they? When you've finished a piece, take feedback, compliments, and criticism; learn from them; and move on. Realize that you will never see your work the way everyone else does. There's no sense in dwelling on what you could have or should have done. Improve your work by carrying these ideas into the next piece, not cringing or rolling your eyes about what's over with. The audience has seen your work and moved on ---shouldn't you do the same?

"Many Animators, but Just One You"

There are a lot of animators these days, and more coming all the time. The competition for work can be intense, and being a skilled computer animator is becoming commonplace, rather than the rare commodity it was even just 10 years ago. There will always be animators who are more skilled than you, no matter how good you are. How do you keep from getting discouraged? By realizing that this isn't a race, and measuring artistic skill is pointless. Your value as an artist comes not from your knowledge of technique, but from being you. No other animator will have your unique experiences, your life, or your knowledge. In your individuality, you have something nobody else can compete with, ever. Focus on becoming the artist that is yourself, with your own ideas and sensibilities, and you will find contentment and success.

"Keep It Real"

You will undoubtedly run into bitter artists from time to time, the ones who complain about everything. They have every right to choose to do this, but that doesn't mean you have to. If you find yourself getting stressed out when working, put things into perspective. Nobody will die based on your animation choices; nobody will get hurt. The fate of millions is not dictated by an acting choice and not nailing your blocking on the first or second try does nothing to disrupt the space-time continuum. If the biggest problem you face during the day is getting a cartoon character to look a certain way, you are most certainly blessed. Even if you're the intern at a studio, remember how many would give their left arm (unless they're lefties...) to be where you are. Happy artists don't get what they want, they want what they have.

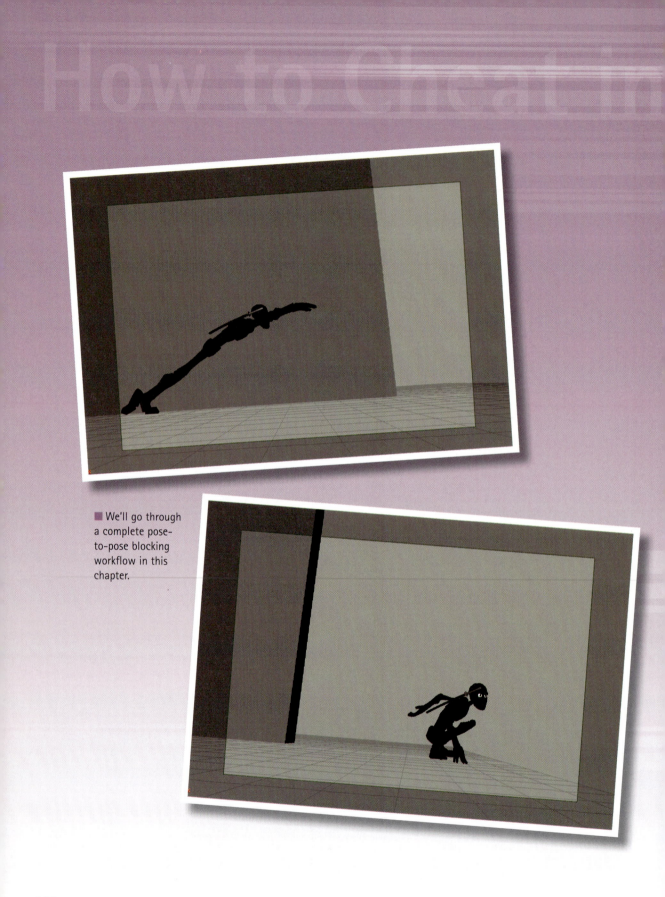

■ We'll go through a complete pose-to-pose blocking workflow in this chapter.

7

Blocking

CREATING THE FOUNDATION of your animation, or
blocking, is arguably the most important phase of
animating. Since almost everything we do is affected
by it, from the performance ideas we incorporate, to the
appropriate technical approach, to the ease of refining
and polishing, it's a great idea to define a solid blocking
workflow. We're going to look at some common, yet very
powerful techniques to make blocking enjoyable and
efficient.

This chapter is based around a short ninja animation, as
the main reason to become an animator is to animate
awesome things like ninjas. We'll go from conception
to splining, all while looking at a myriad of handy
techniques to make your animation kung fu very
powerful. Like, super powerful. Like, Neo fighting off
thousands of Agent Smiths powerful. Hiii-ya!!

DOI: 10.1016/B978-0-240-81188-8.50007-2

Thumbnails and Reference

AH, THE GOOD OLD DAYS. The days we used to have an idea, jump to the computer, start Maya, and animate away! Many hours later, we'd look at our finished work and say, "I thought this was going to look so much better than it does." Sigh, to be young again.

But life moves forward and so must we. In order to do quality work, we must plan what we're going to do. A general idea isn't enough, and some extra planning at the beginning will save you many hours later, fighting to get curves under control in the Graph Editor. There are different approaches to planning, but two of the most common are thumbnailing and reference.

You don't have to be a great traditional artist (and I'm certainly not) to do effective thumbnails. Anyone can draw basic shapes and lines, and that's all you need. Think about the line of action in each pose and sketch it out. Experiment and try different things until you get something you like.

The second part is reference. Every great artist studies what his or her work is about. Video reference and motion studies are invaluable. Whether you film it yourself or find it online, study the movement of what you're going to do until you understand it thoroughly.

Everyone has a preference for detail, so feel free to add more in your planning if it helps you.

1 I want to do a short, physical animation test of a ninja where he enters in a cool way, and then does some acrobatics. To motivate the movement, I decided to have him attacked by an off-screen foe who throws some shuriken at him, and he must avoid it.

For inspiration, I looked at ninja artwork on the Internet, and Spiderman comic books to study the poses of an agile, nimble character.

Good websites for inspiration include deviantart.com and cgtalk.com, as well as blogs by artists and animators. Watch movies, television shows, read comic books, listen to music, anything to get ideas and visualize.

2 I broke down the animation into four parts:

1. Lands into camera in cool pose, looks around suspiciously.

2. Sees off-screen attack coming (does a take to anticipate)

3. Jumps out of the way doing a hand-spring.

4. Ends in a different cool pose

Having a list or outline helps clarify what you're going to do, and picture each moment in your mind. I also use it to make sure I have a reason for the actions, which makes for a better animation test. If the ninja just did the flips for no reason, it would be confusing to the viewer. Yet I wanted to keep it as simple as possible. Having him notice an offscreen threat creates an anticipation so the viewer knows something is about to happen.

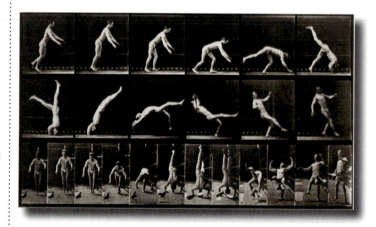

5 Reference like the photography of Eadweard Muybridge is required material for any animator's library. Since most of his work is in the public domain now, you can also find a lot of it online. I also studied his handspring breakdown.

3 For the physical movement, particularly the hand spring, I searched YouTube and found tons of gymnastics and breakdancing videos with that movement. There were also plenty of step-by-step tutorials on hand springs, which is invaluable to understanding how to animate it.

4 If you want to frame through the video to study it (always a great idea), there are some great free options available. You can download a video from YouTube or other streaming video sites using www.keepvid.com. Then convert the .flv file into Quicktime format using Quick Media Converter, a fantastic free program from cocoonsoftware.com, and frame-by-frame away.

The BBC Motion Gallery (www.bbcmotiongallery.com) is also an excellent reference source, as you can download free Quicktime movies of any footage they have available. They're particularly good for animal reference.

HOT TIP

The best advice for planning I ever got (besides DO IT!) was to be able to see the entire animation in my mind before setting a single key. It's a great way to have a solid understanding of what you want to do, and helps avoid the "I'll figure it out later" trap we can fall into.

enter frame

reverse legs

take

hand poses

6 Finally, I sketched out the progression of the animation, focusing on the main poses and lines of action. I also made some notes to myself where needed. Your planning doesn't need to make sense to anyone but you, so do whatever it takes to create a clear picture of what you're going to do.

Setting up the Scene

WITH A CLEAR IDEA of what we're going to animate, let's get our scene ready. This is the part of the process where I map out how I'm going to approach any technical aspects, such as constraints, animated cameras, using IK or FK, etc. I also create the shot camera, reference the character rigs, get their settings in order, put the props in place, and set up the environment.

This is also the time where I decide my approach to blocking. We're going to be doing a stepped keys pose-to-pose blocking of the main poses, then add breakdowns, then convert the keys into spline mode, and refine from there. It's a very common and effective method, but it's not the only way to block. There are cases where stepped keys make things less clear. Short, continuous actions that are part of a group of shots and not started or ended in the current shot are a good example of where I would block with splined keys. It's easier to ensure the timing works between all the shots if I'm not looking at it in stepped mode. Every shot is different and it's a mix of preference, experience, and what's the most clear in how you approach blocking.

1 Open ninjaBlocking_START.ma. The back wall and three shuriken are already created for you. Go to File > Create Reference and select the goonNinja_rig to reference the character into the scene.

2 Since his hands need to be planted on the ground, I'll use IK arms and I won't worry about switching to FK since they're rarely off the ground. Select each hand control and set IK Weight to 1 in the channel box.

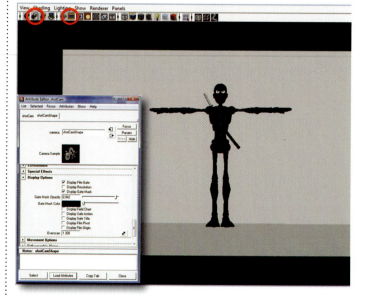

5 I also like to turn on a gate to see exactly what the framing is when rendered by pressing the viewport button (second one indicated). You can adjust the gate's color and opacity to taste in the Display Options tab by pressing the Camera Attributes button (first indicated).

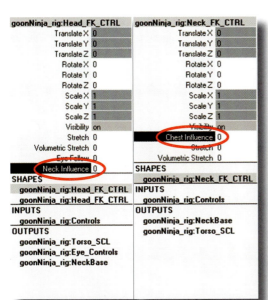

3 I prefer to almost always use the head in world space so I'll also set Neck Influence on the head to 0 and Chest Influence on the neck control to 0 also. These settings keep the head independent so it doesn't rotate with the body.

4 Go to Create > Camera and name the new camera shotCam. Position it angled slightly up with the ninja in the center. We'll no doubt have to adjust it later, as well as animate it, but just get it roughed in for now.

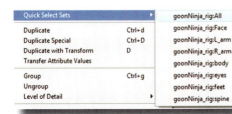

6 There are quick select sets with the ninja rig, and here's a quick way to add them (or any menu command) to the shelf. First hold down **ctrl** **alt** **Shift**. Then go to Edit > Quick Select Sets > the set you want. A shelf button will automatically be created for whatever you choose.

7 Set the timeline to start at 101 and end at 200 (for now). This is common practice in production so no frame number starts with 0, which can potentially confuse the computer's ordering of frames when rendering and compositing.

Key Poses 1

NOW THAT WE'RE ALL SET UP (finally!) we're ready to create the framework of our animation with the key poses. We'll start with the storytelling poses, or golden poses as they're sometimes called, and add more detail from there.

It might help to think of storytelling poses as what you would need if you were doing a comic strip with only two or three panels. Reduce the idea down to where you could convey the fundamental events in your animation with only two or three poses. That's a good rule of thumb to what the storytelling poses are. My thumbnails were pretty basic, but I could communicate the animation's events with these:

I even left out the last pose, as it's not essential to understanding the fundamental actions: he lands; then he jumps away. It's a matter of preference, but the point is to distill the animation to its most basic level.

I'm also going to put these poses on consecutive frames and not worry about timing when they happen yet. This keeps me from being distracted by any timing issues and helps me focus on the poses themselves and making them read as clearly as possible. Let's start animating!

02_keyposes.ma is the reference file for this cheat.

1 In the animation preferences, set the Default out tangent type to Stepped. Then shrink the timeline range down to 101-107 to make for easy scrubbing through the poses.

4 While it's true we animate to camera and the pose only has to look good there, you don't want to cheat things if you don't absolutely have to. In the perspective view, I make sure the pose looks as natural as possible to prevent problems later.

7 It looks weird for a moment, but now the foot lands exactly where it was headed in the previous pose, and I can move the body and other foot in relation to it.

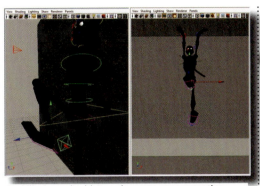

2 Select all the controls using the Quick Select Set, and set a key at frame 101. Using the thumbnail as a guide, I pose the ninja above the ground in his descending pose. I adjusted the gate opacity so you could see outside the frame.

3 I like to work with two viewports, one perspective and the shotCam. I select controls and position in the perspective window while always making sure the pose looks good in the shotCam.

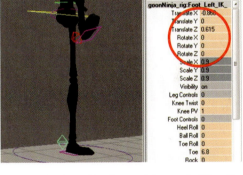

5 Select all controls and set a key on f102. Setting the key on everything first lets AutoKey do the work of updating the key's data as you adjust the manipulators, and lets you concentrate on posing.

6 Using the channel box is a good shortcut for things like putting the feet on the ground. Instead of moving it back manually, select the left foot and in the channel box enter 0 for Translate Y and Rotate XYZ. The foot will move to the ground.

8 The second pose isn't exactly like my thumbnails. There are times the rig and/or character design won't work with the poses exactly the way you planned. Putting his foot more underneath made him feel more dynamic from the diagonal line from his right toe to left knee.

9 Select all controls and set a key at f103.

149

Key Poses 1 (cont'd)

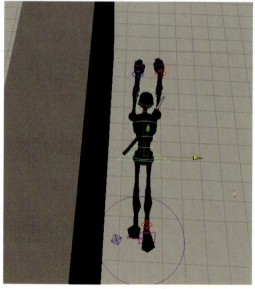

10 Since he must push off from his left foot for the leap to be physically possible, keep that in place and pose the body and arms based on its position.

11 To rotate the planted left foot, use the Pivot attribute instead of the Rotate Y on the left foot to make it a smooth transition. This rotates his foot from the ball instead of the ankle.

13 It's especially important to watch the perspective view for poses that are profiled, like pose three. It can look fine in the shotCam but be way off at other angles.

14 Poses being off like this have the potential to cause extra work and headaches once you switch the curves to Spline mode, so fix inaccuracies as you find them. Many technical problems in animation are cumulative, meaning they rear their ugly head long after they appeared.

12 Get the third pose blocked in, keeping the line of action his body makes strong and dynamic. This character doesn't have controls to add a bend through his legs, so just get it as close as possible to an arc.

15 With the last storytelling pose in, you can see we're running out of room quickly. In the next cheat, we'll continue adding key poses and also block in the camera panning along with his handspring. While camera movements are usually planned beforehand, this will offer us an opportunity to experiment with the staging and make the animation even more dynamic.

Key Poses 2

f102

1 We're going to need to make camera adjustments, so press the Select Camera button. Go to f102 and press **S** to set a key on the camera. This will lock it in position up until this frame.

THE STORYTELLING POSES ARE DONE, so now let's add the next pass of key poses. We'll do four more poses: the hands planting in the hand-spring, the flip, landing, and the end pose. These describe the parts of the animation where the movement changes. Once he does his leap (the third pose from the previous cheat), he's going to continue that movement until something changes the momentum, which is landing on his hands. The motion that happens next is his feet leading his body in the second jump. He'll continue through that jump until he lands, at the last pose.

f104

4 Use the **Shift** **alt** MM drag to continue the camera pan with this pose, and set a key on the camera.

Working in passes, which means starting as broad as possible and adding detail each time through subsequently, is a good approach to computer animation. It makes it easy to refine things as you work, and making changes is simpler because you're not bogged down in detail. We'll also block some camera positioning, since it became clear we need to track the camera with the character as he does his acrobatics.

f106

7 For the next pose at f106, I'll do the camera pan first to give myself some room. Use the same method as in previous steps.

f103

f104

2 With the camera still selected, go to f103. For now let's just pan with each successive pose; we'll refine later. Hold `alt` `Shift` and MM drag to constrain the camera movement sideways. Pan right and set a key on the camera.

3 Go to f104 and key all the character controls. Block in the next pose, keeping in mind the arc his body is going to continue from the previous frame. Position the main body control, get it lined up along the arc, and then do the rest of the body.

f105

f105

5 Go to f105, key all controls, and block the next pose. From the reference, we can see that the body does almost a mirror image flip, so keep that in mind when you line up the body with the previous pose.

6 Using the same `Shift` `alt` MM drag method as before, continue the camera pan, and set a key on it.

HOT TIP

Don't block each pose in a vacuum. Use the `<` `>` hotkeys to keep flipping between the previous pose to compare. Look at the line of action, and make sure the body is transitioning smoothly. You can also hold down `K` and drag in the viewport to scrub without moving to the timeline.

f106

f107

8 Key all controls, then block in the landing pose, flipping back and forth to the previous pose to ensure they are making an arced path of action.

9 Go to f107, key all, and do the final pose. Keep the left foot in the same location as f106. Remember that zeroing out your rotations can help make posing easier and cleaner. Flip through the frames, and you'll have a smooth sequence of poses. Feel free to refine them as you see fit.

Rough Timing

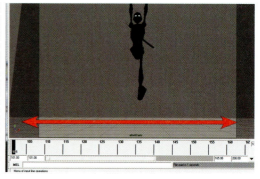

1 First we need to give our timeline some more room to work in. Expand the time slider to f165.

O UR KEY POSES ARE SET, so let's create the rough timing of when they happen. These will likely be adjusted when we add more poses, so for now we just want to get everything in the ballpark. Since we blocked our key poses in sequentially, we can now focus solely on timing. This approach helps us make each individual element of the animation as strong as possible. This is the main advantage of animating with a computer: the ability to separate and focus on specific things. Use it to your advantage!

We'll use the Dope Sheet editor for quickly moving around all of the keys in our scene, including the camera's keys, without having to select any controls, . The Dope Sheet does a few other things, but its main function is managing large amounts of keys quickly and easily (two words you should never tire of hearing).

03_roughTiming.ma is the reference file for this cheat.

4 Starting at f101, there are blocks indicating keys present. In the scene summary row, if there is a key on anything in the scene file on a frame, a block is present. This saves having to select anything since we blocked all our controls and camera on each frame.

7 In the Dope Sheet, select the keys from f107 on, and with the Move tool **W**, MM drag them over 3 frames to give some space between the descending and landing poses.

2 Go to Window > Animation Editors > Dope Sheet to open the editor. Currently it only displays keys when something is selected, so let's change that.

3 In the Dope Sheet's View menu, click on Scene Summary to turn it on.

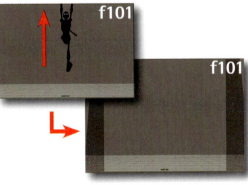

5 Press **W** for the Move tool and marquee select all of the keys. MM drag them over to f106. This will give us time at the beginning to drop down from off-screen.

6 Let's do a pose with him off-screen to better gauge the timing. At f101, key all controls. Select the body, IK arms, feet, and knee PV controls, and move him up out of frame.

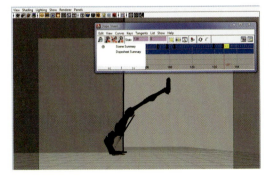

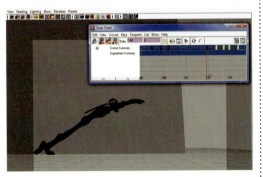

8 Continue adjusting the timing to get a rough flow between the poses. Keep playblasting the animation and flipping through the poses to get something that feels good to you.

9 I placed them sequentially on f101, 106, 110, 131, 136, 140, 143, and 147 for now. Things will still feel a bit choppy because of the camera still being on step keys, so in the next cheat we'll get it moving smoothly.

Camera Animation

BEFORE WE GO ANY FURTHER, we need to get the camera in a good place to finish the blocking process. A stepped key camera works for storytelling poses, but to refine things any more, it needs to be smooth. We'll keep things simple by only keeping two positions for the camera and simply following the character's actions to keep him in frame. At the end, we'll add a few extra frames to the camera's movement so it doesn't stop exactly with the character, giving the feel of a cameraman following an actor (or stuntman!).

04_cameraAnimation.ma is the reference file.

1 In the shotCam's viewport, click the Select Camera button to select it.

4 Once the camera starts moving, it should go at a fairly constant rate, so we really only need the starting and ending keys of the movement. Select all keys between f128 and f148 and delete them.

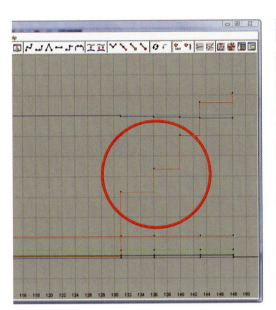

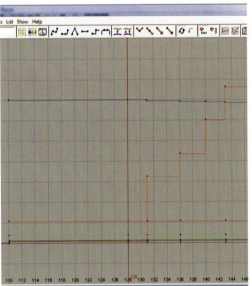

2 In the graph editor you can see the camera's keys. Notice how they're a bit uneven in the Translate X, which even when splined will make for jerky movement.

3 We want the camera to hold position until he starts jumping away. Move to f128, 3 frames before the jumping away pose, and set a key.

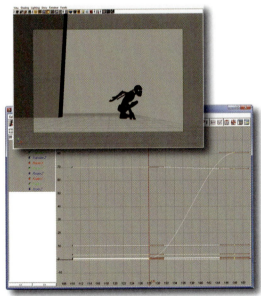

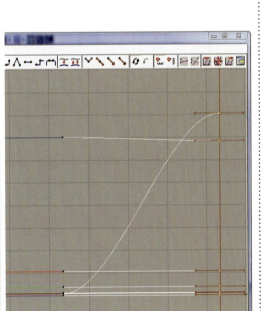

5 Select all the curves and press the flat tangents button to make a smooth transition between positions. Play the animation and you'll see the movement is much nicer through the flips, but it still stops abruptly with the last pose at f148.

6 Select the camera's keys at f148 and drag them over 4 frames to f152. Now there's a slight lag behind the character, which feels better. In the final polishing of this animation, we'd most likely tweak the timing a bit more, but now the camera will work great with the next blocking step: adding breakdowns.

TweenMachine

W E'RE GOING TO CREATE BREAKDOWN POSES to add more detail and clarity to our animation. Breakdowns are the poses that happen between the key poses. They show how we get from one key to another, as well as define anticipations, overlap, arcs, and the other animation principles. There aren't any rules for how many breakdowns need to be added: some keys will have one breakdown between them, others more. Time and experience will give you the knowledge to know what's right for you.

But first let's look at a tool that makes doing breakdown poses super efficient. It's called TweenMachine, created by animator Justin Barrett, and included on the DVD as well as freely available on his website www.justinanimator.com. It's a fantastic tool used in many animation studios. This cheat will give the basics on how TweenMachine works, and then we'll put it to good use as we create the breakdown poses for our ninja animation.

TweenMachine lets you set the position of selected controls relative to the keys on each side by simply using a slider or buttons, instead of manually positioning it. Generally speaking, Maya's curves will always lean towards making things in motion feel even, as that is what computers are good at. To fix this, we tend to have breakdowns favor either the pose before or after to create ease outs and ease ins. In other words, it's safe to say that in many cases, a breakdown pose in the middle of two keys will be closer in position to one of them, rather than perfectly between. TweenMachine lets you quickly experiment with different amounts with your entire character, or just parts of them, rather than doing all the positioning yourself or by copying positions from other frames.

If you need some tips on installing scripts for Maya, be sure to check out the Workflow Foundations chapter, where installing this script is explained step-by-step.

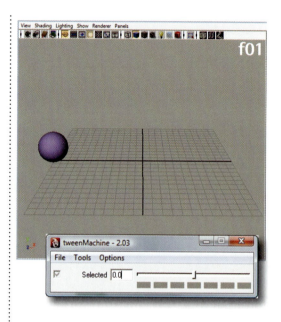

1 Open tweenMachine.ma and go to the shotCam. We have a sphere traveling from one end of the grid to the other evenly. Run the tweenMachine script (see included readme) to bring up the interface.

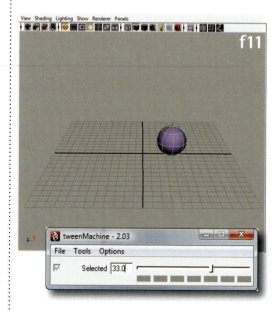

4 Now press the fifth button and the sphere will jump closer to the end position by 33%. Each side of the 0 will favor the closer keys by increasing amounts. Play the animation and the ball will slow down as it gets to the end, as the middle point is already closer to that side.

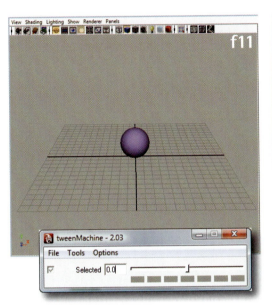

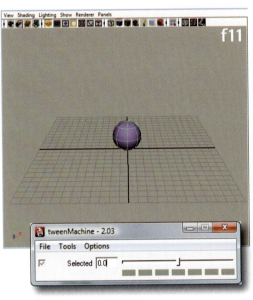

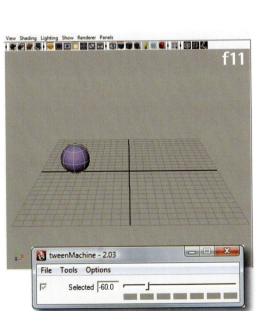

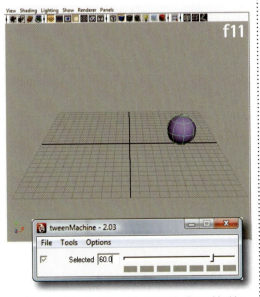

2 At f11, we can see that the sphere is perfectly in the middle of the two key poses at frames 1 and 21.

3 Select the ball and click the fouth button in tweenMachine. You should see *absolutely nothing* happen. This is because the middle button is 0, or perfectly between the two keys, which the ball already is.

HOT TIP

If you enable the Overshoot option in TweenMachine's options, you can adjust the slider to 150% in either direction. This allows you to set breakdowns either before or past the keyframe positions, which is very handy for doing overshoots. We'll look at overshoots more as we refine the ninja animation.

5 Experiment with different amounts at f11 to get a feel for the favoring percentages. Here we're at -60, or favoring the previous frame by 60%. You can also use the slider if you like or type in amounts in the field. Play the animation each time to see how the favoring affects the timing.

6 There's a lot of additional functionality TweenMachine has, but this is the essence of how it works. On a full character, the speed of getting the breakdowns to their general position and tweaking them makes working very efficient. We'll see this in action in the next cheat as we employ TweenMachine with our ninja animation.

159

Breakdown Poses

1 As a warmup, let's add a breakdown between f101 and 106, as it currently looks like he's just appearing out of thin air. Select all controls and set a key at f104. Then start TweenMachine.

WITH THE TRUSTY TWEENMACHINE by our side and the camera locked down, we can shape our animation to communicate the timing and movement much more accurately. I'm going to use a simple workflow that is efficient and still leaves room for experimentation. At each frame that needs a breakdown, we'll set a key on all the controls. Then TweenMachine will help us quickly get the character in the general position we want at that frame. Finally, we'll tweak the individual body parts to get the pose looking good. By the end of the breakdown phase, it should be pretty clear what this animation will look like when it's finished.

05_breakdowns.ma is the reference file for this cheat.

4 Scrubbing through, we now have a huge spacing gap between f104 and f106, and a small one between f106 and f108. This will make him appear to slow down before he hits the ground, so let's make his fall more constant.

7 Continue adjusting this pose, thinking about the hands dragging, and a clean path of action through the hips, spine, and head into the next pose. Keep flipping and comparing, focusing on one body section at a time. The right leg stays in because it will swing out later.

2 With all controls still selected, click the middle button in TweenMachine (0.0). The ninja will move to halfway between the two poses.

2 With all controls still selected, click the middle button in TweenMachine (0.0). The ninja will move to halfway between the two poses.

3 Go to f108, and set a key on all controls. We need a contact pose of the foot touching the ground. Because the pose is still the same and not changing, I'll just select the body, arms, knees, and feet, and move them down, rather than use TweenMachine.

5 At f106, with the body, arms, knees, and feet selected, press the 0.0 button on TweenMachine to make the spacing even. Animating is a constant back and forth, so it's necessary to alter the key pose in this situation to make the motion work.

6 Key all at f109. I selected the body and used TweenMachine at 0 to position halfway again. Then I used it at 100 on the left foot to lock it down where it landed. I then adjusted the ball roll to 0 so the heel comes up in the next pose. Bring down the right leg and arms also.

8 Be sure to check the pose in the perspective view to make sure nothing strange is happening that can't be seen in the shotCam angle.

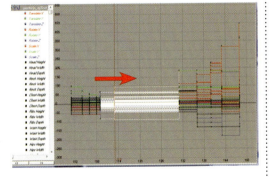

9 We'll need some more breakdowns here, so select the keys at f110 and move them to f113 however you prefer. I used the Graph Editor, but you can also use the Dope Sheet or timeline.

HOT TIP

Remember that you can use TweenMachine on individual and groups of controls. You'll need different amounts of travel depending on the action and things like drag and follow-through. It also has capabilities for putting controls and groups right in the interface for working quickly, so check out the tool's readme!

161

Breakdown Poses (cont'd)

10 There are times where it's easier to do a later breakdown first. Let's do the overshoot of his body when he lands before we do f110. Select all, go to f113, and MM drag in the timeline to f111 and set a key.

11 Work backwards from the landed pose, thinking about the compression in the body happening as he hits the ground. I lowered the body, compressed the spine/head in Rotate X, and lowered the right arm. You can rotate the hips in Z to counter the knee moving when you adjust the body.

14 At f110, the body, spine, head, and arms are dragging, creating an arced path into the next pose. The R leg is easing out to the extended position. Dragging the R foot in an exaggerated way helps the expanding feel as well.

15 I'll do the take when he sees the offscreen attack coming next. This is really a key pose, but I'm doing it in this phase since it's so close to the landing pose. Again, it's a matter of preference. Go to f122 and key all.

18 At f119, I did an anticipation into the take pose. A slight body and shoulder compression, with the brows scrunching and the eyes narrowing, works well to set up his surprise.

19 At f127, key all and add a small anticipation moving down in the body right before he starts to jump away.

f111

12 The right leg is in the middle of pushing out into the last pose, and the left arm is compressing into the ground to balance. Scrub through and his weight should feel much better when he lands.

f110

13 Go to f110, select all, and set a key. Use TweenMachine to interpolate the pose at 33% to get a starting point.

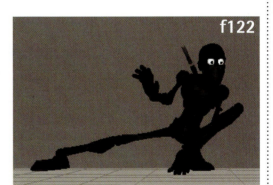

f122

16 For the face, I pulled up the brows and pulled down the cheeks to widen the eyes. This will help his surprise read more clearly. I also rotated the jaw down to give more of a change in the face shape since the face has limited detail.

17 His head comes up for the take, along with the right arm. The fingers expand a bit, and his body opens up as well. Bring the shoulders up and make the left hand adjust on the ground slightly so it doesn't have that IK stuck-to-the-ground feeling.

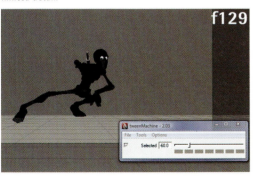

f129

20 Go to f129 and key all. Run TweenMachine at -60 to start off the pose.

f129

21 Adjust the body to have a good path of action into the next pose. The chest and head are still turning while the arms drag. The left heel is pushed down from his body weight, and the right foot is lifting off.

HOT TIP

When doing breakdown poses with TweenMachine, don't get stuck going in a linear order. If another pose is closer to what the breakdown is than the current one, copy it and work from there.

Breakdown Poses (cont'd 2)

22 The next breakdown I'll do is at f134. So we can feel his weight as he lands at f136, this breakdown will be him arcing through the air. Key all and TweenMachine 100% to copy the following pose.

23 The pose needs to be manually positioned from this point. Since this rig doesn't have bends to put in the legs, just get the body arc as nice as you can. The three jumping poses should make a nice shape throughout.

26 At f139 I'll put a continuation of the crunch, pushing the body down a bit more. The feet continue through to lead into the next foot forward pose.

27 For f142 I'll do another pose that's the same idea as f134. His body will "trace" along the arc of the leap. I found it easier to start with f143's pose.

30 Adjust the pose so the spine continues through the arc of the motion. Make sure the spacing in the body control is in the middle of the surrounding frames. This will make it feel like he's dropping, and not slowing into the landing.

31 Select all and set a key at f150 to duplicate the pose at f147. At f147, compress the body and the planting hand as his momentum carries through.

24 Let's do a body compressing pose at f138 to give him some better weight. I keyed all and ran TweenMachine at 33%.

25 Get a nice crunch in the body and separate the feet. Since this is an FK spine, rotate the spine into the shape you want first, and then reposition with the body control to put it in the right spot.

28 With the breakdown in place, the key pose at f144 needs adjusting. It doesn't make sense now for his R foot to travel upward, so adjust it down without making the feet too even.

29 At f145 we'll add another breakdown into the landing. Key all and set TweenMachine at 33%. The head may interpolate strangely depending on your rotations, so just fix it manually.

HOT TIP

Don't let anything remain in stone. If you need to go back and change your key poses, timings, etc. when you add breakdowns, do it! The end result is what matters, rather than sticking to the original plan at all costs.

32 Make another pass through the animation and refine the breakdowns. Make the lines of action as nice as possible and adjust timings if necessary. We're almost done blocking!

Adding the Shuriken

1 In the perspective view are three shuriken positioned out of the shotcam's view. Select one and set a key at f123.

WHILE BEING ABLE TO WRITE a section entitled "Adding the Shuriken" is justification alone for doing this entire book, it is nonetheless an important part of our animation. After all, the ninja must have some motivation for jumping that's clear to the viewer. We'll block in the basic choreography of the throwing stars narrowly missing his evasive jumps.

Things like this are often better to do once the character is blocked in, which is why we've waited until then. Three simple objects are much easier to manage than an entire character. As long as their action is readable, they can go pretty much anywhere and work, unlike the ninja.

4 To make it easier to position the star from an angle, you can hold down **W** and then hold down the left mouse button in the viewport. In the marking menu that pops up, select Object. Now the Move tool is based on the object's position, rather than the world.

f129

2 At f129 position the shuriken in the wall somewhere close to where his head just was. I also angled it to the side a little so it reads better as a star.

3 In the graph editor, select the curves for the star and change them to linear splines. The star will now move to the target in a straight line.

HOT TIP

To get the Move tool back to World mode, just repeat holding down **W** and the LMB in the viewport, and select World.

f133

f130

5 I positioned the other two stars at f132 and f133. Change their curves to linear and adjust their paths and timing as you see fit.

6 You can add spin on the stars if you like, but I usually save details like this for polishing. It's a good approach to only do what is necessary in the blocking process.

Refining the Timing

W E'RE AT A GREAT SPOT to do another pass on the timing and tighten everything up a bit. Timing can be subjective and very dependent on the poses you came up with, so I'll show you what I ended up with. Feel free to make the animation your own if you're inclined.

Before shifting around lots of keys, I usually go through and make sure I've keyed everything on each frame with a pose as a precaution. It's easy to miss a few controls here and there and have the knees go crazy if you forgot a pole vector control or something. So I make sure every control is selected and quickly go through resetting keys on everything using hotkeys.

1 Double check all controls are selected. Then use the ▶ hotkey to step through each keyframe and press **S** to set a key.

f106

f108

f111

f113

2 Once this is done, make another pass on the timing, shifting keys around whichever way you prefer. I used the timeline, but the Dope Sheet and Graph Editor work just as well. See the techniques chapter for more on using the timeline.

f109

f110

f119

f122

Refining the Timing (cont'd)

f128

f129

f134

f136

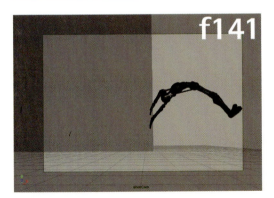

f141

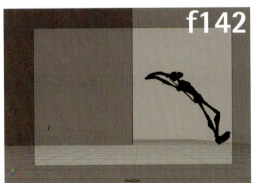

f142

f149

HOT TIP

A good guideline for the number of poses to have before splining is at least one in every four frames. This keeps Maya from needing to do too much inbetweening and looking floaty.

171

Copied Pairs

WITH OUR BLOCKING NEARLY COMPLETE, we are almost ready to spline the animation to begin refining it. Before we do that, however, we're going to use a very powerful technique called "copied pairs." By copying held poses over several frames, we can keep better control over the in-betweens when we convert from stepped keys.

Normally when we spline, Maya figures out the transitions into a pose, and then immediately starts transitioning to the next pose on the next frame.

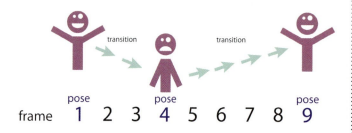

Copied pairs is simply rekeying a pose that you want to hold several frames later. Since it's the same pose, there won't be any in-betweens, because it's already there.

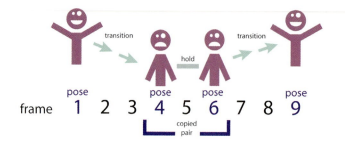

This works well for spots like the pose where the ninja lands. We want him to hold that pose for a bit, not immediately start moving into the anticipation pose. Once we've splined, we can add some subtle animation on these holds to keep the character alive (moving holds, overlap, eye darts, etc.).

A simple concept, but extremely powerful. Perfect for cheating!

1 The first pose we need to hold is the landed pose at f113. Select all and set a key at f117 to duplicate the pose and hold through that frame.

4 Select all the curves in the graph editor and spline them by pressing the Plateau Tangents button.

f125

2 Next I want a hold on his surprise pose at f122 so it can read clearly. Go to f125 and set a key on all.

3 The rest of the animation is continuous actions, so we don't need any holds on those. Next, select all controls.

5 The animation is in good shape to start refining, but let's fix a spacing issue right away. Because his starting frame is at 101, it makes the drop uneven. At f101, MM drag in the timeline to f105 and key all. This is how we can create a copied pair in splined mode.

6 Congratulations! We've taken an idea from conception through blocking and now are ready to refine and finish it. The idea for the animation reads clearly and gives us a solid foundation on which to continue working. Enjoy!

Making a Short Film

ANIMATION TESTS CAN TEACH YOU A LOT about animating, but they often come up a bit short on the side of filmmaking. There's nothing wrong with that, but tests have their purpose and place, and they can only go so far in terms of thinking of the bigger picture. If you want to work as an animator in feature film (and games too; there are plenty of cinematics in them these days), there is probably nothing that prepares you better than creating your own short film.

Making a short film, by yourself or with others, is a tremendous undertaking. It's one that will test all of your animation skills, and demand others that you didn't know you needed. The spectrum of what you do throughout the process is great, and you will find it trying at times, but the rewards are most certainly worth it. You will have something that is uniquely yours, that people can watch and be entertained by, and which you can use to illustrate your understanding of the filmmaking process.

Why do a short instead of more tests? Because it will require you to think of the broad picture: from story, to shot composition and flow, to animation, to sound and music, and more. Doing tests exclusively can box you into a mindset that can be difficult to break out of. Cycles, as valuable as they can be for body mechanics, will not force you to think of the shots before and after your animation and how it connects within them. Lip sync tests are difficult to create situations where your acting choices need to be truly dependent on an established context. They're too short, and you can make up any justifications you want for a why characters are acting the way they are in a 10-second clip. Presenting a story clearly, so anyone can watch it and understand it, is a tremendous challenge and one that will strengthen your animation in ways that technique simply can't.

Of course, there can be widely varying connotations of what constitutes a short film, and everyone is at different levels of skill. Knowledge of other disciplines, such as rigging, texturing, lighting, etc. may or may not be realistic at this point. Some people are able to do many of these things well enough to make a finished product; many others are not. So let me clarify by saying that you don't need to do anything well besides animation to make a short film that can entertain and teach you volumes about filmmaking.

Use the skills you have to make something that has a little story (intro, conflict, and resolution), multiple shots, and character acting, and you'll get the benefits the short film endeavor has to offer. "Short film" may conjure up visions of elaborate sets, particle effects, and beautifully textured characters, but those are not necessary for the experience to benefit you greatly as an artist.

You can challenge yourself to make your tests into mini short films. You want to work on your physical animation by doing a heavy lift test? Come up with a simple story of why this character needs to lift it and give it an interesting twist. Create storyboards, experiment with using different shots to tell the story and communicate the weight, and animate it. It can be 15, 20, 30 seconds max, and at the end of it you will have grown tremendously.

Of course, you must actually finish a short for it to give you a higher understanding. Make it something you will really enjoy doing and that you will finish. A 20-second ditty that's entertaining is 1000 times better than the quarter-finished epic sitting on your hard drive. Make a schedule and stick to it! I promise that things will look different on the other side.

It's easy to forget that the true reason to be an animator is to tell stories and entertain. Everything we do should be in service of that. The best animators I've seen and worked with have all had a thorough understanding of story, character arcs and development, and a love for filmmaking that shined through their animation.

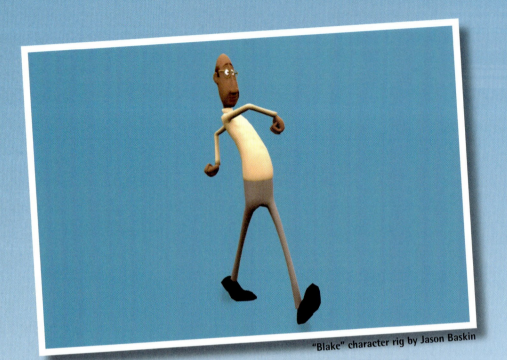

"Blake" character rig by Jason Baskin

■ Walks can embody every element of animation: physicality, attitude and emotion, appeal, and more. We're going step by step (ahem) to create a solid walk technique that you can continue to build upon.

8

Walk Cycles

CREATING A WALK CYCLE is a fundamental skill for every animator. Whatever the medium--- film, video games, TV, etc.--- all depend on cycles in a variety of ways. Having a solid technique for creating a walk cycle will pay dividends time and time again, so we're spending this chapter looking at how to create them with minimal fuss. We'll also see how to easily fix some common issues that crop up, like knee popping and foot slipping.

I've always found walks to be a constant negotiation, because almost every part affects all the others. As you work through this chapter, keep in mind that you'll be going back to revise and tweak your work throughout the animating process. The files for this chapter are a general guide, but not a perfectly sequential progression, because that's not how animation works! Now step to it!

DOI: 10.1016/B978-0-240-81188-8.50008-4

Blocking the Core Positions

EVERY WALK has four core positions that create its foundation: contact, down, passing, and up. The first step is getting these positions keyed in the root, hips, and feet controls, and we can continue to build from there. Cycles are typically created in a layered style, where specific body parts are done before others. We'll be doing our initial work in stepped keys, although some animators prefer using linear or some other spline type from the start. This cycle will be an in-place one, where the character does not move forward in space, but rather walks as if he is on a treadmill. Towards the end of the chapter, we'll learn how to make him move forward in world space using the master control.

We're going to use AutoKey in our workflow. We'll set a pose on all controls on all the frames we need for blocking. Then AutoKey will automatically update them any time we make an adjustment to a pose, and we don't have to press **S** every single time to set new keys. This saves tons of time and hundreds of keystrokes!

01_CorePositions.mb is the reference file for this cheat. The screengrabs have the right leg colored blue in the interest of clarity.

1 Open the Goon character and give yourself a 25-frame span in the timeline. This is a regular walk, so it will be 24 frames long with a pose set every 3 frames. We add an extra frame at the end to copy the first pose to so it will loop properly. Take both knee pole vectors and pull them out in front of the rig. This will prevent the knees from flipping.

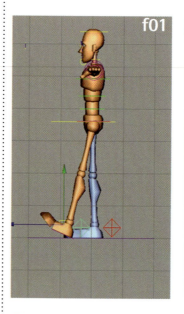

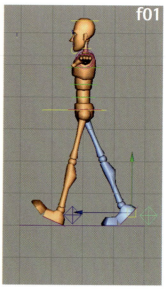

5 f01 is the contact position. Rotate the hips in Y to around -10 and bring the left foot forward. Use the Heel Roll to angle it up and the Toe control to rotate the toes upward.

6 Pull the right leg back and use the Ball Roll attribute to rotate the heel up. Tweak the pose like above, keeping both legs straight. Select All controls and set a key.

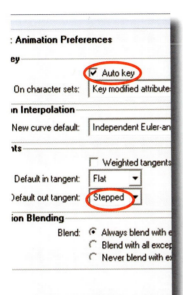

: **Animation Preferences**

ey

☑ Auto key

On character sets: Key modified attribute:

ɪn Interpolation

New curve default: Independent Euler-an

ɪts

☐ Weighted tangents

Default in tangent: Flat ▼

)efault out tangent: Stepped ▼

ion Blending

Blend: ⦿ Always blend with ɐ
☐ Blend with all excep
☐ Never blend with eɪ

Head_FK_CTRL

Translate X	0
Translate Y	0
Translate Z	0
Rotate X	0
Rotate Y	0
Rotate Z	0
Scale X	1
Scale Y	1
Scale Z	1
Visibility	on
Stretch	0
Volumetric Stretch	0
Eye Follow	0
Neck Influence	0

SHAPES
Head_FK_CTRLShape
Head_FK_CTRL_pointConstrai
INPUTS
Controls
OUTPUTS

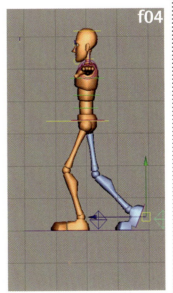

2 In the animation preferences, set the Default out tangent to Stepped. I've also turned on Auto Key.

3 Select the head and set the Neck Influence attribute to 0. Then select the neck and set Chest Influence to 0. The reason for this will be explained in detail in the head and neck section.

4 The only controls we'll be using right now are the root, hips, and feet. Switch to a side orthographic view.

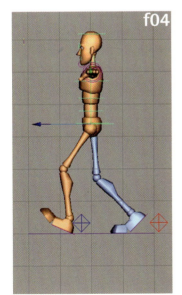

f04

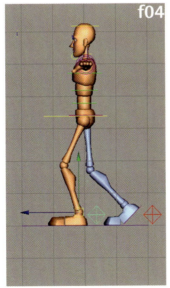

f04

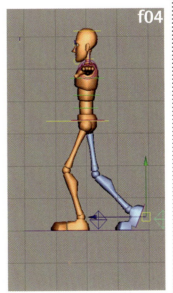

f04

7 Move to f04, select all, and set a key. Now auto key will set the key each time you adjust something on this frame. This is the down position, so move the root down in Y about -1.

8 This is an in-place cycle, so imagine he's on a treadmill. The front foot will plant and move backwards. Set the Heel Roll and Toe to 0 and move the foot back a bit.

9 The back foot is still on the ground, so it moves backwards also. Pull it back some, and also increase its Ball Roll attribute as the heel is pulled farther off the ground.

Blocking the Core Positions (2)

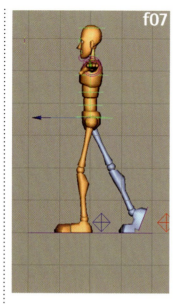
f07

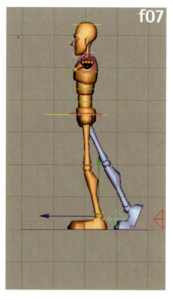
f07

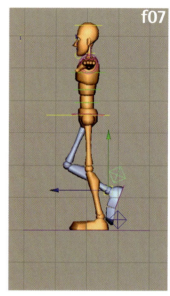
f07

10 Move to f07 for the passing position and set a key on All. Move the root up in Y to -0.2 or so, and rotate the hips in Y to around 2.5.

11 The planted front foot continues to travel back, and I've centered it more or less under his body to take the body weight, since his back foot will be lifted in this position.

12 The back foot is lifted in the passing position, so translate it up and forward. Set the Heel Roll to 0 and use Rotate X to get the angle here. Also use the Toe attribute to give a nice curve in the foot.

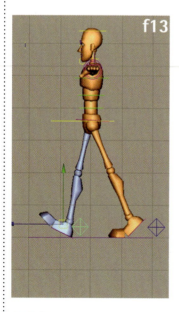
f13

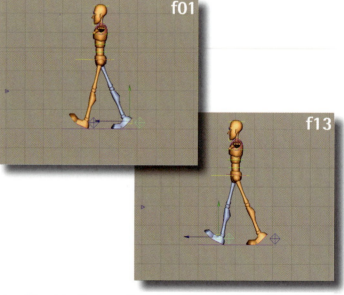
f01

f13

16 We now need to repeat the above poses but with the feet reversed. Move to frame 13, select all and set a key. Do the first contact pose, but with the opposite feet.

17 When doing these opposite versions of the poses, I like to flip back to the mirrored pose and make sure they line up as close as possible using the grid lines. This keeps things consistent and easier to adjust later. I'll also compare the values in the graph editor to make sure there aren't any huge differences.

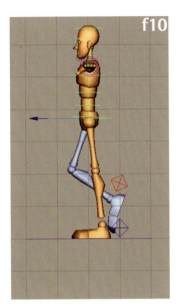

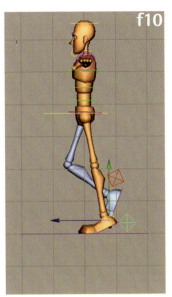

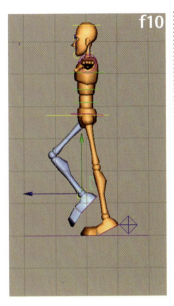

13 Go to frame 10. Select All and set a key. This is the Up position, so pull the root up in Y to .6 and rotate the hips in Y to around 6.5.

14 The left foot is still on the ground, but the heel is starting to be pulled up. Move it back some more and adjust the Ball Roll to about 25.6. Remember to keep the leg straight.

15 The right foot is now in front to take the next step. Adjust it using the Translates and Rotate X attributes.

HOT TIP

For every method of doing a walk, you can find the opposite approach that will work just as well. Never take any animation approach as the only way to do something.

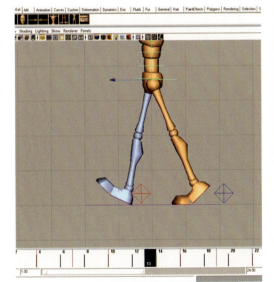

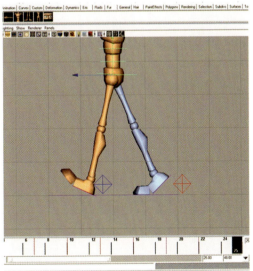

18 Another tip for saving time is to copy the root poses over again, since those are the same regardless of the foot stepping. The root will be the same on frames 1 and 13, 4 and 16, 7 and 19, and 10 and 22. Use the MM drag technique in the timeline to quickly do this.

19 Finally, to loop properly, the first and last poses need to be the same. Select all controls and go to frame 1. MM drag in the timeline to frame 25 and set a key.

8

Rotating the Hips

W E HAVE THE BASIC FOOT POSITIONS and up and down for the body blocked in, so now it's time to flesh them out a bit more. This section we'll be working from a front view to get the weight pushing the hips up in Z rotation.

We'll be using a technique of getting the extreme pose (the frame where a part is rotated or translated the farthest) in the viewport, then moving to the graph editor for the keys in between. This saves time and effort, and is also more precise, because we're able to see the actual values of the keys instead of eyeballing it. There's nothing wrong with eyeballing things, of course, but for cycles, especially walks, I find that precision in the blocking stage makes things much easier later. Once everything is working mechanically, we have more freedom to go in and make things more irregular and organic. 01_CorePositions. ma is the reference file for this cheat.

1 Continuing with your walk cycle from the previous cheat, switch to a front orthographic view.

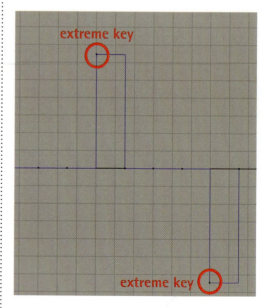

extreme key

extreme key

4 For blocking, I have the hips Rotate Z at 0 on the Contact positions (f1 and 13). Here is what your rotate Z curve should approximate in the graph editor.

2 We need to put some Z rotation on his hips to better communicate them pushing up from the weight on his planted leg. They're at their highest on the Up positions, so go to frame 10, select the hips, and Rotate Z to 3.2.

3 Go to frame 22 for the other Up position and Rotate Z the opposite to around -3.2.

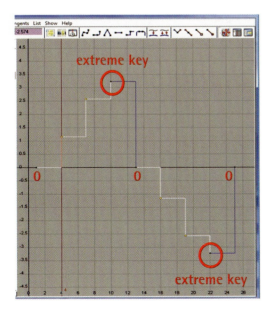

extreme key

0 0 0

extreme key

5 On frames 4 and 7, I use the Move tool **W** and MM drag the keys to progress to f13's Up position. Then do the same in the other direction on frames 16 and 19.

6 Playback the animation and the hips should now be rotating with the walk, being highest on the Up positions.

Walk Cycles

Body and Feet Side Motion

NEXT WE MOVE ON to the sideways, or Translate X, movement of the body and feet. The body needs to shift to the side the character's weight is on to keep him in balance. This also communicates that the character has weight and needs to compensate for it while moving. So we'll stay in our front view and also be using the viewport to graph editor technique from the previous cheat.

Also, the feet tend to cross over at least a little in most walks. We'll shift their planted positions inward, as well as swing them out when they're lifted to start working in the arcs of the foot (which we'll polish up later). Onward! 01_CorePositions.ma is the reference file for this cheat.

1 Select the body control. For blocking, I'm putting the side-to-side extremes on the passing positions (f7 and f19). On those frames, Translate X about 0.46 and -0.46, respectively.

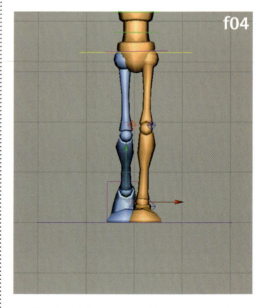

4 Move the left foot's Translate X curve to -0.4. It should look something like this on the character now.

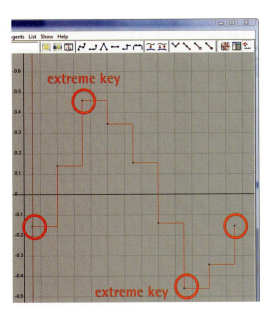

2 The body moves through to those extremes, so again using the graph editor, I pull out the keys progressing to each one. Keep each side consistent, and don't forget that frames 1 and 25 must be exactly the same to loop properly.

3 The feet usually cross in front of each other a bit, so let's move them inward. Select the right foot's Translate X curve in the graph editor, and move it to around 0.4. Moving the curve is much faster than using the timeline. Also, keep an eye on the viewport to judge how far you're moving things.

HOT TIP

The amount the feet cross in front of each other can be influenced by the gender of a character. Female walks can have the feet almost lining up in a perfectly straight line, while a macho male walk would likely be much farther apart.

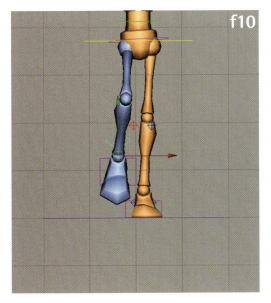

5 The feet arc outwards in Translate X when they're in the air, so move the right foot out to -0.3 at f7 and -0.6 at f10.

6 Do the same with the left foot, setting f19 to 0.3 and f22 to 0.6. Play back the animation and your walk should feel noticeably better.

Rotating the Spine

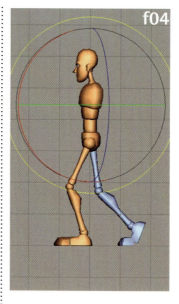

W ITH THE FEET AND BODY fairly well blocked in, let's focus our attention on the spine. I've hidden the arms in this example (the reference file also has a display layer for the arms on/off) so we aren't distracted by perfectly straight arms pivoting around the chest. The chest's Y and Z rotations are the opposite of the hips.

It's good practice to rotate the spine as a unit when blocking. Select all three controls, and rotate them together, getting as close to the pose you want as possible. Then rotate them individually if necessary for further tweaking. The reason for this is posing the individual spine sections is more time consuming, and can lead to strange results when splined. If you rotate the middle or lower sections noticeably more than the top (easy to not notice in blocking), the spine can move in an bizarre, alien way (can you twist your stomach with your chest perfectly still?) after you leave stepped keys. 02_CorePositions.ma is the reference file for this cheat.

1 Select the chest controls (all three of them) and go to frame 4. This is a Down position where we want the extreme for the spine's Rotate Y to be. Rotate all 3 in Y to 4.7.

2 I'd like to move the upper chest further, so select only that and rotate it to around 8.8. You can also do this in the graph editor if you prefer.

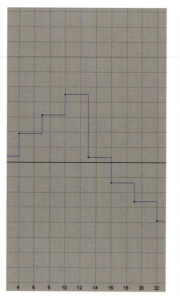

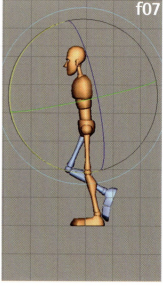

6 Rotate Z the opposite at f22, and then use the Graph Editor to pull out the keys between the extremes. Here is the general timing I used.

7 Rotate X is all that's left. In a side view at f7, rotate all three controls downward, and adjust the top spine control to taste.

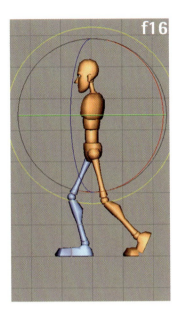

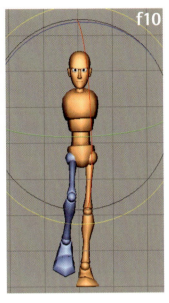

3 Repeat the same process on the other side at f16, using the opposite values.

4 Using our Move tool **W** and graph editor technique, I now pull the keys to progress between the extremes at a timing/spacing I like. Do this for the Rotate Y of all three spine controls, keeping f1 and f25 the same value.

5 Add some Rotate Z to all three controls, using the same technique. The extremes will be at the Up positions, f10 and f22. At f10 I went to about 0.9.

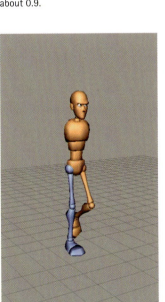

8 At f10, rotate down in X just a bit further. Then repeat the same two poses at f19 and f22, respectively. Here are my Graph Editor curves for all three controls. Yours don't have to be exactly the same, but they should be in the same ballpark.

9 Our walk is shaping up nicely! We're almost done with blocking everything in.

Blocking the Arms

THE ARMS ARE the next part to block in, and we'll start with the upper arm and work down to the wrist. I find it easier to do the arms using this layered approach, rather than posing the whole arm, because the isolation helps me figure out the drag and follow-through better. It's a good idea to put the overlapping action into your stepped keys as much as possible, because it communicates the motion better at this early stage and helps clarify the way the animation will end up.

There will usually be a lot of refining done on the arms later, but for now we just want things blocked in cleanly and working mechanically. The extremes for the arm poses will be placed on the Down positions, and we won't worry about the fingers right now. This keeps everything as simple as possible. 03_CorePositions.ma is the reference file for this cheat.

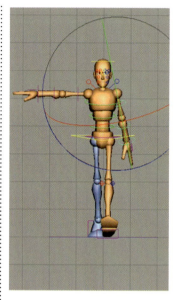

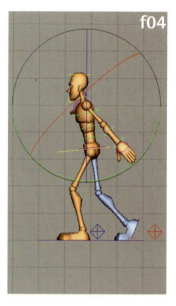

1 Select the left upper arm control and in the Graph Editor pull down the Rotate Z curve to about -78. The arms arc out in Z during the walk, but we'll come back to that later. Switch to a side view to work on the Rotate Y.

2 At f04 is a down position. Since the left foot is forward, the left arm will be back. Rotate it in Y to 41 or so.

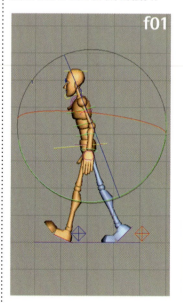

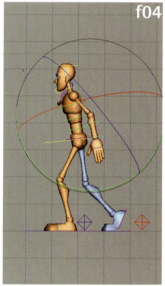

5 Now for the elbow. We're going to be roughing this in, as the overlapping action is much easier to work on once we've gone to splined keys. At f01, rotate it forward in Y -27.

6 At f04 the lower arm is dragging behind the upper, so rotate it forward more in Y -29.

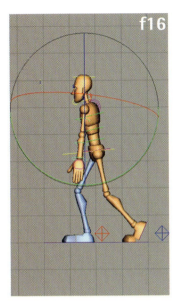

3 The other down position is at f16, so go there and rotate the arm in Y to its forward extreme. I put it at -6.2.

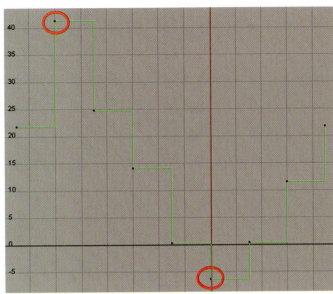

4 Go to the Graph Editor and pull out the keys between the extremes to a timing and spacing that looks good to you. Here's how I did it. Remember to keep f1 and f25 the same values.

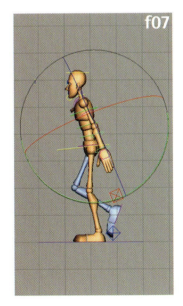

7 At f07 the upper arm is now moving forward, but the lower still has momentum going the other way, which makes a straight arm. Rotate Y to -4.5.

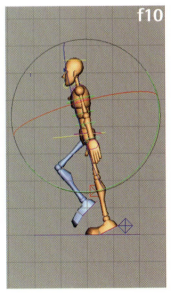

8 The lower arm is still dragging at f10, and can't go any farther (as this isn't a cartoon-style walk), so we'll keep it straight. Rotate Y to 0.

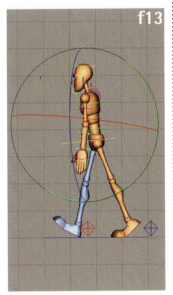

9 At f13 the lower arm now starts to move the other way. Rotate Y to -6.7.

Blocking the Arms (cont'd)

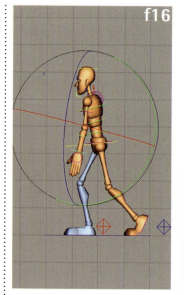

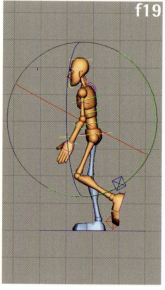

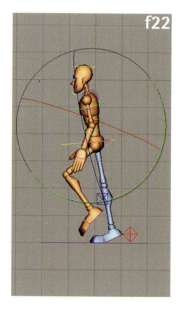

10 At f16, the lower arm continues in the same direction. Rotate Y to -7.8.

11 At f19, the upper arm starts back the other way, but the momentum keeps the lower arm going the same direction. Rotate Y to -28.

12 f22 has the lower arm dragging a bit more, but now ready to start moving back the other way. Rotate Y to -31.

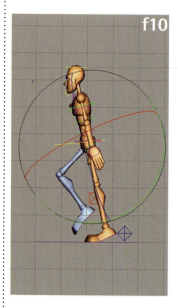

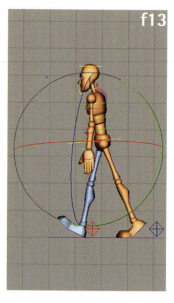

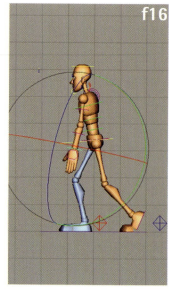

16 At f10 the wrist is still dragging as the lower arm is just starting to change direction. Rotate Y to 10.7.

17 At f13 the wrist is now starting to move forward with the rest of the arm. Rotate Y to 7.6.

18 The wrist continues its direction at f16. Rotate Y to 3.1.

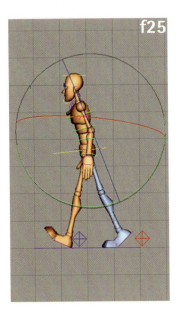

f25

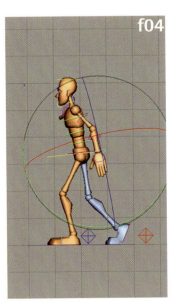

f04

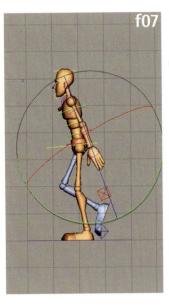

f07

13 Since we need f1 and f25 to be the same, key the lower arm's Rotate Y at f25 the exact same value you have at f1. In my case it's -27.25.

14 For this style of walk, we don't want the wrist too floppy. I'm keeping it straight, except when it drags at, and right after, the extremes. At frames 1, 4, and 25 the wrist Rotate Y is at 0.

15 At f07 the arm is moving forward, but the wrist is still dragging. Rotate Y to 9.5.

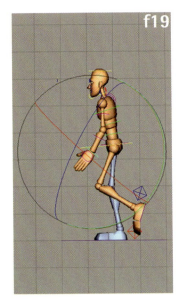

f19

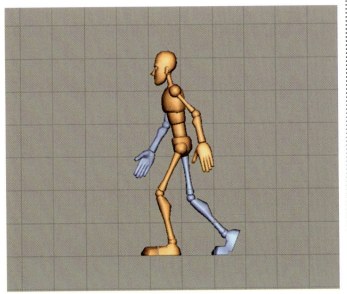

19 At f19 the arm is moving back but the wrist is still going forward. Rotate Y to -14.

20 Keep the wrist the same at f22. We now have the left arm roughly blocked in. Repeat these poses for the right arm, except with opposite extremes: the right arm will be forward with the left foot, and vice versa.

Head and Neck

THE FINAL SEGMENT of the blocking phase is getting the head and neck moving, and then we'll be ready to start refining this walk into a fully animated one. These two parts are pretty straightforward, as they basically overlap the spine. However, getting just the right amount of head overlap for the walk you're doing is important for the entire body to feel organic. Like I stated before, in a walk everything affects everything else in some way. That's what makes them challenging (and fun).

We're also going to be using the head in Master space. On the Goon Rig the attribute is called "Neck Influence" on the head and "Chest Influence" on the neck. Other common names I've seen on rigs are "Global" and "Align." Some rigs you turn this on, although the Goon Rig you actually turn it off (set to 0), setting the neck to have no influence on the head and the chest to have no influence on the neck. By doing this, you are making the head and neck independent of the body. Normally rotating the neck and/or spine will rotate the head along with it, but in Master space, the head will stay facing its current direction until you actually rotate it. This is great for a walk cycle, because it saves you TONS of counter-animating. Otherwise, every time you rotate the chest, you'd have to rotate the head back to its original position. Very time consuming and annoying! 03_CorePositions.ma is the reference file for this cheat.

1 For a quick demo, go to perspective view and go to f01. On the neck control, set Chest Influence to 1, and on the head, set Neck Influence to 1. The head position will probably change when you do this.

2 Rotate the chest in Y and notice how the neck and head simply follow, as if they were all one piece. This is because the influence of the chest is at 1, or 100%. Undo all of these steps.

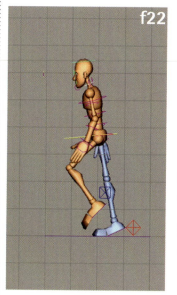

f22

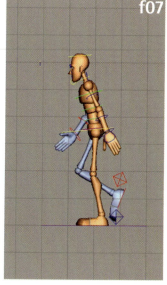

f07

6 Repeat the same values in Rotate X at f22.

7 At the positions before those poses, I'm going to do an ease-in. At f7, rotate the neck in X to 22.7 and the head to 4.9. Repeat at f22.

3 Set the head and neck influence at 0, and rotate the chest in Y again. Now the head maintains its current angle, as the rig is automatically countering any rotations you do in the chest. Undo everything you just did.

4 Switch to side view. We're going to only work on the Rotate X for the head and neck. Since the down position happens at f4, the spine follows at f7, and the head/neck will move down at f10 for the overlapping action.

5 At f10, rotate the neck in X to 24.8. Then rotate the head in X to 6.2.

HOT TIP

If you're having trouble getting something to look right and are getting frustrated, try deleting the animation on that part and starting over. It may sound painful, but it actually can make things much better. It's easier to see how to fix something when it's 100% wrong, rather than only 10% wrong.

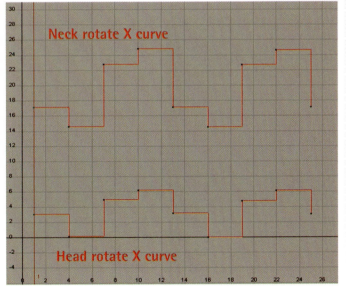

Neck rotate X curve

Head rotate X curve

8 At f04, the head is back. Set rotate X to 0 for the head and 14.5 for the neck. Repeat at f16.

9 Set the remaining pose at frames 1, 13, and 25. I set the Rotate X on the neck to 17.1, and the head to 3. Here are my Graph Editor curves. And that's it! We've now blocked in the walk and are ready to start refining the animation.

Splining the Walk

NOW THAT WE'VE BLOCKED in all the major body movement, we're in a good place to start refining the animation. We'll move out of stepped keys and into splined curves, where Maya interpolates between the keys. That's a fancy way of saying it fills in the frames between where we set our blocking keys. A good portion of computer animation is editing these Maya-created in-betweens to make them less perfect and exact (as computers are so good at that), and more organic, imperfect, and alive.

A very important ritual in splining your stepped keys is ensuring that every control has a key at every frame we blocked in a pose. It's easy to miss some in the blocking process, and if you spline without ensuring this, you can create a lot of extra work for yourself later. So first we'll use some hotkeys and double check that we've keyed everything before we move to spline mode. 04_Splining.ma is the reference file for this cheat.

1 Before we spline, let's make sure there are keys on every control, as it's possible to miss a few in blocking. Select All controls, and go to f01.

2 Press **S** to set a key on all the controls. Then use the **>** key to advance to the next keyframe at f04. Set another key, and continue through f25, setting keys on each frame that keys currently exist.

5 Select all the curves, and press the Pre and Post Infinity Cycle buttons in the Graph Editor. These tell Maya to loop the curves infinitely before and after to make a continuous cycle.

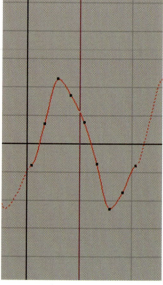

6 In the graph editor menu, go to View > Infinity. You'll see dotted lines on each side of the curve representing the looping.

3 With all controls selected, open the graph editor and select all of the curves.

4 Press the Plateau Tangents button to convert to splined curves. Plateau does a respectable job of flattening extreme keys and smoothly transitioning in-between keys, making a good starting point.

HOT TIP

Plateau tangents work well, but even better is using an auto-tangent script. This script will go through your curves and place a flat tangent on every extreme and a spline tangent on every in-between. Check out Michael Comet's website at www.comet-cartoons.com for a fantastic auto-tangent script, as well as a ton of other fabulous tools.

7 Playblast your animation and your walk should be fairly smooth. There will be some very minor hitches but overall everything should be moving fine. If not, undo the splining and make sure you have a stepped key on every control at every blocking frame. This is much faster than dealing with it later in spline mode.

Refining the Body

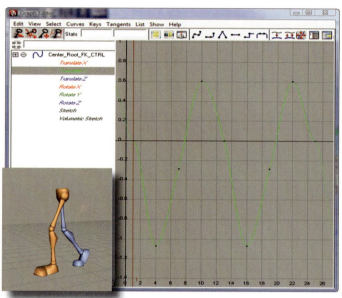

W ITH THE CURVES NOW SPLINED, we can really get things going. We'll start by refining the body control. When using a layered workflow, it's extremely important to always start with the foundation and work your way up from there. Since the body control is the center of the character's gravity, everything branches from there, and that's what we'll work on first. The legs will follow, since they are dependent on the body's movement, and form the physical base of the walk.

I've chosen this approach because everything else, like the spine, neck, head, and arms, all get their reference of movement from the body. It doesn't make sense to work on them yet, since they will change based on what you do with the body control. Always base a layered workflow from the character's center of gravity, and work your way up from there.

It bears repeating that we're now knee deep in the organic part of animating that is impossible to accurately represent in a step-by-step succession. These next few cheats will introduce the techniques for refining your own walk, but ultimately use your judgment and intuition, as that's the only way to learn how you animate.

I've created some display layers to hide the upper body to focus on the parts I need with minimal distraction. 05_Refining.ma is the reference file for this cheat.

1 I'll start with the up/down of the body. Select the body and focus on the Translate Y curve in the Graph Editor. We're going to be doing all of our adjustments in the graph editor since it's faster and more precise than doing them by hand in the viewport. Be sure to keep an eye on your viewport while you're making the changes, so you can see how altering the curves affects the character.

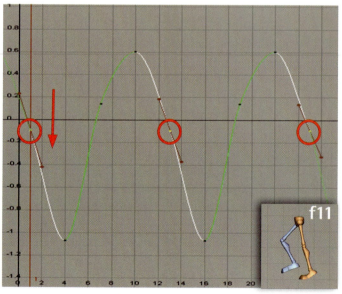

4 A walk is a controlled fall, so let's adjust the keys travelling down at f01, f11, and f25 a bit lower. Now he's getting to the up position a bit faster and holding there longer, and then moving to the down position faster.

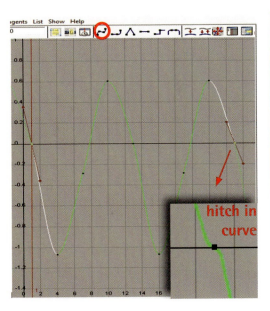

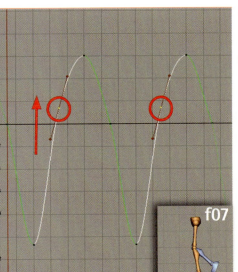

hitch in curve

f07

2 The ends of the curve are flat, but looking at the dotted infinity lines before and after our curve, they should be smooth since they aren't extremes. Select the two end keys and press the Spline Tangent button. You can also adjust the keys' tangent handles manually if you like.

3 At f07 and f19, I want his body to ease into the up position so things don't feel so even. Select those keys, press **W** for the Move tool and MM drag them up to around 1.5.

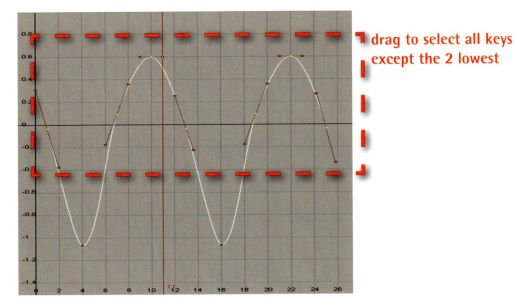

drag to select all keys except the 2 lowest

5 We can push these timing changes even further. Let's add a frame on the way up to make it hang even longer, and take one away from the way down to make his weight drop faster. We won't change the number of total frames, but rather shift the keys we've already set to different positions. Select all the keys except the two down positions.

Refining the Body (cont'd.)

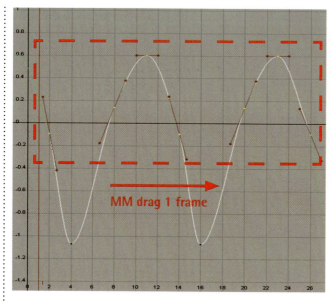

MM drag 1 frame

6 With the Move tool (**W**) MM drag the keys over 1 frame. This will offset his up position 1 frame over from the rest of the keys.

7 The body will now have a nicer bounce instead of a regular sine wave type motion. Right now it's a subtle difference, so feel free to experiment with the placement of the keys and find something that you like.

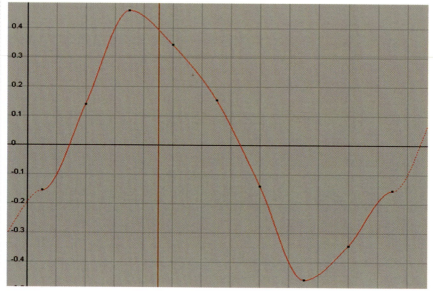

10 This is what the original Translate X curve (sideways movement) looked like for me...

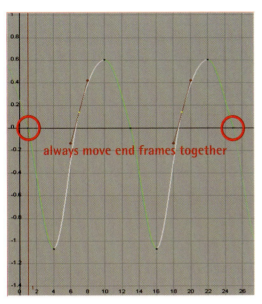

always move end frames together

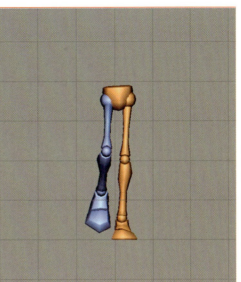

8 When offsetting keys or changing timings for a cycle, remember to keep the number of frames for each curve exactly the same, in this case 25. If you shift either the beginning or end key, move the other one also. For example, if you shift the first key one frame to f02, you'd also move the end frame to f26, as f02 to f26 still totals 25 frames.

9 Try your hand at the side-to-side motion of the body. Switch to a front view to see the Translate X movement more clearly.

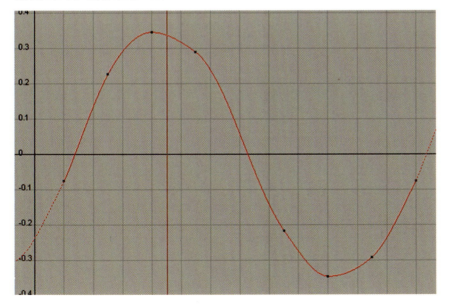

11 ...and this is what I ended up with. Ease ins and outs at the extremes, a smooth transition between them, and shifting the entire curve over 1 frame to offset the motion from the rest of the body.

Hips

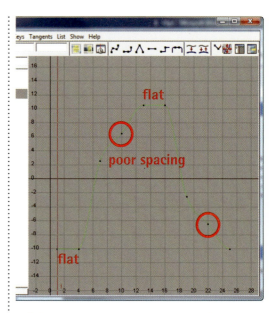

1 We've roughed in the hips' Y movement, Now let's tighten it up some. Currently they have some flat sections in the curve and the spacing makes the movement a bit jerky.

THE HIPS ARE ONE OF the most important things for conveying weight, and go a long way in defining the attitude of the walk. Since we're doing a standard walk cycle, things won't get too crazy, but it's good to exaggerate them a tiny bit, even if the style is more real or naturalistic. I believe that not pushing the hips' movement can make an animation feel kind of light and mocap-ish. If you're doing a personality walk, pay very close attention to the hips, as they will be a central element in making it feel right. A female walk, for example, can be almost completely sold with the hip swing. 05_ Refining.ma is the reference file for this cheat.

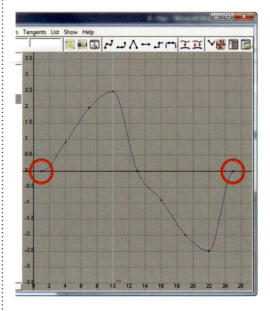

4 Like the Y curve, the Rotate X curve has some spacing issues. The ending key tangents also flatten out, which will add a slow-down in the movement we don't want.

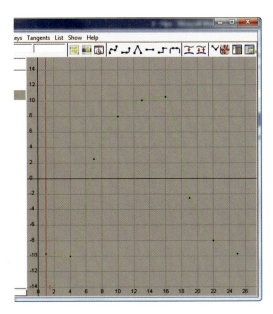

2 On f10 and f22, adjust the keys for a nicer ease in. On f01 and f25, and f13, tweak the keys so we don't have perfectly flat tangents. Subtle tweaks like this will add up to make everything feel more organic and loose.

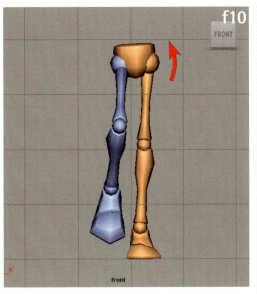

f10

FRONT

front

3 Switch to a front view to work on the hips' Rotate Z. For this walk, the hips over the planted foot will be pushed up from the body's weight.

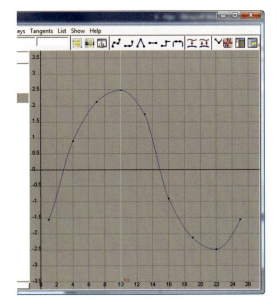

5 Around f10 and f22, I adjusted the surrounding keys to ease in and out. This is so the hip stays in the up positions longer while the weight is on his leg. Select the keys on each end and click the Spline Tangents button so they move smoothly through the cycle when it loops.

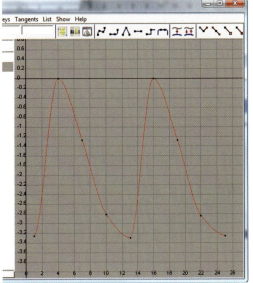

6 Some animators don't use much (or any) rotate X on a vanilla walk. I did a little bit and it works fine for now with how it splined. Here's what I came up with. Feel free to adjust yours as you see fit.

Walk Cycles

The Feet

I N ANY WALK, THE FEET can have a lot of subtlety, more than they may appear to at first glance. A step can seem like a simple movement, but when we study it closely, the little details that we can put into our animation really make it come to life. From the overlap and drag of the toes, to the peeling off the ground, to the drag and swing in the air, all of these things differentiate a functional walk from an appealing one. While we could probably use half of this book to talk about feet, let's look at the vital things we'll need to transform these simple splined feet to ones that are really going somewhere. 05_Refining.ma is the reference file for this cheat.

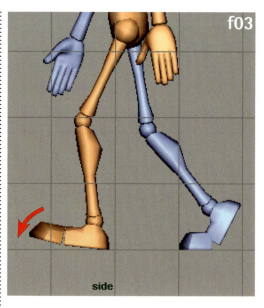

1 Right now the feet are taking three frames to go from contact with the ground to planted. This is too long and makes him feel like he's stepping very softly.

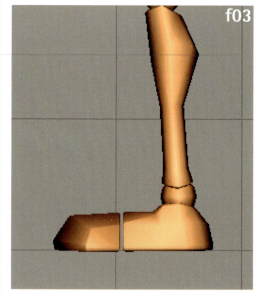

4 Now the foot snaps down over 1 frame, adding to the feeling of weight. It's still a bit mechanical, though, so let's add some overlap with the toe.

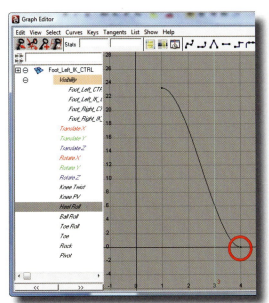

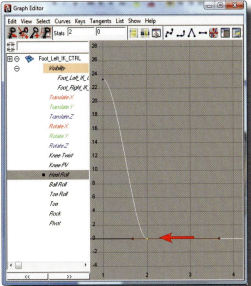

2 On each foot, select the key on the Heel Control attribute that is at 0 immediately after being raised. In this example, it's f04 on the left foot and f16 on the right.

3 Drag them over 2 frames so the transition happens over 1 frame.

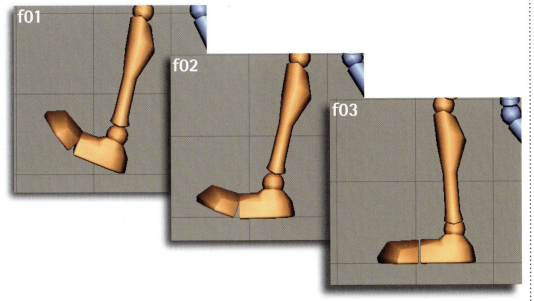

f01

f02

f03

5 Adjust the curve for the Toe attribute so it is still up the frame the foot plants on the ground, and then have it go down the frame after. Repeat with the other foot.

The Feet (cont'd)

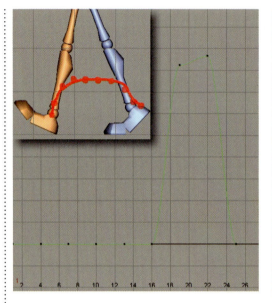

6 The Translate Y curve looks a little clunky with the flat tangents at the peak. This creates an awkward arc in the step's path of action.

7 I adjusted the timing and smoothed out the top to give the motion a nice slope. It starts lifting a frame earlier at f15 and gets to the ease in key at f20. Now we have a smooth lift, slight hang, and nice drop in the step.

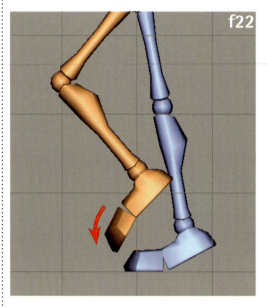

f22

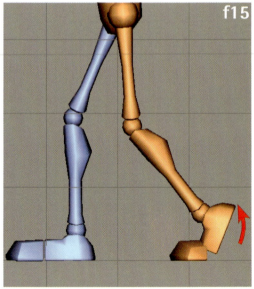

f15

10 Use the Toe attribute to add some drag on the toes as the foot travels through the air.

11 Once the heel starts peeling off the ground, have it keep peeling until the foot comes off the ground. The curve should keep travelling and not plateau, which will make it look stuck and mechanical.

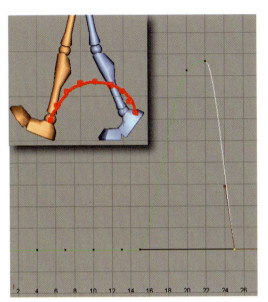

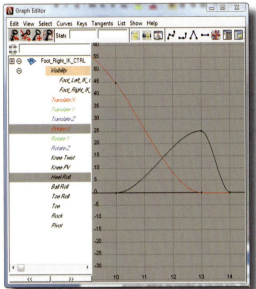

8 When it hits the contact position, I made the keys at f13 and f25 linear. This makes a hard in, as the foot is stopped by the ground and doesn't slow down before landing.

9 One of the tricky parts when using both Rotate X (when the foot is in the air) and the heel roll (when it's on the ground) is getting the transition to not look jerky. The key is to overlap them. Experiment until you get a smooth motion.

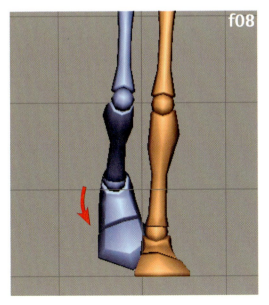

f08

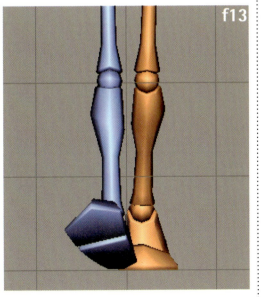

f13

12 The lifting foot can have a slight drag using the Rotate Z, which helps add to the weight.

13 Some slight Rotate Y and Z on the contact position also adds some nice detail.

Walk Cycles

Spine, Neck, and Head

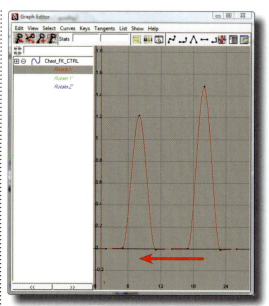

A S WE WORK ON THE SPINE, it's helpful to think of the Rotate X motion working its way up from the hips through the head. The chest can't rotate forward until the waist does, and so on up the chain. If we keep this principle in mind while we work on the upper body, it will go a long way toward loosening everything up and making the walk feel weighty.

We'll be sure to work with all three axes. As a general guide, the chest and hips rotate in Y inverted from each other. For the Y rotation, I'm going to have the chest be the base of the arm swing movement and therefore lead the waist in that direction. We'll also have some subtle compression with the Rotate Z. As you work on the spine, I would definitely recommend looking at video reference and studying books like *The Animator's Survival Kit* by Richard Williams.

The Rotate X for the head will also receive some attention, and for a nice touch we'll add some squash and stretch to the whole spine at the end. walkFinal.ma is the reference file for this cheat.

1 Select the chest's Rotate X curve. From the blocking, we have where the chest rotates forward but nothing else. First I'll shift the entire curve over 1 frame so it rotates a bit later than the waist for the overlap.

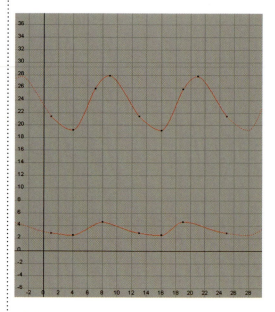

4 The neck Rotate X curve will continue the same rotation, but later than the chest. For this I lined both curves and then shifted only the extreme of the rotation down over 1 or 2 frames. Offsetting everything equally can start to look mechanical.

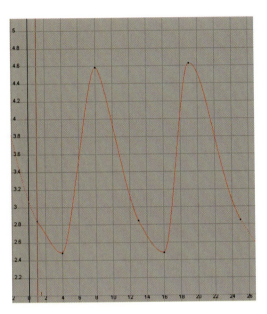

2 I moved the entire curve up so the rotation forward is more pronounced. Then I smoothed out the flat sections so it drags back smoothly, and snaps forward with each step.

3 Smooth out the other Rotate X curves similarly, keeping a nice curve in the spine throughout the walk.

HOT TIP

Getting the overlap just right takes time. Remember that you may have to rotate something backwards to get the drag right before it starts moving in the direction it's being pulled in. Simply offsetting the curves will rarely get you the motion you need.

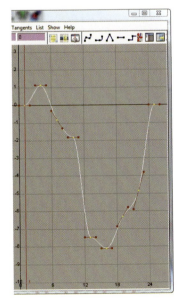

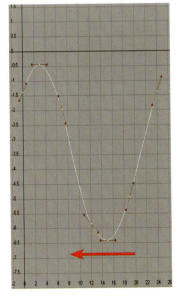

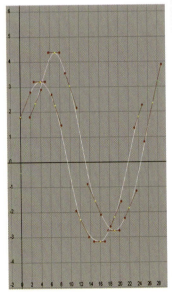

5 For the Rotate Y I'm going to make the chest lead the rest of the spine, as it will be the base of the arms' swinging motion. To start, the curve from blocking needs a lot of clean-up.

6 Smooth the tangents, adjusting the ease ins/outs and compressing the entire curve a bit. Then move the curve one frame earlier since the chest leads the ribs and waist in Rotate Y.

7 Clean up the ribs and waist Rotate Y curves. I put the extremes of the ribs 1 frame behind the chest, and the waist 2 frames to keep everything from moving too perfectly.

Spine, Neck, and Head (cont.)

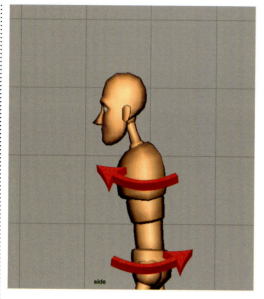

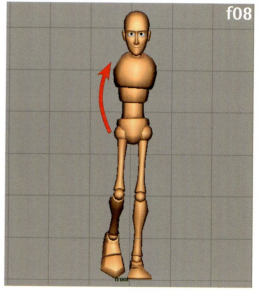

8 Continue to work with the spine's Y rotation until you're happy with it. Make the chest and hips complementary in their movement, as well as where they hold around the extremes.

9 Switch to a front view to work on the Rotate Z. For this walk, I'll make sure the spine will compress into a slight C shape with the planted foot side.

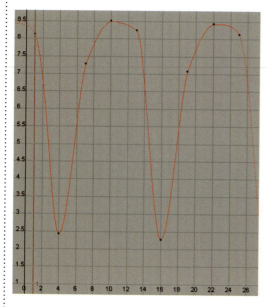

12 The head will move back quickly at f04, then down quickly to f07, where it slowly starts to reverse direction until f13 where the cycle starts again.

13 Once you're happy with the spine movement, adding a bit of squash and stretch in the spine can be the touch that really makes the walk feel weighty and organic. On the main body control there is a stretch attribute.

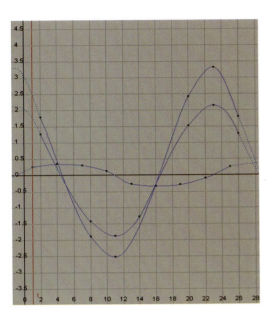

f04

10 Continue the refining process by cleaning up the Rotate Z curves until you're happy with the movement.

11 Moving on to the head, think of the wave principle we used when doing the spine Rotate X, just more pronounced. The head will rotate back and down quickly from the body's weight hitting the down position, and slowly rotate until the next drop in the body snaps it downward.

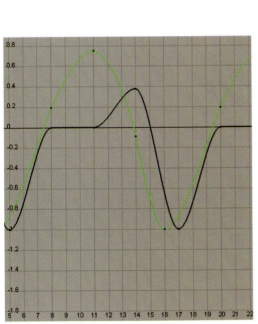

14 Use the body's Translate Y as a reference point. When it starts downward, the spine will continue to stretch a couple frames before starting to squash. The curves in the screenshot have been normalized (made the same proportion visually only) for clarity.

15 After the body hits the lowest down point, the squash will continue a couple more frames before going back to normal. Work with the stretch curve until you're satisfied with the animation.

Arms and Hands

8 Walk Cycles

THE FINAL PARTS WE NEED TO REFINE are the arms and hands. I've saved them for the end because their movement is almost completely based on the body. When doing the overlapping action for the arms, it helps to think of how a pendulum works. The upper arm leads the forearms and wrist. Once the upper arm changes direction, the forearm must keep going in its current direction for a few frames before following the upper arm. The same principle continues through the wrist and fingers.

We also need to add some rotation in X and Z to keep the arms from feeling robotic or locked on a track. To finish, we'll add some rotation in the shoulders and some bounce from the body's up and down to loosen the walk up even more. walkFinal.ma is the reference file for this cheat.

1 Switch to a side view to focus on the Rotate Y of the upper arm. We'll go through refining on the left arm, which you can then mirror and apply to the right arm.

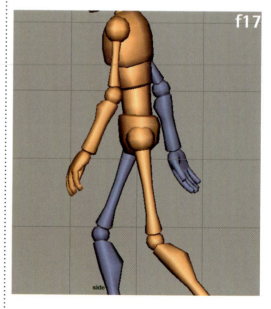

5 Before you do the wrist, rotate the wrist in X so the palms are facing back. I also posed the fingers, making them relaxed but not identical.

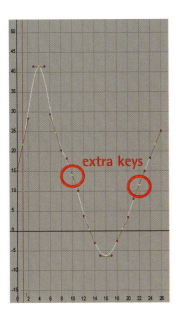

2 First I'll clean up the Rotate Y curve. It's fairly even, so I'll delete some extraneous keys and add ease ins and outs to the extreme keys as a starting point.

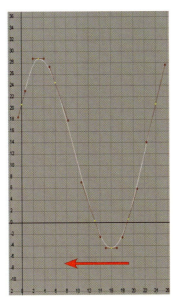

3 I also shifted the curve earlier one frame since the upper arm will be leading the rest of the arm. Here's the curve after refining and checking in a playblast.

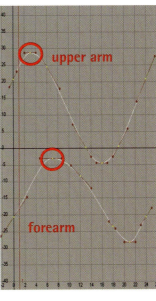

4 Continue the refining process for the forearm's Rotate Y curve, using the upper arm's curve as a reference. For my walk I had the forearms overlap the extremes by 4 frames.

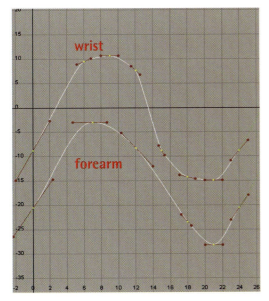

6 Use the forearm's Rotate Y curve as a reference for the wrist's Rotate Y. I ended up putting the wrist's extremes 2 frames after the forearms and making the ease in and outs tighter. Refine the wrists to a point that looks good to you.

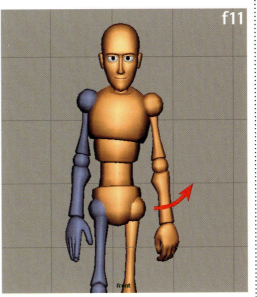

7 Switch to a front view to work on the Rotate X and Z. The upper arm's Rotate Z will control how the arm swings out, which I'll make more pronounced as the arm goes forward than back.

Arms and Hands (cont'd.)

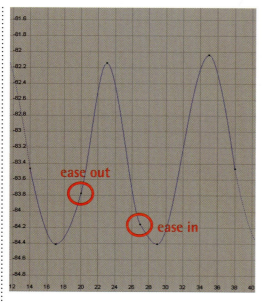

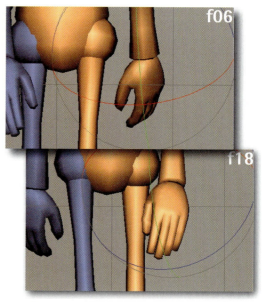

f06

f18

8 I made the arm swing out more as it travels forward than back. The curve is very similar on each direction; the difference is done mostly with ease ins and outs.

9 Add some Rotate X as well, mainly in the wrist. There's a subtle rotate outward when the hand is back, and inward when it's forward.

12 To finish we'll add overlap in the fingers. Make all of them offset from each other, but not necessarily in perfect order, to make them feel more organic.

13 When the arms are travelling forward, the fingers compress together from the drag.

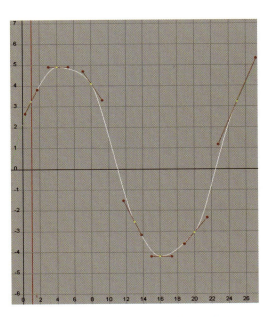

10 Moving to the shoulder, I refined the Rotate Y to work with the upper chest, just offset by a few frames.

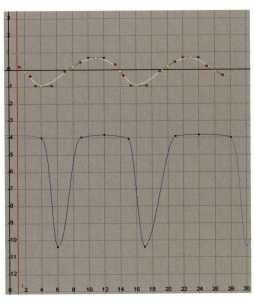

11 Put a pronounced drop in the shoulder using its Rotate Z, offset a couple frames from the body's Translate Y, which I used as a reference point.

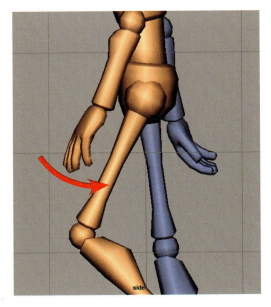

14 The fingers will separate again as they get dragged back with the arm.

15 Mirror the animation on the right arm and our walk is almost complete!

Fixing Knee Pops

WHEN IT COMES TO POLISHING A WALK, we will invariably need to fix popping in the knees. When you watch the animation, you'll probably notice some jerkiness, jiggle, or pop in this area, particularly around the foot contact frames. Knee pops are a by-product of using IK legs, and it's essentially just a problem of spacing. The knees will have too far a gap between frames from the IK leg trying to figure out where they go based on the body and foot positions. They can also pop if we have something like a perfectly straight leg for only one frame. It generally takes 2 frames for a pose to be felt by the viewer, and just 1 frame of straight into a bent knee will feel like a hitch in the motion.

All of this is remedied using the Stretch attribute on the foot control. Because the body and feet are working the way we want, we don't need to mess them up just because of the knees. So we'll simply adjust the stretch in small increments, shortening or lengthening the leg frame by frame to put the knee where we want it. Since it will only take small amounts of stretch to accomplish this, the change of length in the leg won't be noticed.

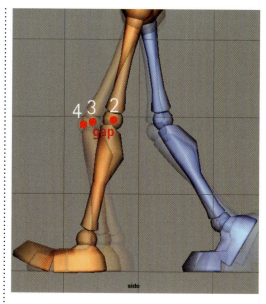

1 Open KneePops.ma. On frames 2 and 3, we have a spacing issue in the left knee. There's a large gap between them, making it pop when the animation plays.

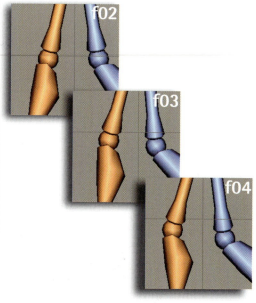

4 Now on those frames we have a smooth motion in the knee.

2 On the foot control, select the Stretch attribute's curve in the Graph Editor, hold 🅘, and MM click to insert keys on frames 2-6. Often when using this technique, you must adjust the stretch on surrounding frames to make it look good.

3 While watching the viewport, adjust the keys to smooth out the spacing on the knee from frames 2-6.

HOT TIP

Save this stretch technique for the very final stage of your walk. Check the arcs of the feet and body and make sure they're exactly how you want them. Double check that the peel-off is working and that everything else is finished. If not, you are adding yet another element into the complex mix and can create a lot of frustration for yourself.

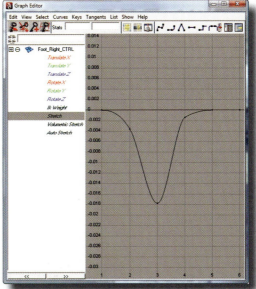

5 There's also a pop in the rear leg that we should fix. Add keys to the Stretch attribute on the surrounding frames and smooth out the knee spacing.

6 Now the knee is smooth on the back leg as well. Continue to smooth out the knees until all pops are fixed.

Translating the Walk Cycle

THIS IS IT! With the walk finished we're now ready to make this in-place cycle actually move forward. The cycle itself will remain inplace, but we can figure out the amount to translate the root controller forward to create the illusion of walking. For each frame his feet slide back, the root control (which moves the entire character) moves forward the exact amount to counteract and make the foot appear to stay on the ground.

To get this to work properly, we need to do some slight adjustments on the Translate Z curves of the feet, along with some basic math. While the feet are translating backwards, they need to be linear splines, which make each frame the exact same value. Ease ins and outs change the amount the foot is moving back from frame to frame, and will make the feet slip when the root control moves. Now, grab your calculator! walkTranslate.ma is the reference file for this cheat.

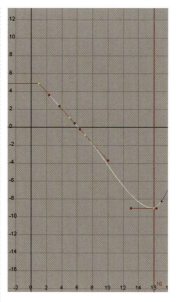

1 Select the left foot. The foot contacts at f01 and travels back through f16. Select all Translate Z keys from frames 1-16.

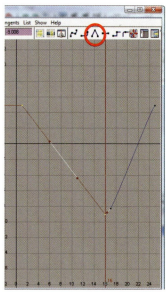

2 Change them to linear tangents, and delete any keys between f01 and f16. This ensures that these 16 frames are all exactly the same value apart.

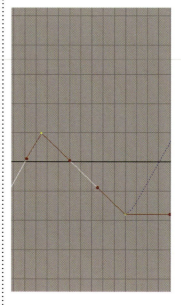

6 Delete any keys between f13 and f28 and make those two keys linear tangents. Make sure that f13's value is 4.916 and f28's is -9.008, just like the other foot.

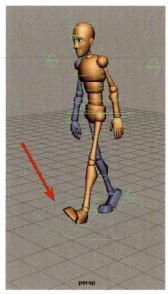

7 Select the root control and set a key on it at f01 and f02.

f01 value f16 value

4.916 + 9.008 =

13.924

total distance travelled in Z over 15 frames

13.924 / 15 =

.928

distance travelled in Z per frame

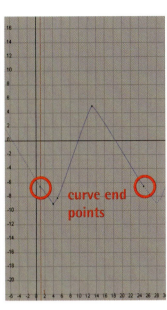

curve end points

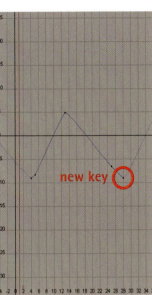

new key

3 We need to figure out the value of each frame. f01 is 4.916. f16 is -9.008. Adding them for the total distance is 13.924. That divided by 15 frames is .928. So the feet travel back .928 units each frame.

4 The other foot needs to match that amount per frame and it makes things simpler if both feet have the same starting value (4.916). However, the curve itself ends while in the middle of traveling backwards.

5 The easy thing to do is simply insert a key at f28 where the travel back ends, and delete f01's key. The infinity cycle will ensure that everything stays lined up.

8 On the root's Translate Z curve, enter .928 as the value on f02. Then select the curve and go to Curves > Post-Infinity > Cycle with Offset.

9 Cycle with Offset makes the root translate forward .928 each frame to infinity, and now our character is walking through the viewport.

Spotlight: Chris Williams

CHRIS WILLIAMS IS AN ANIMATION SUPERVISOR at Sony Pictures Imageworks where he has worked on a variety of projects encompassing both visual effects and character animation. His credits include the *Spider-Man* trilogy, *Open Season*, and *Cloudy with a Chance of Meatballs*.

HOW DO YOU APPROACH FINDING THE BEST ACTING CHOICES FOR A CHARACTER?

This to me is the hardest part of the job. The thing with acting choices is that they are very subjective in nature. There are so many ways to approach a shot. Any or all of them could be right and what one animator thinks works might not land for someone else. And who knows. Maybe the director is so clear on his/her vision, I don't need to make any choices at all! But if it's up to me, I start by listening to the audio track over and over (and over) again. My goal here isn't necessarily to envision the whole shot and lock it down. Instead I'm trying to establish a handful of strong poses that really define the performance to act as anchors for the shot. I appreciate that there are a lot of animators out there that like to act out and thumbnail the whole shot from the get-go, but I find that by dropping in just a few poses, I get a much more organic workflow. My end result is never what I first envisioned because I allow the shot to evolve. So although this is the hardest part for me, it's also the most rewarding when I really see the shot come to life.

WHAT'S THE MOST CHALLENGING SHOT YOU'VE EVER WORKED ON AND WHY?

This is a tough one. I feel like any shot can be hard in some way or another. But I'm going to go with a shot that was done for the extended *Spider-Man 2* DVD. The shot was initially meant to be about 30 seconds of intense fighting between Spider-Man and Doc Ock, and although it was subsequently broken up with new camera angles, I still remember it as one big challenging shot. Here's why.

First, the initial concept was to have a fairly static camera moving along the side of the train. How does this make the shot hard you ask? The static camera meant I had nowhere to hide. The shot had to look realistic and the choreography had to be exciting because I wasn't going to benefit from some generous camera shake or big moves to conceal shoddy animation.

Secondly, the choreography. The trick with these fight shots for me was making sure I got the audience to look exactly where I wanted them to look. I guess that doesn't sound too hard, but if you have a bunch of tentacles moving around, you can get yourself into trouble fairly quickly because your eye will jump around in all directions. When Ock grabs Spidey's hand, for example, I made sure the tentacle reared up and held a strong silhouette before grabbing while the foot tentacles waited for their mark so to speak. Only when I got a read on the tentacle grabbing the hand did I move the foot tentacle down onto the train. And only then did I rear up the right tentacle to grab the other hand. Essentially, the challenge was to find the balance between keeping it exciting and ensuring the action was clear and readable. I need to guide the audience on where to look so they can absorb the action on a first pass.

Thirdly, the tentacles. Need I say more?

The fourth element was the cloth. Although I didn't have to animate Doc Ock's jacket and vest, I still had to give the cloth team enough room to work their magic once my animation was done. What this meant was making two characters appear to be grappling and fighting, but in terms of the actual geometry, they could never touch. So when Spidey is straddling Ock and pulling him up by the collar, he isn't actually sitting on the geometry, nor is he grabbing the collar. It all had to be cheated to camera. Think of it as WWF wrestling. They look like they are fighting, but they never really hit each other. Take that wrestling fans! Essentially, it's another layer to manage as you try to get a hard shot out the door.

Finally, I have to say the schedule. It was short! I never really felt I had enough time to begin with, but when they changed the camera angle for two sections, it got even crazier trying to rework the animation! Still, I think it all worked out. Hopefully you have a copy kicking around to check it out.

WHAT IS YOUR TYPICAL WORKFLOW FOR A SHOT?

That depends on the style of animation. If I'm doing a realistic visual effects show, I tend to work straight ahead. Pose to pose just doesn't work when for me when I'm trying to assess whether a character has the appropriate amount of weight or velocity,

etc. I need to see it in motion all the time to know whether or not the speed accurately represents real-world physics. Consequently, the question I constantly ask myself while I'm animating is "Does this look real?". Seems like an obvious one, but it forces me to look very critically at my work. I think it's possible to get romanced by a cool pose or some fancy choreography, but if it doesn't look realistic, and I'm meant to be animating something from the real world, then I get a big old fail on the shot.

For a character like Spider-Man, I always approached him like he was a stunt double. That meant no shortcuts where I would allow myself to say that he has super-human speed because he has super-human strength. If he moves too fast, he looks light. For a swinging shot, I start by animating his overall body mass and some rough key poses. The goal is to simply get him moving at the correct speed. Only when I was satisfied with that would I move onto finessing the key poses, transitions, and in-betweens required to bring him truly into the real world. The final polish stage is where I will throw in all the texture for the shot. Texture might be a slight body adjustment or a little shake on a leg to break up the smooth feel of the shot. Think of a gymnast on a beam. Usually, they do very small adjustments with their limbs so their core can stay balanced. In addition to breaking up the shot, it also provides some more real-world detail that can really take your shot to the next level.

For a character shot, I work a bit differently. As I mentioned earlier, I spend a lot of time in the beginning simply listening to the audio performance and imagining what the character could be doing. Eventually, certain acting choices become very clear to me and that's where I start. I don't worry about blocking the whole shot with breakdowns because I personally like to allow the shot to evolve as I'm working. Simply put, throwing in a few solid posing choices and playing them with the audio track always opens new and unexpected avenues for me to pursue while animating the shot. For all of us, getting started is often the hardest thing to do because that blank canvas can be pretty intimidating. So dive in with as few poses as possible needed to define the broad strokes of the performance. Even two or three will be fine. Then allow your shot to grow.

One thing I don't do at this stage of a character shot is worry about facial poses or lip sync. There are two main reasons for this. First, bad lip sync distracts me and I know that if I try to block something in, my focus will constantly drift into the smaller confines of the face. But perhaps more important is the idea that you can really sell the emotional feel of a shot with good facial poses. Just by having a sad face on a default pose will make the audience read the character as sad. By not including the expressions, I'm forcing myself to make the body poses convey as much of that

emotion as possible. If I can sell the emotional state of the character without facial poses, then I know that when I do finally get to the face, the shot will just get that much stronger.

Once I get a strong pass of key poses and breakdowns, it's time to convert my shot from stepped mode to spline. It's always painful, but I try to manage my suffering. The first thing I do is break up the shot up into manageable chunks. You can usually find a beginning and an end to a specific action or perhaps a line of dialogue. I'll key all on either side of that chunk, convert to spline, and leave the rest stepped. By doing this, I never get overwhelmed by the amount of massaging I need to do. Baby steps. When I'm satisfied with the first portion, I'll move on to the next section and so on. Once this phase is done, I should have a pretty solid timing and performance pass with the addition of facial expressions and basic lip sync. Then, just like I do with my visual effects work, I layer in the texture. Essentially, I always layer from broad action to detail work with the idea that my detail work should improve an already successful shot. I never want to use facial work as a crutch for weak body and performance choices. Rinse and repeat.

WHAT DO YOU FEEL ARE THE MOST COMMON PITFALLS FOR BEGINNING ANIMATORS?

I think the biggest thing for me is that beginning animators try to cram too much into their shots. Quantity does not equal quality. This creates a couple of issues. Firstly, the shot gets a little muddy and the audience is unclear where to look, or the actions all feel rushed. But the larger issue is how hard the shot becomes to troubleshoot. By jamming all those ideas into your 5-second shot, how do you assess what's working and what isn't? What do you strip out to make the shot sing? So, I recommend layering up. Start with the basic concepts you are most attached to and then add the texture as you see fit.

LOOKING BACK, WHAT WOULD YOU HAVE DONE DIFFERENTLY AS A STUDENT?

I learned to animate the old-fashioned way with a pencil and paper. My issue was that I wasn't a fantastic artist. If you throw in my need to keep things on model, what you got was a student spending way too much time on the minute details of a character and not the broader elements of motion and performance. So if I could do it all again, I'd throw away the model sheets and animate with a grease pencil. Make sure your work is loose!

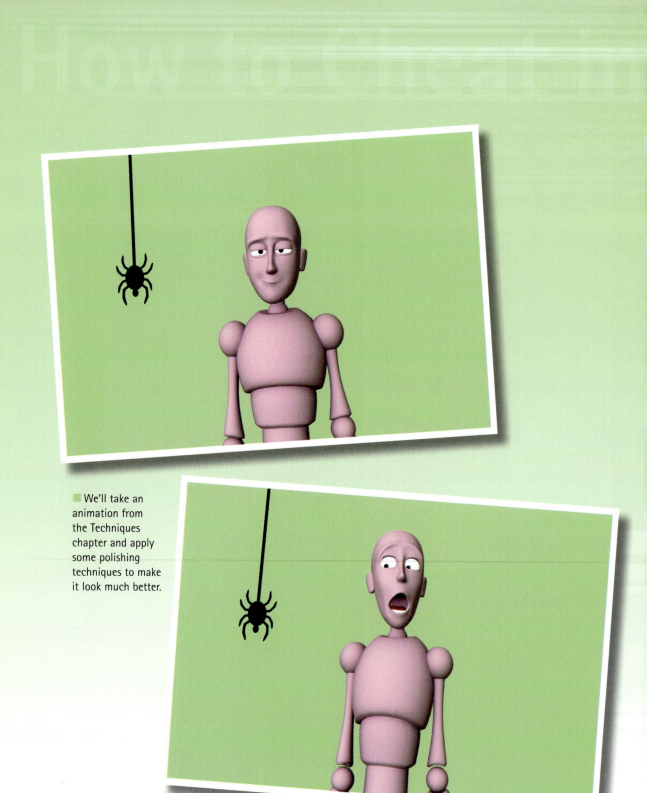

We'll take an animation from the Techniques chapter and apply some polishing techniques to make it look much better.

9

Polishing

IT'S THE LITTLE THINGS that really make an animation sing, and the polishing phase is where they happen. Polishing is the detail work; adding those little nuances that take the animation and push it to a higher level. When we reach this part of the process, we're no longer making big changes to the acting or timing or poses. We're simply going in and making everything as appealing as possible. Polishing is where we go through our animation with a fine-tooth comb, and make sure we're employing the 12 animation principles everywhere we can.

While the polishing needs will vary depending on the animation, there are some techniques that will be called upon in most cases. Those are what we'll go through here. Get out your animation wax, it's time to make things shiny!

DOI: 10.1016/B978-0-240-81188-8.50009-6

Cushions

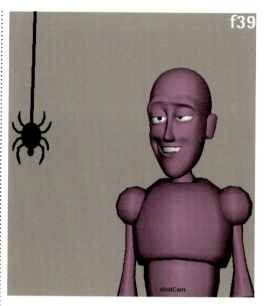

W HEN YOU GET TO the polishing stage, you'll most likely have some movements that just stop on a pose. There may be an ease-in, but chances are there are a lot of places where body parts move to the pose and stop at a flat curve. Things can look pretty good at this stage, but adding cushions can often be the tiny, almost imperceptible thing that really gives the character a nice, fluid feeling.

Cushions are really just very small ease-ins. They're simple to add in, and can work on everything from hand gestures to blinks. Going through your animation and cushioning the places that are a bit too flat is one of those "greater than the sum of its parts" techniques. Have them throughout the animation in the right spots, and suddenly the character feels more alive and natural.

1 Open cushions.ma, which is a more refined version of the animation we used in Chapter 4. Good candidates for cushions are spots where the character stops at a pose, like f39 after the head turn.

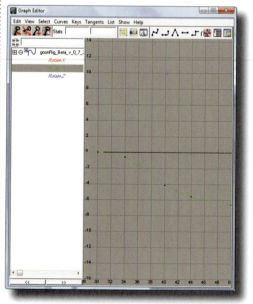

4 Do the same for the upper chest's Rotate Y at f40-f44.

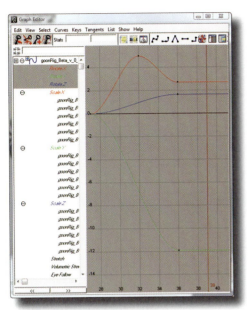

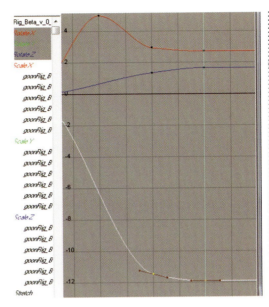

2 Select the head control and look at its rotate curves around f36. We can see that once we get to the pose, the curves just stop and remain flat.

3 Insert a key 4 frames down at f40 (select curves, hold **I**, and middle-click). Then adjust the keys at f36 to do a very small ease-in. You want the cushions big enough where you feel them, but not so it softens your timing noticeably.

HOT TIP

Adding a 4–frame cushion on the lids at the end of the blink helps to keep it from feeling mechanical (unless you're animating a robot blinking, of course).

5 The mouth corners and jaw at f39 are another spot where cushions will help. Add them at this pose as well.

6 The spot where his arm comes up in the anticipation to the scream is another good spot for cushioning. Continue going through the animation and adding subtle softening where you feel it's necessary.

Moving Holds

THERE ARE PLENTY OF TIMES where a character needs to be fairly still. Whether it's a subtle acting shot or a background character listening attentively, computer animation generally does not have the luxury of just letting things freeze for awhile. If it does, the character suddenly transforms into a doll or statue and looks completely lifeless. 2D animation can get away with held drawings, but a computer animator needs to employ moving holds in most styles.

Just like the name says, the character is holding a pose, but still moving so as to not freeze in place. It's simply adding a subtle amount of drift in the curves so the character still feels alive. This reconciles with real life, because nobody is ever perfectly still. We breathe, shift weight, drift around our balance, and more.

Moving holds are pretty simple to add into your work; the trick is figuring out the right amount of drift and having the right amount of slightly different drifts between different body parts. In this cheat, we'll add some moving holds while the Goon grins and before he registers the spider. We'll also put some drift on the spider as well. Be sure to look at the scene file for this one, as it definitely can't be seen on the written page.

1 Open movingHolds.ma. The first place we need a moving hold is the start, where the Goon is just obliviously grinning. I like to think of moving holds on a 2D plane, so the drift mainly happens right and left here.

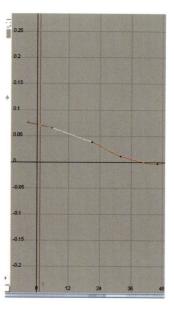

2 Select the body's Translate X curve. I'll make the drift travel from his left to right, since he turns to his right. Select the first key and drag it up almost to 0.1. Shape the drift so it's not too even, but not too defined either.

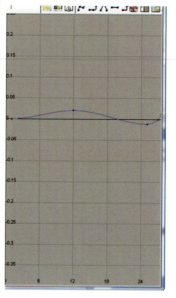

6 Select the head control and add a very slight, almost imperceptible drift in Rotate Z, just enough where you don't notice the head moving, but it's also not frozen in place.

7 After his shriek, have the Translate Y on the body travel through the end of the animation at f70. This keeps him pushing upward to not stop in the middle of this emotional response.

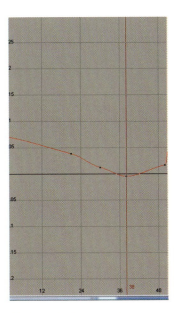

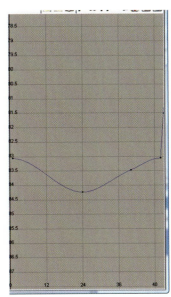

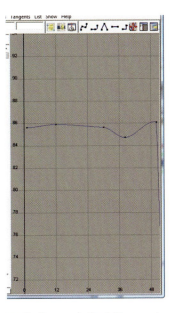

3 He finishes his turn at f38, so make the drift go the opposite way while he stares at the spider, before it registers that he's afraid of it and starts to do the take.

4 Next we'll put some drift on the arms so they don't look frozen. On the left arm's Rotate Z, do a subtle sway back and forth.

5 Do the same in the right arm and give it a subtle drag when he turns to the spider. Counter-animating the arm backward and then catching up to the body keeps everything from moving at the same time and feeling stiff.

HOT TIP

For most styles of computer animation, moving holds are necessary to keep it feeling alive and organic. If you have flat curves in the body, arms, and head, chances are they need some appropriate drift added in those places.

8 Now let's fix the spider. I made this hold quite a bit bigger and more noticeable than the Goon's, more like a bob, to make it feel creepier. This also helps compensate for the fact that we can't move his legs.

227

Texture

TEXTURE IS VITAL in making our animation interesting and fun to watch. Many times animators speak of "adding texture to a shot," which I have come to interpret as embodying two fundamental concepts: detail and variety. They can be employed in any or all of the principles, and masterful animation will possess it in just about all of them.

In terms of detail, computer animation gives us a tremendous ability to create detail, sometimes to a fault! When we think of detail in the polishing phase, it's often things like making sure the fingers spread out all a little differently, the way the lips press together and then relax, or anything that most people won't notice the first time they see an animation; but still feel it. Thoughtful detail can add sincerity and believability to a performance.

Variety is nothing being quite the same. This can be difficult in computer animation, as the computer's gravitational pull is always toward evenness and regularity. If a character is nodding yes, each back and forth can have a slightly different number of frames and a slightly different amount of rotation. If there are several head turns or accents in the jaw, try making them all different in some way. When we polish, we go through our animation over and over, looking for these places where we can do these things and make the character more believable and organic.

In this exercise, we're going to add some texture in his shriek. Right now it's pretty plain and straightforward, so adding some trembling throughout his body will be a nice detail and go a long way in improving this animation.

1 Open texture.ma. We'll start with the body, adding some left-right shaking. Select the body control.

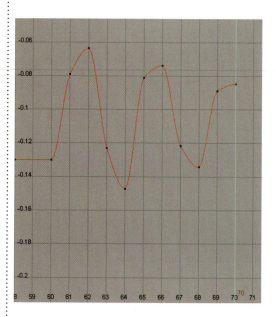

4 With fast 2-frame movements, you can add variety into the spacing and break up the evenness of flat tangents by inserting keys between them. Make them ease-ins of varying amounts.

2 Starting at f60, add a key on the Translate X on every other frame.

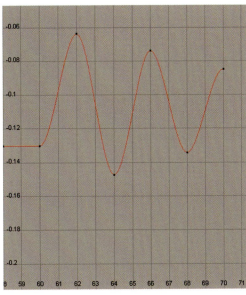

3 Pull the keys out, making sure that they're all a bit different in value.

5 Next is the head, which I'll animate in all three axes, but make each one contrasting. First is the Rotate X, which I'll simply continue tilting upwards throughout the movement.

6 Rotate Y will be a 1-frame jittery shake back and forth. Keep the value small but varied.

Texture (cont'd)

7 Rotate Z has a 2-frame jitter, again using the ease-ins to break up the spacing variety a bit more.

8 Next I worked on the jaw's Rotate Z. It's the same type of movement, but I'm just looking for ways to make it a little different from the others. This one has a mix of one and two frame movements and some spacing variation.

11 The left arm is the same idea, yet started a frame earlier and doing the opposite motion so both arms don't look the same.

12 For an extra detail, I added an eye dart from f16–18.

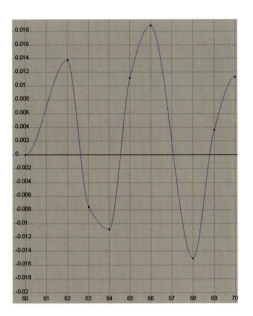

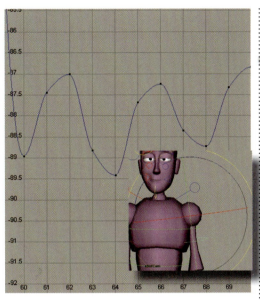

9 This contrasts with the Translate Z in the jaw, which is more straightforward in its spacing.

10 The arms are animated on the Rotate Z channel, doing a shake and using the same ideas of variation.

HOT TIP

One of the few "rules" is never have both arms hit a pose at exactly the same frame. They're generally separated by a few frames at minimum.

13 We'll do some finishing touches in the next cheat, but feel free to add more to this animation where you feel it needs it. Some potential places are the chest and the tongue, for a start.

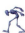

Finishing Touches

W E ARE NOW AT the finishing stage of this animation. The main idea here is going through it and making sure the 12 animation principles are at work throughout. That may sound daunting, so it helps to isolate everything as you do this. Make a list if it helps you, and focus on a principle and if it's happening (or needs to be) at each part at each specific movement.

As an example, let's use anticipation. Start with the body control, and at each movement ask yourself "Is there an anticipation to this movement? Does it need one? Should it be seen, or does it just need to be felt?" and so on. Then move on to the arm and repeat the process. Once you've gone through an anticipation pass on everything, go through doing a pass at overlap, then ease in/out, and so on.

Polishing is something where the end result is greater than the sum of its parts. Each little tweak may not seem like much on its own, but together they can make your animation really sing. This cheat is just a few of the possible areas for polish to get you started. Happy animating!

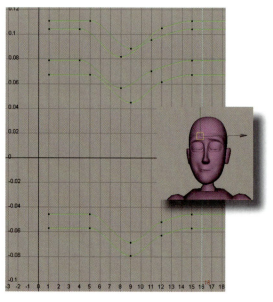

1 Open finishingTouches.ma. The first detail I'll add is a tiny bit of movement in the brows with the blink at f07. You don't always want to move the brows in a blink, but this one is slow, deliberate, and makes sense. Have them lead the blink by a frame and overlap the center with the sides and cushion the end.

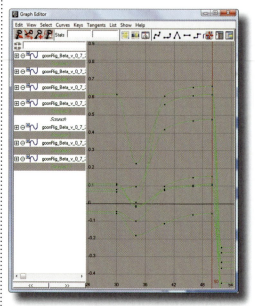

4 Put a nice cushion on that raised brow pose at f40 so they keep pushing up during the look.

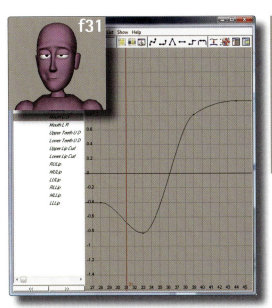

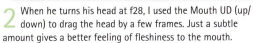

2 When he turns his head at f28, I used the Mouth UD (up/down) to drag the head by a few frames. Just a subtle amount gives a better feeling of fleshiness to the mouth.

3 Also on that head turn, do a small anticipation with the brows going down before he raises them into the pose where he's looking at the spider.

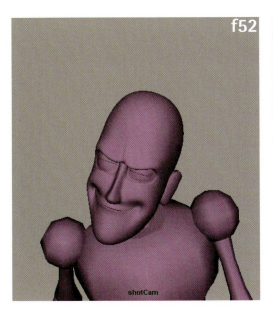

5 We can add some overlap with the squash and stretch in his head to make him feel more organic. With the squash control on the head, stretch it out at f52 so it's dragging behind his body's downward anticipation.

6 The squash then catches up by f56...

233

Finishing Touches (cont'd)

7 ...still slightly squashed at f58 on the way up...

8 ...and then overshoots at f60, a frame later than the body's extreme up, to overlap...

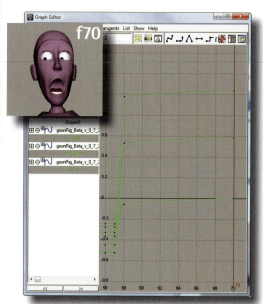

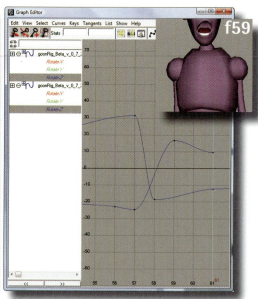

11 Key the brows at f70 and have them keep pushing up as far as possible until the last frame.

12 Little overshoots on the shoulders (with the arms offset by a frame) when his arms snap down at f59–f60 help loosen things up as well.

f62

9 ...and settles back into normal position 2 frames later at f62.

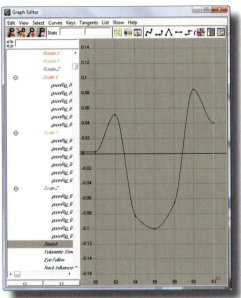

10 This is the curve I came up with for the head's stretch control.

13 Keep polishing the animation, looking for more spots you can improve. Some other ideas are seeing his mouth smirk a bit in the opening, moving his tongue during the shriek, and offsetting the eyes during the blinks or when closing.

Getting Feedback

IT WAS NOT TOO LONG AGO I realized something that completely changed the way I approached my work. Animation is, above all, a group art form rather than a solo one. Sure, much of the time it's a single animator doing the actual animation work on a shot (save for the gigantic crowd ones), but if the animation looks sweet, you can bet they received lots of feedback on it throughout the animation process.

Feedback is probably the single most important element of developing as an artist. I'll say it one more time for emphasis: feedback IS the single most important element of developing as an artist. You can learn quite a bit on your own, sure, but without comments, criticism, and feedback from others, your work will stagnate.

I think most people struggle with taking criticism of their work at some point. After all, it's an artistic endeavor and artists pour so much of themselves into what they do. Anyone who says that it's easy to listen to someone tell you everything you did that's wrong is lying! It can be hard to not take criticism personally (and it's almost never meant that way) because it's natural for us to attach ourselves to our work. That said, if you want to be an animator anywhere besides your home, you will have to reconcile taking feedback and seeing it for what it really is: making your work better.

Why do we need feedback? Because the amount of focus we are putting into animating something causes us to lose objectivity. We work with a minimum measurement of 24 frames per second. The minutiae of that is really incredible when you stop and think about it! When you watch something over and over again, your brain will adapt to how it looks. Watch anything a few times, and stuff that was glaringly wrong suddenly seems OK because it's familiar.

This phenomenon isn't unique to animation. When I was working as a musician, I noticed that I could record a take playing something, and the first time I played it back any mistakes would stick out like a sore thumb. If I listened a few more times, more and more they stopped sounding like mistakes; my ears had become used to it. The same happens with our eyes.

Feedback circumvents this by having someone who's not focused the way you are give you an objective opinion. They are watching it from the point of view of an audience. They will immediately see things that don't look right, or be able to tell you if they understood what's going on. When we know what we're animating, it makes it harder to tell if what's on screen reads clearly to someone who doesn't know.

Show your work throughout the process, not just when you feel you're done (and you're not... the law of animating is if you think you're done, you're halfway done). I can't tell you the number of times I would have saved myself a lot of work simply by showing others my blocking earlier. Problems I never would have realized are obvious to a neutral party.

Feedback from non-animators is just as important. Showing work to your friends or family will give you a perspective of an audience member just watching something naturally. Animators have developed an ongoing sense of analyzing what they're watching, so it's almost impossible for us to see things from this perspective. Non-animators may not be able to say specifically what doesn't look right to them, but if they comment about it, that alone should tell you there's something that needs attention. And, there's no better test to see if something reads clearly or is funny than having someone watch it and see if they react the way you've intended.

Finally, from a practical standpoint, taking feedback is half of an animator's job. Ask any professional, and they will tell you that a big part of the work is hearing what they did was wrong, what they need to change, and what isn't working. Everyday I'm told I need do something different from the way I did! On any commercial project, it's an animator's duty to take criticism positively, graciously, with a good attitude, and to do what is asked of him or her. Get feedback on everything you can, as much as you can, and you'll be able to navigate the waters of critique with ease.

■ What's his
motivation? The
face is a huge
part of conveying
this clearly and
convincingly
through a
performance.

10

Facial Animation

ANIMATING A CHARACTER'S face is one of the most interesting and enjoyable parts of the animation process. We can convey much with the body poses, but this is the really good stuff, the detail that literally breathes life into our characters. The drama and emotion that the face contains really make us look inside ourselves and seek to understand and identify with a character. If animating the body makes us entertainers, then animating the face makes us actors.

Facial animation could fill many volumes on its own, but here we'll get into the bread and butter techniques that give us a great starting point. No two animators work through the face the same way, and you can build your own dramatic philosophies on the essential tools in this chapter.

DOI: 10.1016/B978-0-240-81188-8.50010-2

Planning and Prep

W E ARE GOING TO WORK THROUGH some facial animation techniques using a simple example of a typical close-up shot. This keeps the staging simple and makes it easy to focus on just the face, while also being a very common shot style found in film, TV, and games. To make the exercises as straightforward as possible, the body has been blocked in for you, so you only need to worry about the face.

When doing any kind of dialog shot, it's important to thoroughly plan your animation. Don't just dive right in and start keyframing. Listen to the audio by itself, over and over, until all its accents and nuances are ingrained in your mind. Also think about the context of the line, along with the character's internal thought process and motivation for saying it. It's quite possible to animate a line in completely different ways, yet when played in context with the surrounding shots, only a specific approach will ring true.

In our case, we don't have a context, just a single line to use for practicing some animation technique. For the sake of consistency, we'll pretend that the ideas in this planning section are what a director has instructed us to do. In the real world, this planning and prep would have been done before the body was animated, as it would influence our decisions in that regard as well.

"I have nothing to say."

1 In the Sounds folder in this chapter's project directory is a .wav file with a short dialog clip (nothingtosay.wav). Open it in your favorite media player and listen to it on looped playback. Use headphones if possible. Write down the line and listen to its nuances.

"I have..."
-slow blink on head raise
-head tilts back
-eyebrows raise

"nothing to..."
-eyes flare slightly
-upper lids still touch iris
-head tilts more
-make brow pose asymmetrical

"say."
-head comes down
-tilt is opposite of up position
-brows lower some
-eyelids stay lowered

4 Reference is always a good idea. Act out the line and create some video reference for yourself. Make notes on the brow poses, eye darts, blinks, etc. You can also make thumbnails, have a friend act it out, whatever you find useful in determining what you will animate.

"I have nothing to say."

"I have nothing to say."

attitude: uncooperative, resistant, possibly hiding something, knows more than he is saying
subtext: "I have nothing to say to you. I don't want you to find out what you are asking me."

HOT TIP

To import a sound file into your scene, go to File > Import and select the audio file. Then right click on the timeline and choose the file from the Sound menu.

2 I hear two distinct accents in the line, on the "noth-" (first syllable) in "nothing," and on "say." The pitch goes up to "nothing" and down on "say." This is also reflected in the body animation. Mark the accents down in your notes.

3 Next I think about the tone of the line and the subtext it may be communicating. The way he says it sounds like he's being uncooperative. It feels like he means "I have nothing to say to you in particular," to whomever he's speaking to. This is more material for our notes.

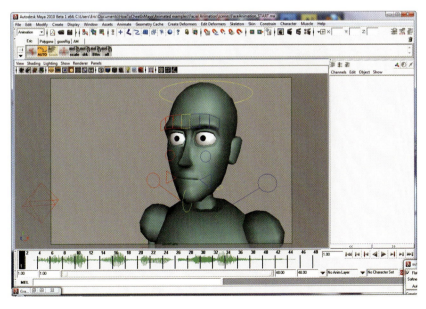

5 Once you've decided on the acting choices and know why you've made them, it's time to start working on the face. Some animators do the lip sync first; others do it last. I find it helpful to first do a few full face poses to use as a structure. Open FaceAnimation_START.ma. The body has animation, but the face is stuck in its default blank stare, which we'll fix soon enough!

Core Poses

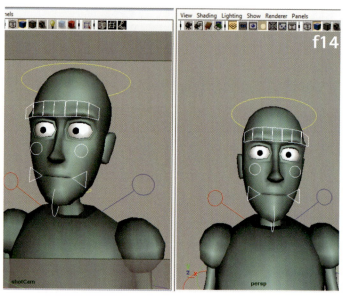

1 In the FaceAnimation_START.ma scene, there is a quick select set for the face. Go to Edit > Quick Select Sets > face, and set a key at f14.

I'S VERY FEASIBLE to animate the face in a layered fashion, but I've found I get better results when I first block in some initial expressions to use as a foundation. The accents we indicated in our planning stage create a perfect framework on which to base these poses. This also helps make the work stronger, since we can focus on just a few expressions and not worry about making fluid motion yet. We'll put in four poses total: the accents on "nothing" and "say," the anticipation pose on "to," and the starting pose. Things will get moved around a little when we refine them, but you'll likely find that these core poses really help keep you on track. CorePoses.ma is the reference file.

5 At f32, set a key on the face controls. Bring the brows down, lift the lids some, and expand and shape the mouth for "say."

6 Copy f14's pose to f18 by selecting all face controls and MM dragging in the timeline to f18 and setting a key. This will hold that pose for 5 frames.

f14

2 The Goon's default pupil size is a bit small, so I increased the Dilate attribute to .2 on the eye controls, and will keep it there the entire animation. This will make him a bit more appealing once the expressions are in.

3 Start with the brows, raise them and make the shape slightly asymmetrical. Raise the lower lids a bit and make the left eye upper lid slightly higher to complement the higher left brow.

4 For the mouth, bring the corners down and inward. It's roughly the mouth shape for "ha-," but we don't need to be concerned with it too much right now. Curl the lips out a bit and shape the mouth.

f24

f01

f01

7 Key the face at 24. Raise the brows even more, lift the lids, and shape the mouth for the "to" sound.

8 Key the face at f01 and create the starting pose. We want to convey him being slightly defiant. Lower the brows, but not enough so he looks angry.

9 A slightly open frown helps show that he's displeased about the situation but not gruff or stewing.

Lip Sync 1 - Jaw Motion

1 If you want to use the face cam, in the viewport menu go to Panels > Perspective > camFace. The angle will stay straight on the face no matter what the body does.

W ITH THE CORE POSES COMPLETED, we're in a good spot to start on the lip sync. As we've seen time and time again, the approach of starting broadly and adding detail in phases will work beautifully here. We won't worry about mouth shapes yet, just the jaw's Rotate Z movement. Once that is working, everything else usually falls into place pretty smoothly.

It's easy to overlook the variety of timing in the jaw movement. In a given line of dialogue, there is usually a wide range of sharp and smooth movements. One trick that helps make them a bit more tangible is to say the line while holding your hand underneath your jaw. You'll be able to feel the words with sharper timings and then translate that into your curves. I found that the biggest accents were on "I," "nothing," and "say."

The Goon Rig comes equipped with a face cam, which some animators like to use for lip sync, particularly if the body is moving all over the place. It's simply a camera constrained to the face, so it keeps the same angle even when the body is moving.

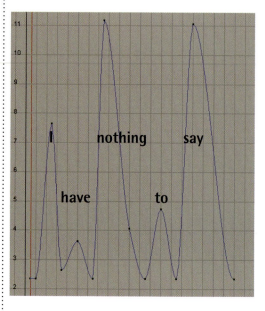

4 This is the curve I came up with for the first pass. Notice the accents on "I," "nothing," and "say," while "have" and "to" are much smaller.

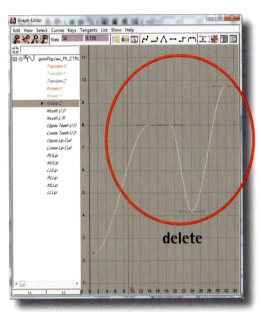

2 It will help to delete the mouth's animation and start fresh. Select all the mouth's keys except on f01 and delete them.

3 Do a first pass just to add the open/close movement. Just get the general timing for now. Do an open/close for each word, or 5 total. Keep in mind that you want the open to be a few frames before the actual sound.

5 Tweak the timing and get the little bump that happens on "-thing." I like to save these secondary bumps for after the main accent so the mouth doesn't get too chattery.

6 Work on the timing of "say", which he draws out longer in the clip. I added a key to hold it open longer, and a longer ease-in at the end.

HOT TIP

Animate the physical movement of what's being said, rather than simply basing it on the words. If you open/close every syllable, the mouth will chatter pop. Analyze yourself saying the line and only put in what you actually see.

Lip Sync 2 - Mouth Corners

THE JAW IS JABBERING AWAY, so it's time to work on the mouth corners. With this rig, the corners are the primary shaping controls. Other rigs might have more controls for the mouth shapes, but the idea at this point is the same: add another level of detail without going overboard. There are plenty of passes left to refine, so we don't need to do everything at once. Because the mouth rig is so simple, we're basically only worrying about if the corners are in or out at a given time. As for up and down, they will stay in a downward frown position for the entire shot.

This is the point where we can start thinking about basic mouth shapes and phonemes. If you're new to animating lip sync, there are plenty of charts online and in classic animation books to study extensively. For this exercise, we'll just walk through the ones we need for the dialogue. To keep things simple, I'll start by posing the corners on the same keys as the jaw. Remember, we're not doing the full mouth shapes yet, just the positioning of the corners to get us on the right track.

1 At f07, move both corners out for the "I" sound.

2 Move to f13 and bring them in some for the "ah" sound in "have."

6 At f26, bring the corners in again for the "to" sound.

7 Hold that shape until f29. Then at f34 the corners come out again for "say." Bring out his left corner more to give a nicer shape on this last word, so it has a slight drawl to it.

3 Two frames later at f15, we need to make an O shape for "noth-."

4 At f18 the corners will expand back out some.

5 Then they expand out more at f20 for the "-ing" sound of "nothing."

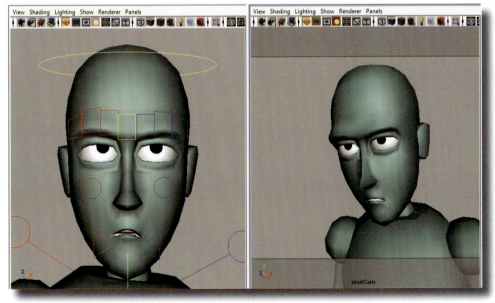

8 Finally, we want a nice ease in to the ending pose as the mouth relaxes into his final expression.

Lip Sync 3 - Mouth Shapes

LET'S CONTINUE REFINING our lip sync by fleshing out the mouth shapes. This is one of the more organic parts of the process, where you need to experiment a little and do some back and forth to get things working. The following cheat is a guideline, rather than a step-by-step process.

f07

f09

1 On the "I" sound, I lifted the upper lip controls a bit to give it a slight flare. Then the mouth corners were pulled out more to create more contrast to the next shape.

2 On "have" I opened the jaw a bit more at f08. At f09 the bottom lip starts to curl underneath the upper teeth.

f26

f29

6 Refine the O shape at f26 a bit more using the lip controls.

7 At f29 for the S sound I closed the jaw more, pulled the corners out a bit, and flared the upper lip some.

f12

f13

lower lip

jaw

f18

3 The jaw is closed a bit more and the lower lip is curled under the teeth on frames 11 and 12. Any shape like this needs to be held for at least 2 frames or it will pop and look like a glitch.

4 At f13 the jaw is moving down into the O shape, but I raised the lower lip controls to drag them behind the jaw. The transition from the V blends better and feels more organic.

5 At f18 I closed the jaw more to make the "th" sound read better. Once we add the tongue it should work nicely.

f35

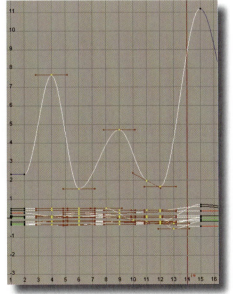

8 From f32 into f36, shape the "ay" sound by curling the lips out slightly, and using the upper lip controls give a very slight flare to help communicate his understated defiance.

9 After looking at a playblast, I decided "I have" was hitting a bit late. I selected the jaw and mouth corner controls and moved all the keys from f05 to f14 one frame earlier, and f08-14 an additional frame earlier.

Lip Sync 4 - Tongue

T HE FINAL STEP TO REALLY SELL the lip sync is getting the tongue moving on the right sounds, in particular "no-" and "-thing," the T sound on "to," and the S sound on "say." Unless it's an extreme close-up or something, the tongue mainly just needs to be seen when it's touching the top of the mouth, such as on N sounds, and when it moves back to the lower palette. Otherwise, it just needs to stay out of the way.

1 Since it's a little difficult to select, make a quick select set for the three tongue controls. Select them and go to Create > Sets > Quick Select Sets. We'll just move and key them all together for this exercise.

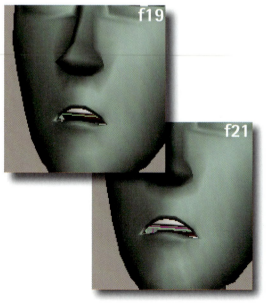

4 Make the tongue touch the roof of the mouth at f19 for the "th-" sound, and then it arrives back to the bottom at f21.

f12

f14

f16

2 The tongue touches the roof of the mouth for the N sound of "nothing." Key the tongue at f12 at its default. It will start moving to the top while he's making the V sound in "have."

3 At f14, rotate all three controls up in X so they're touching the roof of his mouth and key them. Then key them back at 0 on f15 and f16 so the tongue travels back down.

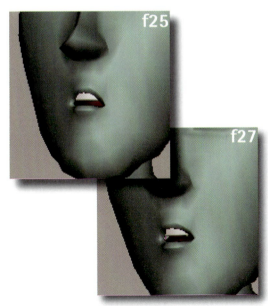

f25

f27

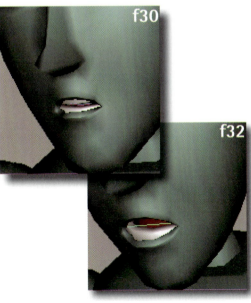

f30

f32

5 The tongue will be at the top of the mouth again for the T sound in "to" at f25 and back down at f27.

6 Finally, have it up at f30 for the S sound in "say," and travel down to f32.

HOT TIP

Most of the time you don't need to get crazy detailed with the tongue for lip sync, unless it's an extreme close-up or realistic style of animation. If it's at the top of the mouth when it should be, and we see it travel down when it needs to, that's usually enough to sell it for many situations.

Facial Animation

Blinks

1 Open Blinks.ma and switch to a front view. Select the eye controls, and at f01 key the upper and lower lid controls at 0.

BLINKS ARE A VITAL PART of facial animation and acting, and a great way to add more life and interest to your character. Before we continue with the lip sync animation, let's take a look at doing a typical, standard blink. This is a common approach to doing them, but you want to make sure you don't do all your blinks this way. There are many different kinds of blinks: fast, slow, half-blinks, fluttering eyes, takes, disbelief, etc. The approach you use will be dictated by the emotion and thought process of the character. Nevertheless, this is a tried-and-true way to get a nice organic looking blink and is a great starting point for building a "blink library" in your animation toolset.

4 At f04, the lids are completely closed. I like .75 on the upper lids and .25 on the lower (adding up to 1.00).

7 At f07 both lids are almost back to the starting pose. Unless the eyes are completely open or closed, I generally like to keep the lids touching the irises on the way up or down, as it makes the blink feel smoother.

2 At f02 key the upper lids down at .1 to create a slight ease out.

3 At f03 bring the upper lids down to cover the tops of the irises, and start bringing the bottom lids up very slightly, about .05 or so.

HOT TIP

Another nice touch for blinks can be adding some very slight up and down in the brows. It depends on the situation, but sometimes adding a barely perceptible amount of motion here can help make things more organic.

5 We'll hold the closed pose for 2 frames, but I moved the upper lids down a bit more (to .78) on f05 for a subtle bit of compressing together.

6 At f06, the eyes are opening back up. For a standard blink, I like to have the upper lids be around halfway past the irises on the way back up. The lower lids start to go back down as well.

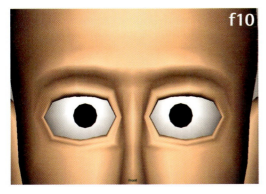

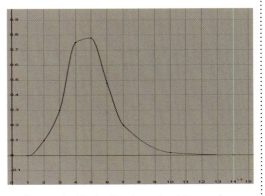

8 Instead of ending on f08, do a nice ease in from f07 to f10 to cushion into the pose and make it feel more organic.

9 For an extra bit of polish, do another 4 frames of very subtle ease in cushioning on the upper lids. This is what the curves look like. Look at Blinks_End.ma for the final result.

Blink and Brows

f05

LET'S REFINE THE BROWS and add a blink to our face animation. We'll have the Goon blink when his head raises, since it's speed fits well with the motion we have going. We'll keep it fairly close to a standard blink, except that the closing will be a bit slower since that fits his uncooperative, slightly indignant attitude. Then we'll tighten up the timing of the brows raising, and add an accent in the brows and eyes to bring out the the final word of the shot, "say."

1 Start the blink at f05. Key the lids' open and close attributes at their current position.

f11

f14

4 A slower opening fits this blink as well. The eyes start opening at f11, and at f14 the tops and bottoms of the irises are still touching the lids.

2 Let's make the transition down into the closed pose a total of 4 frames. Here are f07 and f08. Notice that we always see part of the iris when the eyes are open any amount.

3 On f09 and f10 we'll have the closed pose.

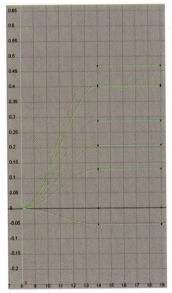

5 The eyes continue to ease in to their pose at f18.

6 Now let's work on the brows during the blink. We want there to be some overlap, with the brows going up, leading the eyes opening slightly. Select all the brow controls.

7 Move the start of the brows' motion to f08, right before the eyes are closed at f09. At f14 they should hit their up pose.

Blink and Brows (cont'd)

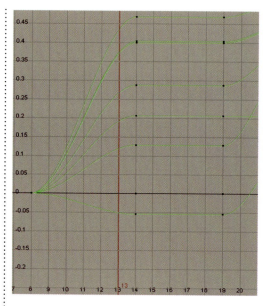

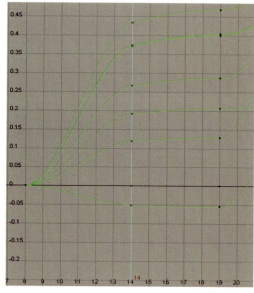

8 A quick trick for doing cushions for the flat curve sections is to move to the frame before they hit the pose, in this case f13.

9 MM drag in the timeline from f13 to f14 and set a key. Now f14 is almost the same value it was, but drifts through to f19. Fix the tangent handles and you instantly have a nice subtle drift to make things more organic and not frozen for a stretch of frames.

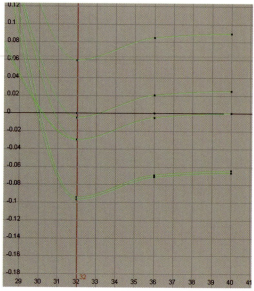

13 At f36, set a key on the brows so they have the same pose as f32. Then at f32, pull the brows down just a small amount to create a little overshoot.

14 Key the brows at f40 and add a little cushion starting at f36.

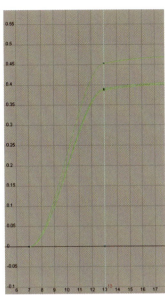

10 To add a bit more fleshiness to the brows, I often like to make the apex lead the rest by a frame. Select the three brow controls shown here.

11 Those are the apex of the brow pose, so select their keys at f08 and f14 and slide them 1-frame earlier to lead the rest of the brows. It's subtle but a nice little touch.

12 Let's move to the end of the animation, on the word "say." Right now the brows and eyes just stop on that last pose at f32, so let's add a little accent. Select the brow controls.

f34

15 Select the three middle brow controls and move from f32 onward 1 frame earlier so they lead the rest of the brows.

16 Make a very small complementary squint with the eyes that trails the brow by a frame. It will help feel that his face is working as an organic unit, rather than an assembly of moving parts. See BlinkBrows.ma for the end result.

257

Eye Darts

ANOTHER IMPORTANT ELEMENT of organic facial animation is eye darts. They're often used for "keep alive" moments, where a character isn't really moving much but needs to still look like he or she is a living being. They show that a character is thinking about something and that there is an internal monologue happening. And on just a practical level, our eyes rarely stay focused on the exact same spot for more than a second or so, and usually less.

Eye darts can definitely go deeper than that, however, and should be thought about with as much attention as any other element in a character's performance. An eye dart at the right moment can communicate things that nothing else could. A character's eyes darting away as he's trying to convince someone of something can convey the thinking "Is she buying this?" or show worry, realization, doubt, or any other internal emotion. This is something that we as animators need to be constantly thinking about.

We'll go through a simple eye dart workflow, but keep in mind it's a starting place. Your decisions about eye darts ultimately involve what you need to communicate about the character's mental state.

Rather than bouncing them around randomly, it helps to create a subtle pattern with the darts. Shapes like triangles, rectangles, etc. can be good guides for plotting the path the darts make, provided you don't make them too obvious. Varied timing and amounts of movement can help with this. Shapes make sense because we often look back and forth between a person's eyes and mouth when we're conversing. For this exercise, we'll do three darts and form a triangle shape with their path. They're traced in the example as they're very hard to see in still pictures. Be sure to follow along with the Maya file.

eye dart 1
eye dart 2
eye dart 3

f07

1 Open EyeDarts_START.ma, which starts with the blink exercise we did previously. Key the EyeTarget control at f07.

f15

4 Do another eye dart, with the ease in, from f13 to f15. We'll work back to the original pose, but rather than do a lateral move right back to where we started, let's go downward.

f38

7 In our face animation, let's add an eye dart at the end for keep-alive and for conveying that he's speaking to someone directly. Our eyes often dart back and forth between the other person's two eyes when addressing them.

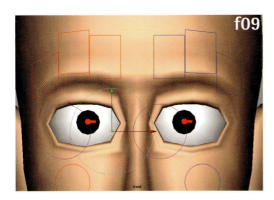

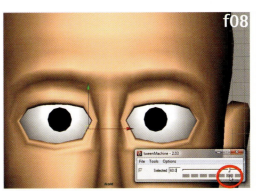

2 Eye darts are generally two frames (at 24 fps), so move to f09 and key the eyes slightly screen left, about -.3 in Translate X.

3 It helps to do a tight ease-in to the next pose, rather than leaving it linear. A quick trick is to use TweenMachine. I went to f08, pressed the 60% button, and it's done.

5 It often helps to think of the eye darts moving in the path of shapes; in this case I'll use a triangle. This helps keep them interesting, rather than lateral or too random. f25-f27 gets us back to the original pose.

6 Here's what the curves look like. Notice the ease-ins, and that we didn't space them evenly apart. Variety in the timing is another characteristic of appealing eye darts.

8 I did a dart from f38-f40. It's subtle but another small thing that helps add up to a more convincing performance. FaceAnimation_darts.ma has the end result.

HOT TIP

Our eyes tend to not smoothly track things, at least not without turning our head with it. If the head isn't moving, it's common to do a series of sequential darts, rather than a smooth pan across.

259

Final Touches

W E'RE AT THE HOME STRETCH with this face animation! All that's left is some tweaks and polishing to make it look as good as possible, which we'll go over in this cheat.

Hopefully this exercise in facial animation has given some insight into both what to think about and how to execute it in Maya. The face rig we're using is only the basics, and you will run into more sophisticated rigs throughout your career, but the principles remain the same. The face is working as an organic whole, yet some parts are influencing others (brows can influence the lids, mouth corners can push up the cheeks, etc.). From ears to nose flares to a dozen lip controllers, modern production rigs are capable of most any expression possible. Study reference and performances by great actors; think about motivation, internal monologue, and thought process; and work through your own Oscar-worthy performances. Happy animating!

1 The first thing to do is give a slight anticipation down before the brows move up. It's another detail that will help things feel less mechanical and more organic. Select the brow controls.

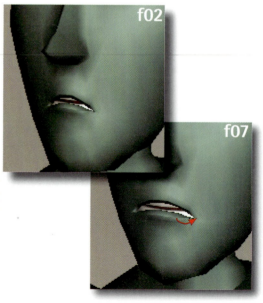

4 Another subtle polish thing is to make sure the mouth corners have nice little arcs in them when moving in and out. It's another one of those details that isn't obvious, but just helps everything feel a little nicer.

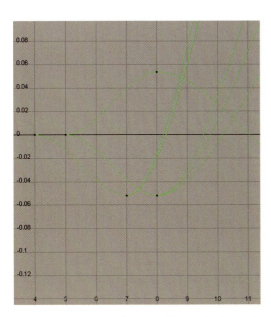

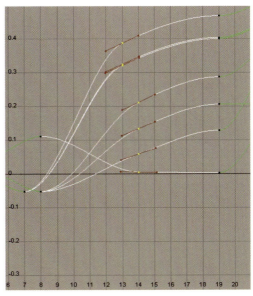

2 Add a key 3 frames before each of the starting keys and then pull the original key's in the opposite direction about .05 or so. Now there's a slight down in the brows that makes them feel nicer going up.

3 On second look, it looks like the up pose at f14 is still hitting a bit too hard. Select the keys at f13 and f14 and pull them down to make the cushion a little bigger. Now they won't stop so quickly and look more natural.

f17

f23

f29

f36

5 "-thing" is another syllable that can have a nice arc on the corners. A subtle loop into the closed position will work nicely.

6 Create another nice little loop on "say." It doesn't need to be very noticeable, just there. Continue tweaking the animation until you're happy with it. The final result is in the FaceAnimation_END.ma file.

Repetitive Stress Injury

REPETITIVE STRESS INJURY, or RSI, is a very real hazard of working on a computer all day, as animation requires us to do. The stress you can put on your hands and wrists doing tiny movements day in and day out can add up to a very painful and debilitating condition that can jeopardize your ability to work. Taking precautions, being conscious of ergonomics, and working smart can keep you happily keyframing for many years.

I've been a victim of RSI, though it was before I became an animator. When I was in music school, I was practicing the piano 8 hours a day, and also worked part-time as an IT supervisor for the university's music computer lab. If I was awake, chances are I was playing or typing and using a mouse. Every day I was constantly using my hands without much of a break and it didn't take long before I pushed myself to the breaking point. The pain had been building up gradually in my wrists and forearms, but I shrugged it off until it became too much to ignore. This was before RSI was common knowledge as it is now, and I went from doctor to doctor trying to figure out what was wrong. Eventually I found one who was experienced with this growing phenomenon of the computer age, and could treat me.

It wasn't an easy road to recovery though. At the worst point, I couldn't turn a doorknob or drive because of the pain. I didn't play music for about 4 months, and had to deal with the possibility of not playing ever again. I had to get lots of physical therapy, quit my job that helped support me through school, postpone classes, and put everything I loved to do on hold. It was an extremely difficult experience to get through, but ultimately an invaluable one because it taught me how important it was to take care of my body. If you can't imagine a life of not animating or at best being in pain whenever you do, you need to make working smart a priority.

Animation is extremely mouse intensive, and until we come up with a better interface, we need to be cautious about our working style. The standard computer mouse is actually one of the worst ergonomically designed devices in the history of civilization. Hold your forearm with the opposite hand and rotate your palm down as it is when using a mouse. You will feel your forearm bones twist over each other,

tightly pulling the tendons and muscles above your wrist together. Tension equals friction, and over time your tendons will become inflamed and possibly develop scar tissue that exacerbates the problem.

So step number one: get a better mouse or mouse alternative. I use a Wacom tablet to animate, and since I started with it years ago, I've had no issues with RSI (along with doing some of the other practices I'll mention). It takes a week or so to get used to it, but once you do, you'll find it puts much less stress on your body. Many artists use tablets nowadays, and every place I've worked at had them available upon request.

If you really like using a mouse, research and find a quality ergonomic one. Evoluent (www.evoluent.com) makes a great vertical mouse that's very comfortable to use. It's oriented vertically to avoid the forearm twisting mentioned earlier. I've seen plenty of these in animation studios as well.

Take lots of breaks! Every hour or so you should take at least 5-10 minutes away from the computer to rest your eyes and hands. It may be hard during a crunch but in the long run it will make you more productive. Besides, it gives you a legitimate reason to make use of the studio's ping pong or pool tables!

Use good posture when working. If you work at home, the investment in a good chair and desk will pay for itself in keeping you healthy. Research ergonomics to find a combination that works for you.

Exercise and eating right are the last elements of staying in the animation game. Exercise releases the tension that builds up in your body from sitting and working long hours. Doing some weight training will stretch your tendons and muscles and make them more resilient and flexible. Since I've stayed with a weight regimen and followed this advice, I've been working happily with no issues and no pain my entire career.

RSI is very real and its effects can be devastating to your career. Do your homework, insist on working only in proper conditions, and your body will reward you by always being there for you.

v.01

■ Undecided? Animation layers will let you organize and create unlimited variations in your work. Much like layers in Photoshop, you can control what curves are playing where and how much they influence the final result. Mix and match to your heart's content and come up with new ideas.

v.02

11
Animation Layers

MAYA HAS POSSESSED a venerable set of animation tools through the years, tools that made it the industry standard for animating. In actuality, not much in its animation functions has changed much over the years. Most of the recent versions have seen very little added on the animation side of things. After all, if it ain't broke...

However, with Maya 2009 a bombshell was dropped in the form of Animation Layers, and they will forever change how you work. They allow flexibility and simplification of animation curves that are completely on another level from how many of us learned computer animation. This chapter will show you how to employ this incredibly powerful feature into what will likely evolve into a new and improved workflow for you.

DOI: 10.1016/B978-0-240-81188-8.50011-4

11

How Animation Layers Work

I F YOU'VE USED GRAPHICS PROGRAMS like Photoshop, then understanding Maya's Animation Layers will be a short leap from there. Layers let us stack multiple versions of spline curves on top of each other, which Maya then mixes together the way we want. This default behavior is one of two available layer modes, and is called Additive mode. A simple example would be two layers for the Translate Y attribute:

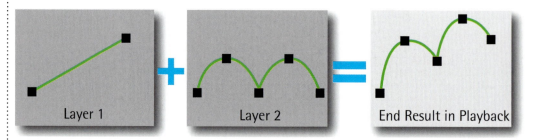

You can see how the two Y curves are mixed together for the end result. While this alone can make working with curves simpler, particularly with more complex examples, the real flexibility is how we can adjust the weight of each layer, much like opacity in a graphics program.

Instead of editing the curve itself, simply turning the weight of Layer 2 down to 50% reduces its influence on the final result by half. It looks like this:

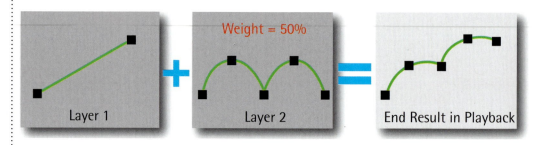

Likewise if we switched that concept, and reduced the weight of Layer 1 to 50%, we get this:

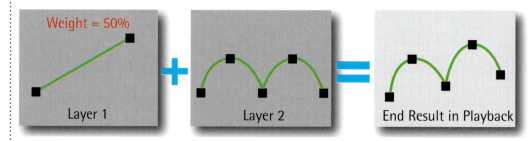

Since the weight is just a slider, we can instantly experiment with any ratio of weights, giving us exponentially more options with no extra spline editing.

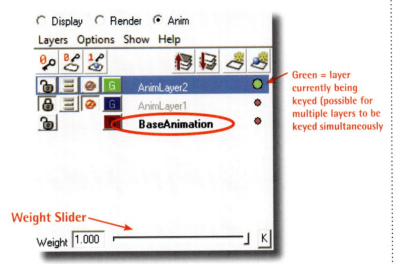

Green = layer currently being keyed (possible for multiple layers to be keyed simultaneously

Weight Slider

When we use layers, any animation we've done before the first animation layer was created will be labeled as BaseAnimation in the editor. BaseAnimation is not actually an animation layer, so we can't adjust its weight or turn it off.

Creating animation layers stacks them on the base layer. As far as Additive mode layers go (which is the default), the order doesn't really matter and the results should look the same. Override, the other mode, does take the order into account. When we set a layer to this mode, it essentially mutes any animation on layers below it that share the same controls/attributes. Animation above an Override layer will be added into the end result.

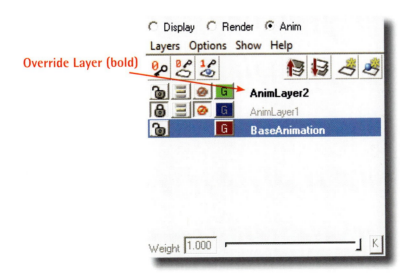

Override Layer (bold)

Animation Layer Basics

NOW THAT WE UNDERSTAND how animation layers work, let's see in Maya the example that was just illustrated. The Translate Y curves are exactly the same as the previous page's example to keep things consistent. You'll be able to experiment for yourself and see how the weighting of a layer affects the animation. Weighting can also be animated just like anything else, so curves can have different amounts of influence throughout an animation, continuing to expand the possibilities. Finally, layers offer some nice organizational colorizing, complete with different colored ticks in the timeline, which can be a lifesaver if you're using many layers.

After this cheat, we'll revisit the facial animation we did in the previous chapter and continue to improve it, as well as create some new variations.

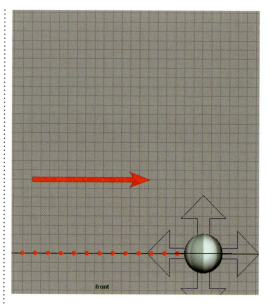

1 Open layerExample.ma and switch to front view. Right now only the BaseAnimation is active, which is the ball translating in X from left to right.

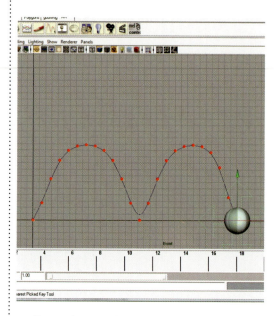

4 Re-mute Layer1 and unmute Layer2. You can see the Translate Y curve from Layer 2 in the illustration at work.

Mute buttons

2 In the Layers panel, switch to Anim Layers. There are the two layers above the base, with the same animation as in the example we just talked about. Currently both layers are muted.

3 Click the Unmute button to enable Layer1. Our Translate Y curve from the illustration is now active and the ball travels upward. Muting is a great feature for comparing how different curves affect the end result.

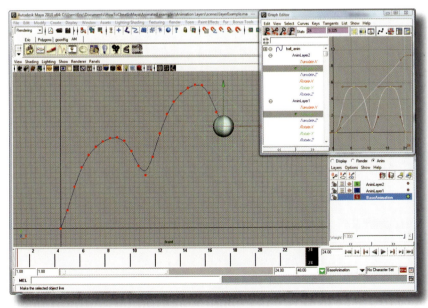

5 Unmute both and they are added together in the final result. You can see that there are two separate Translate Y curves in the Graph Editor, separated by their layers.

HOT TIP

If you have lots of layers and the graph editor is getting crowded, right click in the left panel and select Animation Layers Filter > Active. Now only the active layer's curves will appear.

269

Animation Layer Basics (cont.)

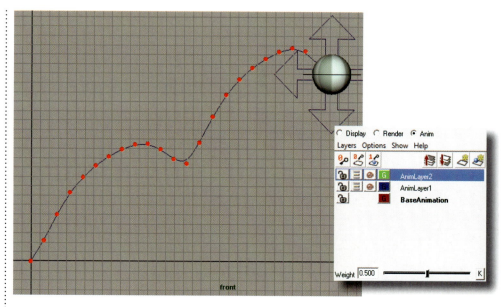

6 Select Layer2 and move the weight slider down to .5, or 50%. Now the peaks of the Layer2 Translate Y curve are half of what they were. Remember that we haven't changed the actual curve at all, only the amount of it that is combined into the final result.

8 The K button next to the weight slider keys the weight attribute. You can set a layer's weight to different amounts throughout an animation. Once you set a key on it, a curve called "Weight" will appear under the layer's name in the graph editor, which you can edit as normal.

9 Right click on Layer2 and select Layer Mode > Override. The name turns bold and the ball only moves up and down. Override causes a layer to mute the layers below that have the same controllers. Since the ball's Move control is animated in everything below, they are overridden.

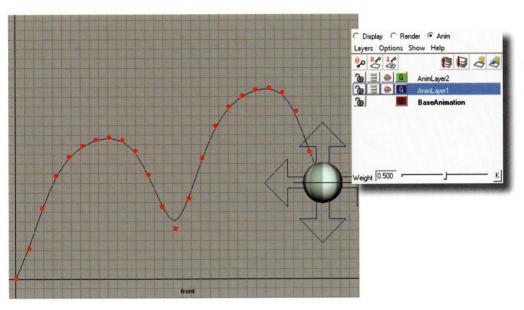

7 Set Layer2's weight back to 1 (100%) and slide Layer1 to .5. Now the ball only reaches half the height it used to at the end, but the bounces are back to their full amount.

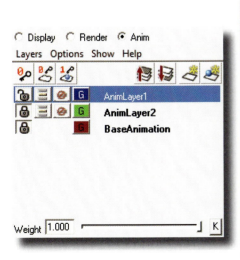

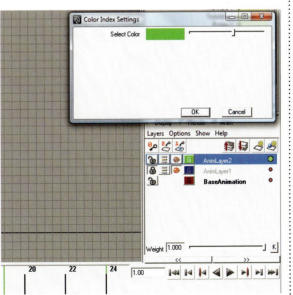

10 MM drag to reorder layers, and the Lock button protects them from being keyed or changed.

11 Right click on the G button to set the layer's color. This will make all the key ticks in the timeline for that layer the color you choose. Clicking on the G button will also enable ghosts for that layer in the color as well.

Creating Variations

ONE OF THE COOLEST THINGS about Animation Layers is they give you freedom to try new things without messing up what you've already done. This is especially helpful if you're doing work for other people, and they're undecided about which direction they want. Rather than having to save multiple versions of a scene and jump back and forth, you can keep everything in a single scene, yet separated the way you see fit. Better yet, I've been in plenty of situations where I've shown three or four versions, and they liked something from each. That can be a nightmare to put all together sometimes! Animation layers eliminate all of that.

We'll open the facial animation from the last chapter, and pretend that the director likes what we've done, but wants to see what it looks like if his body moves a little bigger and more exaggerated. We'll use layers to augment what we already have, and switch between the versions with a click of the mouse.

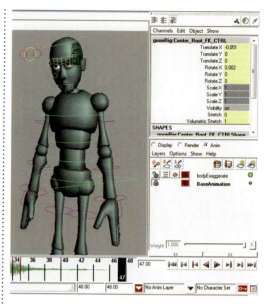

1 Open variations_Start.ma. Select the Body control and in the Anim layers panel, click the Create Layer from Selected button. This automatically puts the control into the new layer. Name it bodyExaggerate.

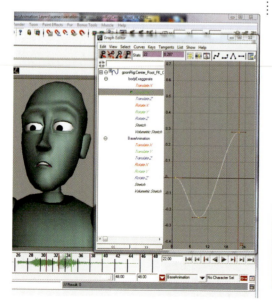

4 At f20, key the body up, pushing his peak higher.

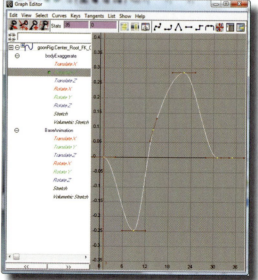

5 At f31, the new Y curve goes back to zero. Continue to tweak the curve until you're happy with his up/down motion.

2 Click the Lock button on the BaseAnimation so we don't accidentally alter our original. Then right click on the bodyExaggerate G button and change it's color.

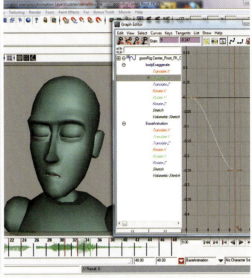

3 Key the body at f01, and then give him a bigger dip downward at f09 so his body arcs down before it travels up.

HOT TIP

If you need to add or remove controls to/from a layer, select the controls, select the layer, and right click and choose Add (or Remove) Selected Objects.

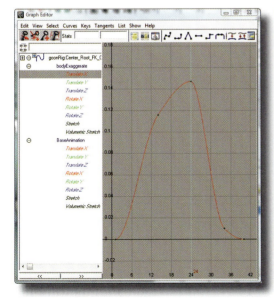

6 I also pushed him screen right more in X to go along with the bigger Y movement, again zeroing out at the end of the motion.

7 He now has a bigger body movement and we can switch between it and the original simply by muting the bodyExaggerate layer. If we wanted to see something between the two, adjusting the layer's Weight will work beautifully.

Creating Variations 2

SIMPLE VARIATIONS, like we just did, are pretty straightforward. But sometimes it's useful to start with animation we've already done and alter it in a new layer. This lets us use the original curve and change it where we need to, while still keeping the original version to compare. Maya makes this a simple process, and it can be very powerful when we want to see subtle variations in an animation.

In this exercise we'll pretend that the director wants to see him close his eyes when he raises his head to make him a little more arrogant. He'll keep his eyes closed until he comes back down on "to say." First we'll extract the original animation on the eyes and put it on a new layer and then copy that layer again for another version to make changes on. When you extract animation, you remove it from the original source, BaseAnimation, and place it into a new layer. Copying the extracted layer lets us keep the original, while having a duplicate to make any adjustments on. Then we'll use the Override mode so only one version is played back at a time.

1 Open variations2_Start.ma. Select the Goon's right and left eye controls and in the Layer panel menu bar, select Layers > Extract Non-Layered Animation from Selected Objects. This takes the eye animation and places it onto a new layer.

4 Name the new layer closedEyes and choose a new color for it. You can also lock the BaseAnimation and originalEyes layer to keep them from being accidentally changed.

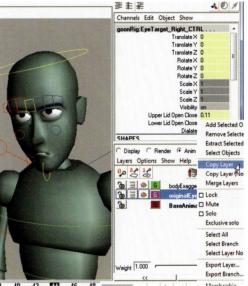

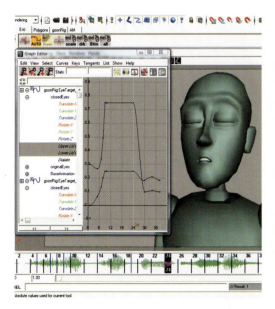

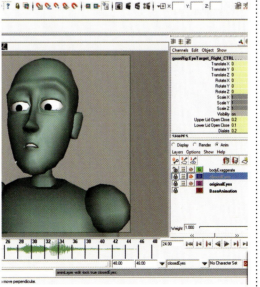

2 Rename the new layer (double click the name) to originalEyes and choose a distinctive color for it. This is where we'll keep the original version of the animation. Note that extracted layers are Override mode by default (name in bold).

3 Right click on the originalEyes layer and choose Copy Layer to make a new layer (in Override mode) with the same eye animation.

5 On the closedEyes layer, adjust the eyelid curves so they stay shut until f24 or so.

6 Since the eye layers are both in Override mode, you just need to mute the closedEyes layer to see the originalEyes animation. Remember that an Override layer cancels out any of the same controllers/attributes below it.

HOT TIP

Instead of extracting, you could have also just copied the curves from one layer to another in the graph editor. This keeps the curves on the BaseAnimation. It's just personal preference to separate the variations into layers for organization, hence the method here.

Layers for Texture

THE ANIMATION IS LOOKING quite a bit better with our recent additions, and we can instantly go back to the original version at any time. Such is the power of layers. Yet it still needs a little something. A little shake when he raises his head and closes his eyes will add a nice bit of texture.

Creating layers to add in texture is a technique that can save you tons of work, especially if working for a picky or indecisive director. It's easy enough to add in the headshake as normal, but if you're then asked to tone it down or take it out, you have to go back in and edit the original curve quite a bit. Using a layer for the shake, you can simply turn the weight down until they're happy. And best of all, it makes your curves simpler to work with. If you were asked to start with the head rotated farther in Y, you can simply adjust the original curve while the head shake stays the same in its own layer, rather than having to tweak where Rotate Y starts and all the shaking keys after it.

In short, Layers have lots of uses and you'll figure out plenty more as you continue to use them and tailor them to your workflow. Happy (easier) animating!

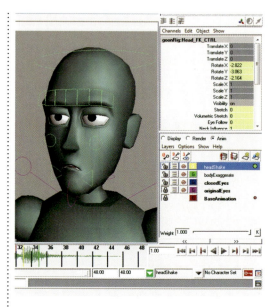

1 Open texture_Start.ma and select the Head control. In the Anim layers click the Create Layer from Selected button. Name it headshake and give it a unique color.

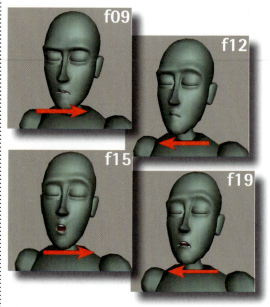

4 The subtle shake.

276

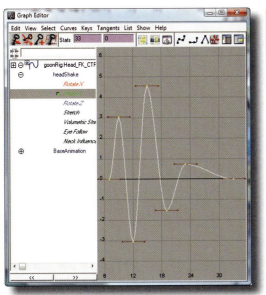

2 Starting at around f07, rough in a back and forth "no" movement as he raises his head.

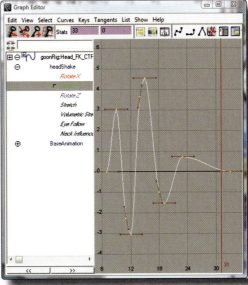

3 Work with the curves until the shake looks good to you. I added some more ease in on some of the shakes.

5 With the bigger movement in the body, I noticed his head needs to drag more in Rotate X. Add that in on the headshake layer, or put it on a new layer if you like.

6 Now you can really tweak things to your heart's content. Using the layers and their weights, experiment with different amounts of head shake, body exaggeration, eye versions, and anything else that you want to try!

HOT TIP

Layers can be parented to other layers. This isn't like parenting with props or anything, though. It's simply Maya's way of organizing layers, like folders in Photoshop.

Spotlight: Sean Burgoon

SEAN BURGOON IS THE LEAD TECHNICAL ARTIST at Cryptic Studios where he has served as an Animator, an FX Artist, a Technical Artist, and a Combat/Gameplay Designer. He has worked on *Champions Online*, *Star Trek Online*, and other internal projects. Sean is the creator of the Goon Rig used throughout this book, and it's also available free via his website, www.seanburgoon.com. Sean also writes and continues to work on a variety of creative projects in his free time.

WHAT'S YOUR BACKGROUND AND HOW DID YOU COME TO WORK IN ANIMATION?

I always loved animation, but my first love as a kid was always computers, and specifically video games. I learned some simple programming in BASIC back on my Commodore 64, and just kept learning from there.

Educationally it was always kind of assumed I would be a lawyer, so I ended up getting my degree in Political Science from the University of California, Santa Barbara, with the intention of going to law school. That didn't exactly work out (school wasn't really for me), so after I graduated I started thinking about what I could do to make some money, and maybe actually enjoy my job. I knew I still loved animation, and I was still pretty good with computers and simple programming despite my liberal arts studies, so I decided to take a stab at getting into 3D animation.

Not having easy access to any rigs, I was forced to make my own from day one, and so that became second nature to me very quickly. Once I realized I needed some formal animation training, I signed up for Animation Mentor, and they helped get me over the hump to get my job as an Animator at Cryptic. I wound up doing a lot of our R&D work for animation, and a lot of the more technical tasks, in addition to animating, and so over time I slowly evolved into my current role as Lead Technical Artist. I handle all of our rigging and scripting in 3ds Max, as well as doing some actual programming when necessary.

WHAT'S A TYPICAL DAY LIKE AS A LEAD TECHNICAL ARTIST?

At our studio there really isn't a typical day for a Lead Technical Artist. Part of that is due to the nature of the game industry, and part of that is just due to the nature of my specific skills and roles at Cryptic. My days are generally split between talking to various members of the software and art teams about features we'd like to see, or issues they're having, troubleshooting any problems that do arise, and managing the rest of the technical art team (handing out and reviewing work, as well as assisting with any issues they might run into).

Rigging actually becomes a less common part of the job, in my case, because I've managed to get almost all of our rig types set up with auto-rigging scripts, so any time a new humanoid rig is needed, we just run a script on the skeleton and a rig is spit out, all ready to go. Same goes for quadrupeds and a variety of other creature types. Aside from the general tool development and troubleshooting, we also spend a good deal of time optimizing or making new materials (shaders) for the artists to use or assisting the art team with optimizing their existing assets and levels. Overall the main goal is to make sure the art team is able to efficiently create assets, focusing on the art and not a complicated pipeline, and that once those assets are in the game that we still meet our performance guidelines. That's one trick with games vs. film. In games, you can make the best looking art in the world, but if it doesn't run at 30 frames per second, then it's not going to work.

HOW DOES YOUR ANIMATION SKILL AND KNOWLEDGE CONTRIBUTE TO YOUR WORK?

For anyone making animation tools, actual animation experience is incredibly valuable. Having used rigs, and done the sorts of things your animators are trying to do gives you a lot more insight into what sorts of things will make their life easier. Sometimes, because of the combination of animation and technical skills, you'll actually come up with ideas the animators never would have thought to ask for. It also really helps raise the quality of tools you create. It's one thing to get a request for a tool, or come up with the idea for a tool, but having in-depth knowledge of how an animator would want to use it, minute to minute, is extremely important. Animators are busy people too, and generally having one swing by to give constant feedback on

how your rig or tool works isn't even close to practical. Being able to put on your animator hat and take a critical look yourself is huge.

HOW DO YOU APPROACH LEARNING NEW TECHNIQUES AND SKILL SETS?

I always try to keep a balance between what I'm doing at work, and the personal enrichment projects I work on at home. There is always a tendency at work to fall into a routine, especially when you're in the middle of a production cycle and everything is going reasonably smoothly. You may not have a new, unique challenge every day to keep you on your toes, so what I do is provide those challenges to myself at home. If I'm doing a lot of programming and scripting at work, I try to push myself to do more art at home, and vice versa. Also, for every side project I do, I try to make sure there is at least one component that I've never done before, whether that's low-level graphics programming or a different type of rig for a character. First off, it's fun (and if it's not, you might be in the wrong line of work), and second, it really helps keep your mind fresh and ready to deal with whatever challenges randomly crop up at work down the line.

Other than that, when I'm trying to actually learn something new, it's a lot of research to see how other people have solved similar problems, followed by a lot of guess work, trying to come up with a way to improve on what I've found, or better adapt it to my needs, and then a whole lot of failing forward. The biggest trick for me is to be ready to fail a few times. You will screw up, you will go down a path and then find out it's fundamentally flawed and have to start over. That's all just a part of learning something new. Don't over-plan, just start doing and trying new things. Some of it will work, some won't, but in my experience, you learn a lot more from having to fix something you messed up the first time than you do from any amount of thinking about it before hand. Obviously you need to balance the risks you take with the schedule of the project you're working on (if you're a month from release, you should probably err on the side of caution), but if you're in an R&D phase, or even better, just working on a casual project for your own benefit, constructive failure can be one of the best teachers around.

WHAT ADVICE DO YOU HAVE FOR ANIMATION STUDENTS?

My advice is: learn to take criticism! Force yourself to enjoy it. Even if you think you're a better animator than the person critiquing your work, the fact is they see

something they think could be better, and unless you're Milt Kahl, chances are it could be. I say this because taking criticism is something I have always been bad at, and was bad at for a long time. I hated getting it, especially from people who weren't animators themselves. What I finally learned, though, was that the more people tore my work apart, the better that made me, and even though I ended up shifting into a more technical role, if I ever decide to push back into animation, the first thing I'm doing is getting a bunch of people to tell me everything I'm bad at. It's painful at first, but it works wonders.

Also remember: just because someone tells you to change something doesn't always mean you have to do what they suggest. If it's your lead animator telling you or your director, then yes, do exactly what he says, but if it's a peer, or any random person off the street, listen carefully to what they are saying, and then think to yourself, "What makes them think there's a problem here?" Sometimes the people giving the critique won't know the best way to fix the issue, or even exactly what they're noticing, but 9 times out of 10, they noticed something. It's your job to do the detective work to figure out exactly what that is.

Aside from that, just make sure you enjoy what you do, because you're going to be doing it a lot. Animation, in games or film, as well as related fields like Technical Art, takes a lot of work and a real passion that other professions don't necessarily demand. You can't just phone this job in, it doesn't work that way. You need to be constantly practicing and evolving your skills and keeping up with all the new, hungry young whippersnappers pouring into the industry. If you love what you do, that won't be a problem, but if you don't, it might just drive you nuts.

Of course, a demo reel is all about the animation. But that being equal between animators, which do you think will get the extra point in the end?

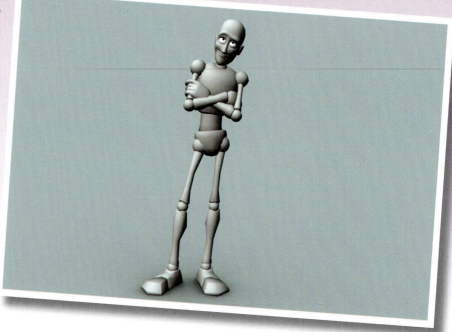

12

Lighting and Rendering

WE'VE COVERED A LOT about animating in Maya throughout this book, but to close it out let's learn some basic lighting and rendering. Since this book is by an animator for animators, we're not talking about feature film quality lighting; that's something covered by many great lighting artists in their respective tomes. What we want to gain is some skill in simple lighting techniques that will add a nice bit of polish to our animations. These are very simple and easy tricks that give good results, and look much nicer than simple playblasts for showing your work. When your animation is done, the cheats you learn here will give you a soft, clean, simple look for a demo reel or portfolio that looks nice and doesn't distract from the animation. All the renders you see in this book have been done using the techniques from this chapter.

DOI: 10.1016/B978-0-240-81188-8.50012-6

Basic Materials

FOR THE LIGHTING TECHNIQUES we're going to learn, we need to know a little bit about materials in Maya and how they work. Materials are the attributes you apply to an object that tell the renderer how it should respond to light. They determine the object's color, how shiny it is, if it looks smooth or rough, anything that describes how it looks when lit and rendered. While the possibilities are truly endless, we're only going to worry about a couple of them. For the simple, clean looks we're creating, we don't need to do much more than pick a color and maybe a bit of shininess. Just those few can create quite a bit of depth. We'll also go over a few tricks that will have you experimenting with ease.

This is a basic introduction to materials, and predominantly centers around quickly adding some nice color to our animations, as texturing is outside the scope of this book. But even if you're familiar with Maya's materials, the IPR (Interactive Photorealistic Renderer) feature that we'll talk about is a great cheat in speeding up your workflow. Things are about to get much more colorful.

1 Open materials.ma and select the shotCam. We have the Goon in a simple pose and the default gray Lambert material all around (yawn).

4 *ctrl* double clicking on the material is a quick way to rename it, which is necessary when you'll have lots of materials. Name it "goonShader."

2 Go to Window > Rendering Editors > Hypershade to open Maya's Material Editor. The left column is the various materials available to create, the upper section is the materials currently in the scene, and below is the work area for editing materials.

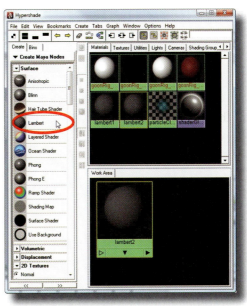

3 Lambert materials have no specular highlights so are good for the soft clay-looking style we'll learn later. Lambert1 is the default material in every new scene. Create another one by simply clicking on Lambert in the left column.

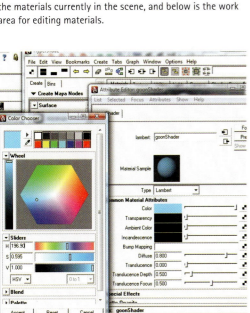

5 Double clicking on the material brings up the Attribute Editor for the material. Click on the box next to Color to bring up the Color Chooser. Choose an appealing color and click Accept.

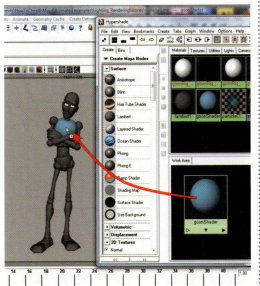

6 There are a couple of quick ways to apply the material to the character's geometry. You can MM click and drag the material from the hypershade onto the part you want to color...

Basic Materials (cont'd)

7 ...or you can select the geometry, right click on the material and choose Assign Material to Selection. Here I marquee selected the character from the chin down to not select the eyes. Then go back and do the ears.

8 Everything about the material in the viewport is very approximate. You need to render to see what it truly looks like. Click the Render button at the top (Movie Clapboard icon) and you'll see what the color really is.

11 Again, you need to render to see the actual look of the material. Adjust the eccentricity in the Blinn's Attribute Editor and click the Render button. You can see that he looks much more like plastic.

12 One very useful tool for speeding up the coloring process is using Maya's IPR render, which is a real-time render that updates as you change material attributes. Click the IPR button, and then select the area with the character to update.

9 You need to make a new material for every color you want. You can also create the material, apply it when it's default gray, and then choose the color. This will let you see the color on the character as it updates in the viewport.

10 Blinn materials have a specular highlight, which can make them look shiny and more metallic (among other things). Take a material that's applied to the entire character and in its attributes change the Type to Blinn. He will look shiny in the viewport, although this is very rough and approximate.

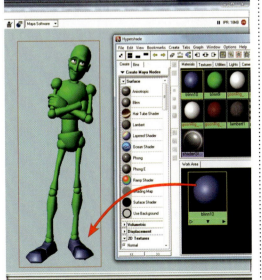

13 Now you can adjust the material attributes and Maya will update the render as you do, giving you instant feedback on what the material actually looks like.

14 You can even MM drag a material from the Hypershade onto Geometry in the IPR render and it will change the material automatically. Continue experimenting with the Lambert and Blinn materials and their attributes to learn more about them.

Rendering with Shadows

NOW THAT WE HAVE some basic material skills at our disposal, let's learn a popular rendering style for animation tests. This style has an infinite ground plane (no horizon) and shadows to indicate the ground level and give a point of reference to the animation's weight. It works really well for physical tests, such as walk cycles and fight sequences, much like you would see on a game animator's reel. We'll add a simple 3-point lighting scheme, give it some color, tweak the shadows, and we're good to go.

The lights we'll use are called Directional lights. They're infinite lights, in that they have no beginning and no end. In other words, it doesn't matter where we put them in the scene,;it only matters which direction they're pointing. Directional lights are often used for things like sunlight, where we don't see where the light starts or ends, and it covers the entire visible area. This makes them perfect for this "infinite ground" plane we'll create.

For the ground we'll use what's called a Use Background material. This material is invisible, but can still have shadows cast on it. We simply see the color that's behind it, kind of like glass, which makes it look like there's no horizon line.

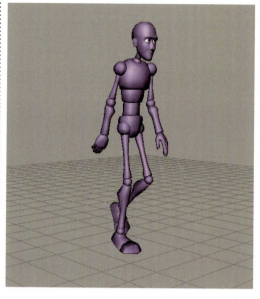

1 Open shadows.ma where we have the character doing a walk cycle in place. The first thing we need to do is create the ground plane. In the Polygons menu set (press the F3 key) go to Create > Polygon Primitives > Plane.

4 Select the camera and in the Attribute Editor, scroll down to the Environment tab. Here you'll find a Background Color Attribute. Select a color you like. I went with a light gray. Render the frame to make sure you're happy with the look.

2 The plane will be hidden under his foot, so press **E** for the Scale tool and scale up the plane.

3 In the Hypershade create a Use Background shader and apply it to the plane.

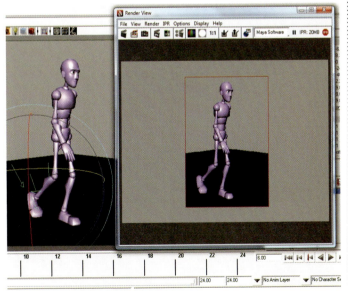

5 To add the lights go to Create > Lights > Directional Light. Remember that only the rotation of the light affects it, so feel free to scale up and move it to make it easier to see.

6 This first light is the key light, or main light. It will be the main light falling onto the character, so poisition it as a good overall light. This is a great time to use the IPR render to tweak the light's rotation. Ignore the black ground while using IPR, as it doesn't work on the Use Background material or shadows. Just focus on the character and how this main light will fall on him.

Rendering with Shadows (con.)

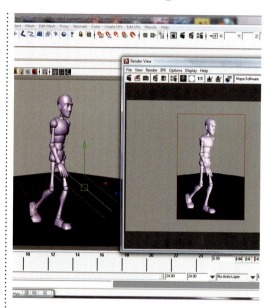

7 Select the light and duplicate it by pressing **ctrl D**. The character will turn white from the brightness, as there's double the illumination now. Move this second light to an easy position to rotate it.

8 This is the fill light, so it only needs to be a fraction as bright as the key light. With the second light selected, go into the attributes and turn the intensity down to .25. Also uncheck Emit Specular so only the key light creates the little white highlights.

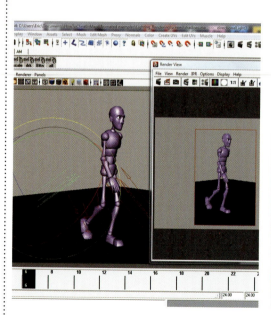

10 Duplicate the fill light and have it fill in the dark patches on his back. I raised the intensity of this light some to .6 or so.

11 In the first light's attributes, check Use Depth Map Shadows. Increase the Resolution for 1024, make the shadow color not completely black, and set the Filter Size to 3. This creates a softer edge around the shadows.

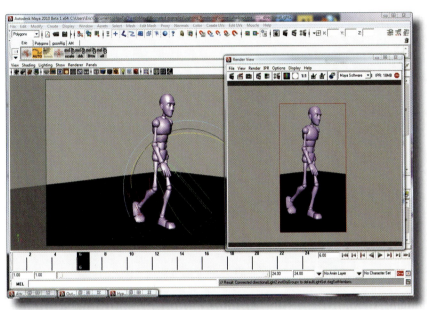

9 Position the fill light where it's filling in the side that's not facing the key light. We want to brighten up some of the darker areas, but not so much where it's all lit the same.

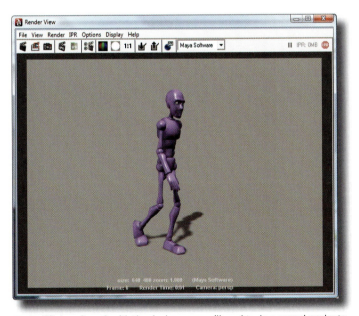

12 IPR doesn't work with the shadows, so you'll need to do a normal render to see it. Continue to tweak the light placement until you're happy with it and the shadow position. We'll render all the frames in the next cheat!

Render Settings

O UR ANIMATION IS READY to be rendered, so we need to adjust the render settings appropriately. Taking a moment to specify how you want the renders created will keep things predictable and organized. You may be rendering an animation that has hundreds of frames, and that means hundreds of image files being created. Rerendering all those frames over and over is not part of the how-to-cheat philosophy!

As you've surely deducted, we're going to be rendering each frame as an image, rather than creating a movie. A movie might seem easier at first, but it actually limits you in a lot of ways. A movie must be completely rerendered every time you make a change. You may render and see a few frames you want to tweak. With separate images, you can simply rerender the frames you changed.

A movie also offers less flexibility for post-production. Using still images, you can render all elements separately in Maya (shadows, highlights, color, etc.) and bring them into a compositing package for the ultimate control of how everything looks.

1 Open shadowRender.ma and click on the Render Settings button. At the top make sure you're rendering the master layer and using the Maya Software renderer.

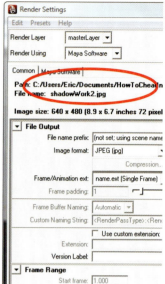

2 Check the Path for the images, and make sure it is the images folder for the current project. If not, close the Render Settings, and go to File > Project > Set... and choose the Lighting_Rendering project folder.

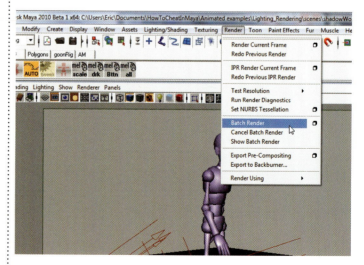

8 You're ready to batch render! Press F6 to switch to the Rendering menu set. Then go to Render > Batch Render. The speed will vary depending on your machine, but this simple animation shouldn't take more than several minutes. Go grab a soda!

3 For the File Output, set the name to walkCycle and we'll use jpegs for the image format.

5 Set the frame padding to 3. You always want to set this to one higher than the highest amount of digits in the frames you're rendering. In this case, it's 2 digits as we have 24 frames. This puts a zero at the beginning. Sometimes other software can get confused by the frame numbering, but the preceding zero will prevent this.

7 Make sure you're rendering the perspective camera. The camera to render is easy to forget, and there's nothing more annoying than accidentally rendering the wrong one! The image size, 640x480 is fine for this exercise. Close the render settings dialog.

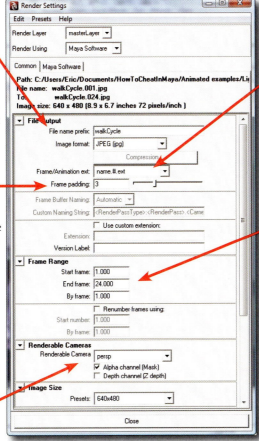

4 Under Frame/Animation extension, set it to name.#.ext. This will name each image walkCycle.framenumber.jpg. At the top under Path you'll see File name, which indicates how Maya will currently name each file.

6 Set the frame range from 1 to 24 to render all the frames in this animation. This is where you can tell Maya to only render a few frames if you've tweaked something after rendering. "By frame" means you could set it to 2 and render every other frame, or whatever you like.

HOT TIP

You can also open an image sequence in Quicktime by going to Open, selecting one of the image files, and checking the Open as Image Sequence box in the dialogue box.

9 Maya comes with a program called FCheck to view your images as an animation. Run FCheck, go to File > Open Animation, and select any one of the image files you created. It will automatically sequence all of them and play the animation.

Clay Render

shotCam

1 Open clayRender.ma for a simple pose of the Goon drinking tea. The materials are Lamberts, one for his body, the other for the cup. Feel free to adjust the colors if you like.

ANOTHER SIMPLE YET APPEALING style for rendering your animation tests is a clay-style render. It's good for a soft, flat, simple look that doesn't distract from the animation like poor lighting and texturing will. Again, we're not talking about doing full-fledged lighting here; these techniques are geared towards simple colors that look nicer than playblasts, are easy to do, and stay out of the way of the animation. All the rendered poses of the Goon character throughout the book were done with this technique.

To create this style of render, we just need to use Lambert materials, and the mental ray renderer in Maya. No lights are necessary, which makes this technique very easy and straightforward. We'll use a feature of mental ray called Final Gather. What this does is actually use the color of the background as a light source, like a giant, infinite sky surrounding your animation. Also known as indirect illumination, it doesn't create defined shadows, so I find it works best with non-physical, non-full body tests. In other words, perfect for dialog and acting tests.

4 Select the shotCam and open the Attribute Editor. Under Environment select a nice, light color. This color is the light source and will cast a colored light onto the character.

2 We need to make sure mental ray is loaded and available as a renderer. Go to Window > Settings/Preferences > Plug-in Manager. Scroll down and make sure "Mayatomr.mll" is checked under Loaded. If it already is, you're good to go.

3 Open the Render Settings and for Render Using select mental ray. Then click on the Indirect Lighting tab and scroll down to Final Gathering. Check the box to enable it and set the Accuracy to 300. Higher accuracy creates smoother results but takes longer to render.

HOT TIP

If you're using a ground plane with this technique, don't forget to put a Use Background Material on it to make it invisible, yet still bounce light.

5 Render the scene and you'll get a nice, soft, appealing render that took about 30 seconds to do!

6 Experiment with different background colors and Lambert materials. For instance, making the character light gray will create a nice monochromatic look, as the light color influences the Lamberts.

Staying Inspired

EVERY ANIMATOR KNOWS WHAT IT'S LIKE to get that "fire in your belly" feeling. After seeing something that you found so cool and awesome, you want nothing more than to run to your computer and create something just like it. Whether it's a film, book, TV show, piece of art, etc., inspiration can come from many sources. As an artist, we can fall into a rut where we forget what made us want to animate in the first place. Experience is a catalyst for growth, but it can also erode the wide-eyed wonderment you had when you first saw that special film or show that made you say "I want to do THAT!". But staying inspired isn't difficult; it's just something that needs some attention every once in awhile. If creating is starting to feel commonplace and uninspired (and it happens to everyone at some point), then perhaps seeking out some of the following will help rekindle the flame:

Top 10

Everyone has a top ten list of favorite animated films. When's the last time you watched one? What was it about them that made you so excited to animate? The films and TV shows that define the art form for you should never be more than an arm's length away from your desk.

Films

Any film, from animated to live action to everything in between, can serve to inspire your creative flow. It's true that many animated films are made for a specific audience range, but many animators fantasize about creating work outside the typical family scope. Documentaries, art films, sci-fi epics, slasher movies, anything outside the box for animation can give you new ideas and things to try. Looking beyond genre, perhaps it's the way a film was shot that inspires new staging and composition ideas, or how it uses a soundtrack. Leave no film-related discipline unturned when searching for something unique.

Other Art Forms

Move away from the time-based visual element we work in. Books, music, museums, graphic design, theater, any creative discipline can give you ideas that can make for refreshing animation work. Different mediums engage your brain in different ways. If you haven't been reading much, you may find that a book opens some new doors for you or that listening to some music you're unfamiliar with gives you visual ideas you wouldn't have had otherwise.

Process

You can be inspired by a particular artistic process or challenge. Never did stop motion? Set up your digital camera, grab some action figures, and give it a try! Create interesting limitations and see if you can meet their challenges. Can you make a simple ball rig emote? Make a cool animated gif with photographs from your family reunion? Animate only characters in the wingding font and tell a story? Anything that pushes you out of your comfort zone or initially seems unreasonable is great process fodder.

Other Artists

With the multitude of blogs, websites, artist sketchbooks, "Art of" books, interviews, DVD extras, and more, we have more information and inspiration available to us than any past society. Make use of it! Having an hour set aside each week to seek out new things you haven't heard of is a wise idea. You can watch shorts on YouTube, read blogs, look through artist websites and communities, photographs, watch other reels, anything that shows you what everybody else is doing. Keep a folder or hard drive that functions as your personal inspiration library, and archive anything you find that you like. When you're not feeling your work, start browsing through your library and see where it leads you.

These are just a few of the ways you can keep your creative desire fresh and always hungry for more. Maintain a steady flow of inspiration, and you'll never tire of challenging yourself and becoming a better artist. And who knows, you just may come up with the thing that inspires everyone else to keep on going. Best of luck, and happy animating!

Symbols

A

Index

Characters

THE NEXT FEW PAGES list everything that's included on the DVD. All of the exercises and techniques include complete scene files for you to study, explore, and experiment with. There are also two versions of the Goon rig, Justin Barrett's fantastic TweenMachine tool, Quicktime movies of the full projects, rendered images from the lighting and rendering chapter, and the scene file and renders of the flipbook animation. I've also included some video tutorials on using constraints, as that's a topic some people learn better by seeing it in action. Enjoy!

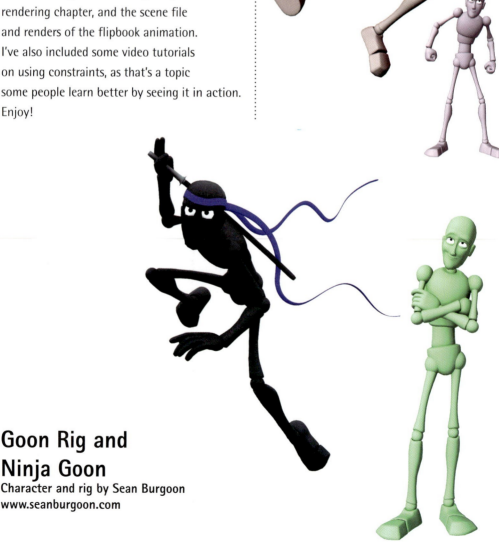

Goon Rig and Ninja Goon
Character and rig by Sean Burgoon
www.seanburgoon.com

Chapter Files

All scenes are .ma files so they can be opened in previous versions of Maya. Previous versions require either setting File > Open > options to Ignore Version, or alteration in a Text Editor (see the Chapter 1 Interlude for more info).

Chapter 1: Workflow Foundation

- panelLayout.ma
- shotCam.ma
- QuickSelectSets.ma
- QuickSelectSetsICONS.ma
- KungFuHouse.ma

Quick Select Set Icons in .bmp and .jpg formats

Chapter 2: Splines

- HowSplinesWork.ma
- TimingSpacing.ma
- TangentTypes.ma
- TangentHandles.ma
- SplineTechnique.ma
- SplineReference.ma

Chapter 3: Graph Editor

- visualTools.ma
- workingWithKeys.ma
- valueOperators.ma
- bufferCurves.ma

Chapter 4: Techniques

- AutoKey.ma
- CharacterSets.ma
- CopyingCurves_start.ma
- CopyingCurves_end.ma
- Figure8_start.ma
- Figure8end.ma
- IK_FK.ma
- IKFKswitching_start.ma
- IKFKswitching_snapping.ma
- IKFKswitching_end.ma
- MakingChanges_start.ma
- MakingChanges_end.ma
- MultiplePivots_start.ma
- MultiplePivots_end.ma
- Timeline.ma
- Timeline_end.ma
- TrackingArcs.ma

Chapter Files (cont'd)

Chapter 5: Parenting and Constraints

- parenting.ma
- parentConstraint.ma
- propConstraintSTART.ma
- propConstraintEND.ma
- constraintWeightsSTART.ma
- constraintWeightsEND.ma
- ballCourse_constraints1.ma
- ballCourse_constraints2.ma
- ballCourse_constraints3.ma

Chapter 6: Gimbal Lock

- WhatIsGimbalLock.ma
- RotationModes.ma
- RotationOrder.ma
- ZeroingOutPoses.ma
- GimbalLockedArms.ma

Chapter 7: Blocking

- goonNinja_rig
- ninjaBlocking_START.ma
- 02_keyposes.ma
- 03_roughTiming.ma
- 04_cameraAnimation.ma
- 05_breakdowns.ma
- tweenMachine.ma

Chapter 8: Walk Cycles

- 01_CorePositions.ma
- 02_CorePositions.ma
- 03_CorePositions.ma
- 04_Splining.ma
- 05_Refining.ma
- KneePops.ma
- walkFinal.ma
- walkTranslate.ma

3 Quicktime movies of finished Walk Cycle

Chapter 9: Polishing

- cushions.ma
- cushions_End.ma
- movingHolds.ma
- movingHolds_End.ma
- texture.ma
- texture_End.ma
- finishingTouches.ma
- finishingTouches_End.ma

1 Quicktime movie of finished project

Chapter 10: Facial Animation

- FaceAnimation_START.ma
- CorePoses.ma
- LipSync1.ma
- LipSync2.ma
- LipSync3.ma
- LipSync4.ma
- Blinks.ma
- Blinks_End.ma
- BlinkBrows.ma
- EyeDarts_START.ma
- EyeDarts_End.ma
- FaceAnimation_darts.ma
- FaceAnimation_END.ma

Audio file: nothingtosay.wav
1 Quicktime movie of finished project

Chapter 11: Animation Layers
- layerExample.ma
- variations_Start.ma
- variations_End.ma
- variations2_Start.ma
- variations2_End.ma
- texture_Start.ma
- texture_End.ma

3 Quicktime movies of variations

Chapter 12: Lighting and Rendering

- materials.ma
- shadows.ma
- shadowRender.ma
- clayRender.ma

Images folder contains all rendered frames of exercises in .jpg format

Extras

THE FLIP BOOK ANIMATION throughout the bottom right corner of this book is included on the DVD with the scene file and rendered images. It was done by New York-based animator Kyle Mohr. Since the final animation was going to be flipped through the pages, he animated it on 2's (every other frame, as is typically done in 2D animation). You can see more of Kyle's work and blog at www.kylemohr.com.

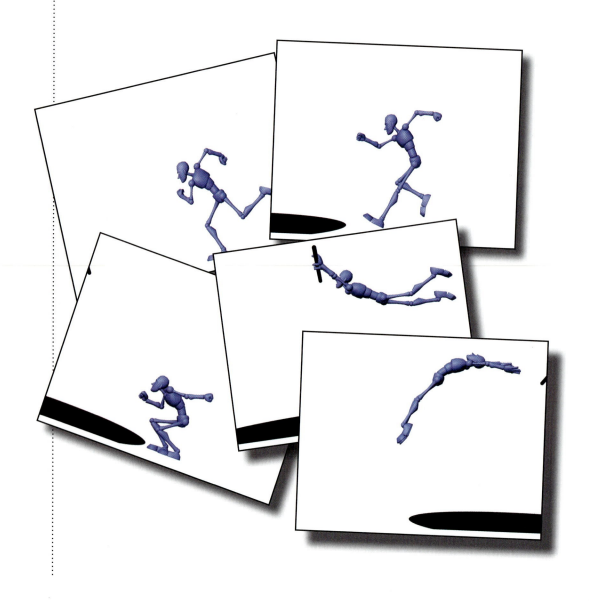

TweenMachine

Justin Barrett's fantastic time-saving tool is included on the disc, as well as available on his website at www.justinanimator.com. Be sure to check it often for updates and new features.

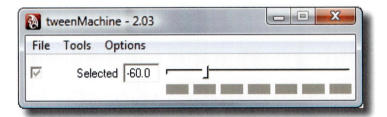

Parenting and Constraints Videos

There are five full-length video tutorials on parenting and constraining in Quicktime format, covering everything you need to know to use them for character animation.